Image and Word

Image and Word

Art and Art History at Smith College

This book is published in conjunction with the opening of the Brown
Fine Arts Center at Smith College.

Library of Congress Cataloging-in-Publication Data
Image and word: art and art history at Smith College.
 p. cm.
ISBN 0-87391-052-4 (alk. paper)
1. Art—Study and teaching (Higher)—Massachusetts—Northampton.
2. Smith College. Dept. of Art—History. 3. Art centers—Remodeling—
Massachusetts—Northampton. 4. Brown Fine Arts Center. I. Title: Art
and art history at Smith College. II. Smith College. Museum of Art.
N346.M42I63 2003
707'.1'174423—dc21
 2002152654

Smith College, Northampton, Massachusetts

Table of Contents

Foreword

The grand opening of the newly christened Brown Fine Arts Center in 2002–03, following an extensive renovation and expansion, marks a new chapter in the teaching of the visual arts at Smith College. When a committee of art department faculty and museum staff talked at the start of the building project about how best to commemorate this occasion, it seemed that this would be an auspicious moment to review the earlier chapters in our history. We wanted to recognize the contributions of the many stellar individuals who have made Smith a leader in the teaching of art for more than a century-and-a-quarter. Thus was born the concept for this book, a history of the three entities that occupy the fine arts complex: the Department of Art, the Smith College Museum of Art, and the Hillyer Art Library. Sections have been written by many current and emeritus members of the art history and studio art faculty, a handful of present and former staff members of the museum, the art librarian, and the director of image collections. A timeline at the end of the volume weaves these separate strands together.

Smith's programs in art and art history have been indelibly colored by the spaces in which they have been located over the years. Hence, we felt it would be as important to profile the various physical homes of the visual arts programs as it is to give credit to the professors, curators, and librarians who worked within their walls. We were delighted that our recently retired colleague, the architectural historian Helen Searing, agreed to write about our architectural history, since no one is better suited to the task. This volume also offers the architects of the building's recent rebirth, James Polshek and Susan Rodriguez of the Polshek Partnership Architects, an opportunity to present the concepts that have informed their work on the Brown Fine Arts Center. The illustrations in the portfolio, which record the nearly final state of the building, were taken at the last possible moment before publication.

This historical undertaking began in October 1999, while the "old" Fine Arts Center was still functioning. Members of the museum's Visiting Committee, whose class years spanned six decades, met with Professor Barbara Kellum and several undergraduates to share stories and memorabilia of their college years in the art department and museum. Memories and mementos were solicited from alumnae at Commencement and Reunion weekends in 2000, as we prepared to close the building's doors; and appeals to the entire alumnae body went out through *NewsSmith* and the museum's Newsletter. We are grateful to all who responded, and particularly to Mary Best Mace (B. A. 1935, M. A. 1937), who provided us with a packet of letters and drawings from former museum director Jere Abbott, and to Priscilla Cunningham (class of 1958), who provided details about the planning for the 1972 building. Several alumnae who contributed to the recollections of Randolph Johnston and Oliver Larkin are cited in the essays by A. Lee Burns and John Davis. Alumnae also recall their printmaking experience in the essays by Gary Niswonger and Dwight Pogue.

Readers who missed our appeals for help but have tales or treasures pertaining to this history to share are still encouraged to do so. We trust that this will not be the last such history to be written, and we remain eager to enrich our institutional archives for the benefit of researchers to come.

We owe thanks to many others who contributed to this endeavor. Provost Susan C. Bourque has been an enthusiastic supporter in both tangible and intangible ways. Karin George, Vice President for Advancement, also helped underwrite the costs, as did the museum's Maxine Weil Kunstadter (class of 1924) Fund. The museum's Tryon Associates have also been significant funders of the publication, and we are deeply grateful for their support for this and so many other ventures.

Special gratitude is due to Michael Goodison, Editor and Archivist at the Smith College Museum of Art, who served as overall coordinator of the project, contributed an essay on the museum's early years, assembled the timeline and back matter, and saw the volume through production. Michael's steady hand was essential to bringing this many-headed Hydra to heel. We are also indebted to editor Faye Hirsch, who managed to bring an appropriate degree of editorial consistency to the manuscript without losing the flavor of its individual components. Nanci Young, Archivist, and her colleagues in the Smith College Archives patiently assisted the authors in their historical research and unearthed many of the photographs reproduced here. John Eue, Director of Publications and Communication in Smith's College Relations Department, created the handsome design. Eve Lambert (class of 2002) served as a persistent and productive research assistant. Caitlin Bass (class of 2002), Katrina Croft (class of 2002), Amanda Glesmann (class of 2000) and Jessica Paga (class of 2005) also provided valuable assistance, as did the art department's Assistant for Administration Rebecca Davis.

And finally, our heartfelt thanks go to all the authors in this volume. Amidst the turmoil of working in temporary quarters, the demands of planning for the new complex, and the excitement of moving back to a state-of-the-art facility, this assignment added another task to already busy schedules. We are grateful for the collaborative spirit of all the authors and their willingness to put their own work aside for a moment of reflection on our shared past.

We look forward to living out the next chapter of the evolving story of the visual arts at Smith in the handsome Brown Fine Arts Center. The lively spaces created by the Polshek Partnership Architects will doubtless provide a salubrious stimulus to our collective pursuits in the years ahead.

John Davis
Alice Pratt Brown Professor of Art
Chair, Department of Art

Suzannah Fabing
Director and Chief Curator
Smith College Museum of Art

Barbara Polowy
Art Librarian
Hillyer Art Library

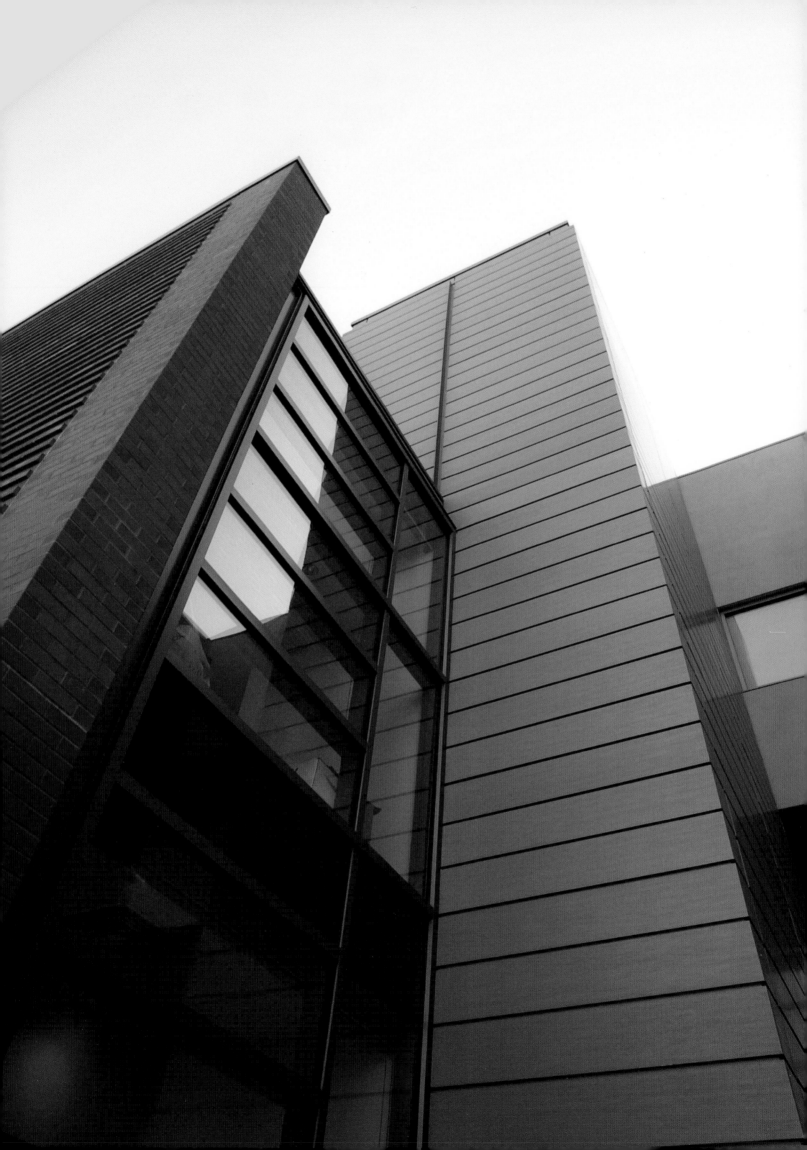

The Brown Fine Arts Center:
An Architecture of Transformation

James S. Polshek and Susan T. Rodriguez, Polshek Partnership Architects

In fall 1998, the trustees of Smith College commissioned Polshek Partnership Architects to renovate and expand the Fine Arts Center, composed of Hillyer Hall (art department and art library), Tryon Hall (Smith College Museum of Art) and Graham Hall (lecture hall). The College's directive was to develop a design concept that would transform the outmoded ensemble into an authentically new building, celebrate the importance of the fine arts at Smith and reinforce the center's role as a gateway to the campus.

Based upon early visits to the campus and initial observations of the building complex, we recognized that a design solution could emerge only with careful observation and analysis of the surrounding context and a considered technical and aesthetic assessment of the spatial, structural and systemic conditions of the existing building.

Buildings, like humans, get old. Their systems break down, and their envelopes decay. They no longer fulfill dreams, respond to users' needs or express the dominant ideas of their times. However, additions and adaptations can transform buildings, allowing them almost magically to begin life anew. These architectural rejuvenations are often more inspiring for their creators and more satisfying for their users than are totally new buildings: the deconstruction and reincarnation of an ensemble of buildings can be a revelatory experience. For the architect of a transformational project, the opportunity to create a new life out of an old one is like discovering an architectural fountain of youth. There is a kind of reassurance in utilizing the past to create a future, particularly when it is appropriate to substitute new imagery for old.

We quickly realized that the deteriorated condition of the existing building, coupled with its large scale, solar orientation, context, site, and tri-partite program, made this a more-than-ordinarily complex project. Further complications were the aggregate memories of alumnae, museum visitors and townspeople, the traditions of one of America's oldest and most prestigious women's colleges, the multiple regulatory and review committees and the geography and micro-climate of the Northampton area. In short, the project could be characterized as a most formidable transformational design challenge.

History

The opportunity to create a new life out of an old one is like discovering an architectural fountain of youth. There is a kind of reassurance in utilizing the past to create a future, particularly when it is appropriate to substitute new imagery for old.

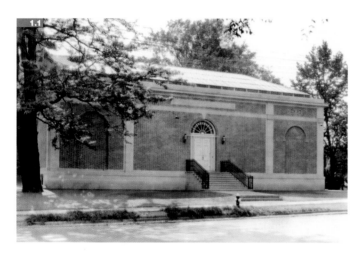

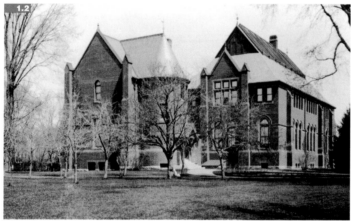

1.1, 2 The 1972 Fine Arts Center replaced Tryon Art Gallery (top) and Hillyer and Graham halls (above). Smith College Archives.

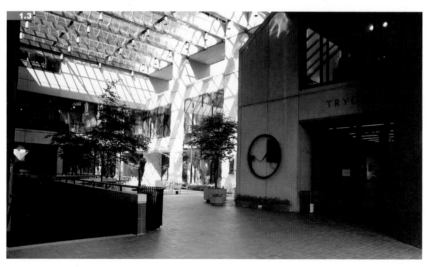

1.3 The physical linkage of the museum, the art department and the art library around a "public" space—a skylit outdoor courtyard—was among the most important of the Fine Arts Center strategies. Photograph by Jim Gipe.

Completed in 1972, John Andrews's original building replaced two historic structures, Tryon and Hillyer, and integrated Graham (**1.1, 2**). His design for the new ensemble addressed the immediate surroundings in ways more insolent than conciliatory, not unlike other Brutalist architectural examples of the time. In this case, the Brutalist vocabulary, with its industrial and quasi-military aesthetic, was manifested in faux turrets and bunker-like wall openings on the exterior and portholes in doors throughout the interior. Both the red tile cladding, typically associated with farm silos, and the greenhouse-like studio enclosures that thrust aggressively toward historic Elm Street were anomalous to the architectural articulation of a fine arts facility and in relation to the immediate Northampton context (**1.4, 5, 6**).

Thirty years is a long time in the short history of modern architecture. It would be unfair to burden John Andrews, a superbly talented architect, with responsibility for not having predicted the social and political changes and technological advancements of the past quarter century. The engaged interest of both faculty and townspeople, which is largely attributable to increased populist involvement in urbanism and design, was not a factor in the early 1970s. Modernism was an orthodoxy, and determined originality was the architectural norm. Moreover, Andrews had experienced the triumph of his design for the Harvard Graduate School of Design (Gund Hall, 1972), a credential that must have further reinforced his design autonomy. Notwithstanding the building's appearance, Andrews's most important original idea remained valid: the physical linkage

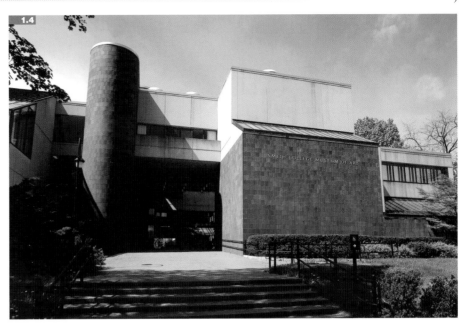

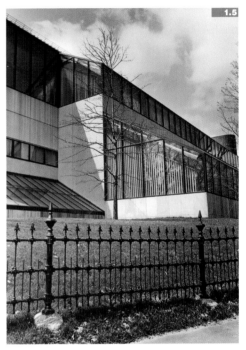

of the museum, the fine art department and the art library around a "public" space (1.3) would allow the buildings, and by extension the arts, to serve as a connector between the inner campus and the street.

The site's visibility suggested to us important opportunities for reinforcing the building's role in defining campus identity and symbolizing the significance of the fine arts at Smith. Directly north of College Hall, the building occupies a pivotal site on the campus, with Elm Street to the northeast and Seelye Lawn to the southwest. Whether by accident or design, the original building's large scale, massing, materials and abrupt termination of the south elevation dramatically separated it from its immediate context. In addition, the opportunity to relate the building to College Hall, which could have resulted in a dignified gateway to the inner campus, had not been explored.

That the Fine Arts Center should connect to its place, and that the museum could have a role in physically and metaphorically linking the neighboring community and the College were for us axiomatic. Having determined the importance of creating a gateway, preserving the continuous landscape zone along Elm Street and reinforcing the permeability of the building, we looked to the material quality of the surrounding context as well as patterns of movement and open spaces between buildings for design inspiration (1.7–11).

1.4, 5, 6 An industrial and quasi-military vocabulary, typical of the Brutalist aesthetic of the period, characterized the Fine Arts Center's architecture. Smith College Archives.

The need to address the deteriorated condition of the building, resolve a myriad of technical and accessibility issues and update the technological infrastructure was the impetus for the College's initial decision to renovate the Fine Arts Center. In response to a feasibility study completed in 1997 by R. M. Kliment Frances Halsband Architects, the scope of the project was expanded further to include new program spaces (galleries, a state-of-the-art imaging center, expanded collection storage spaces for the museum and a new auditorium) and the replacement of the entire exterior envelope of the building. These factors, coupled with the original building's negative place in the collective memory of students and alumnae, gave us license to redefine its architectural identity dramatically.

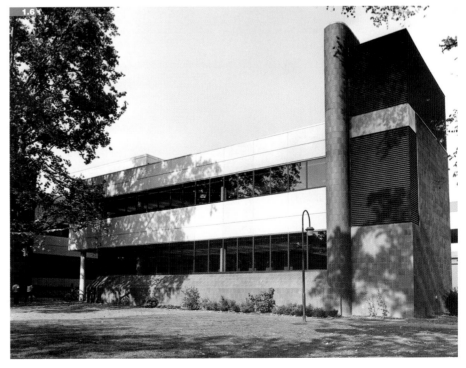

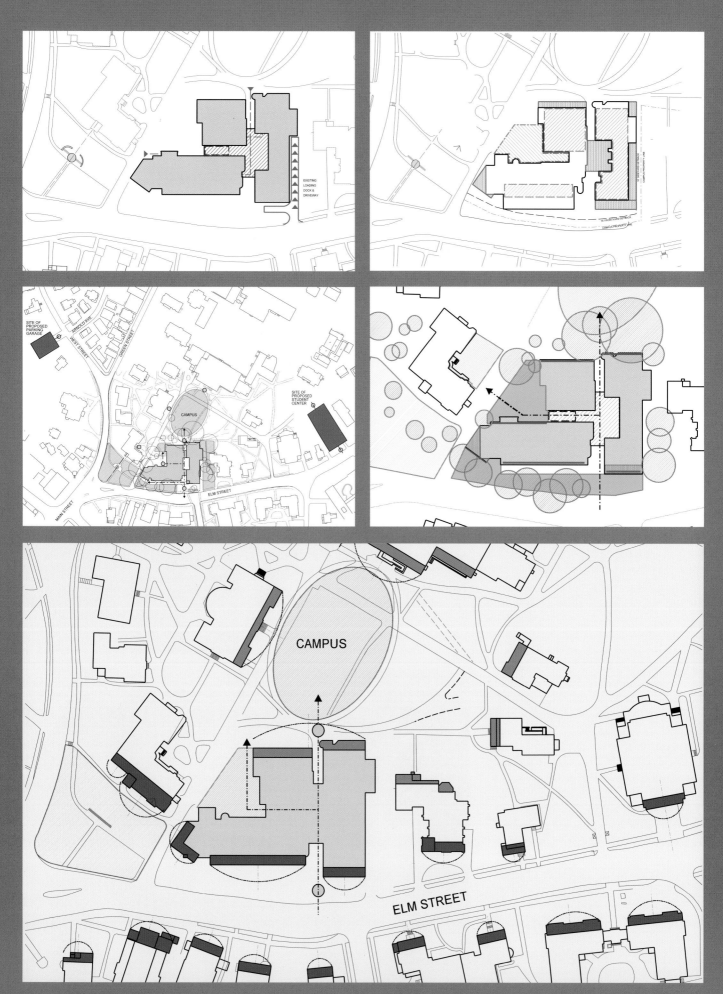

1.7 Site diagrams indicating patterns of movement and open spaces, servicing, landscape, scale and connections. © Polshek Partnership Architects.

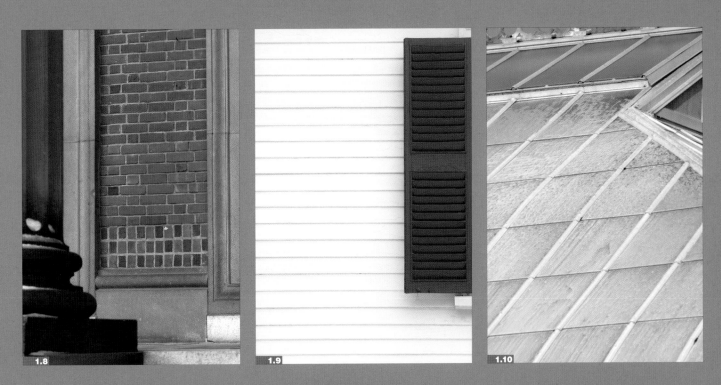

1.8, 9, 10 The material quality of the surrounding context provided inspiration. Photographs by Jim Gipe.

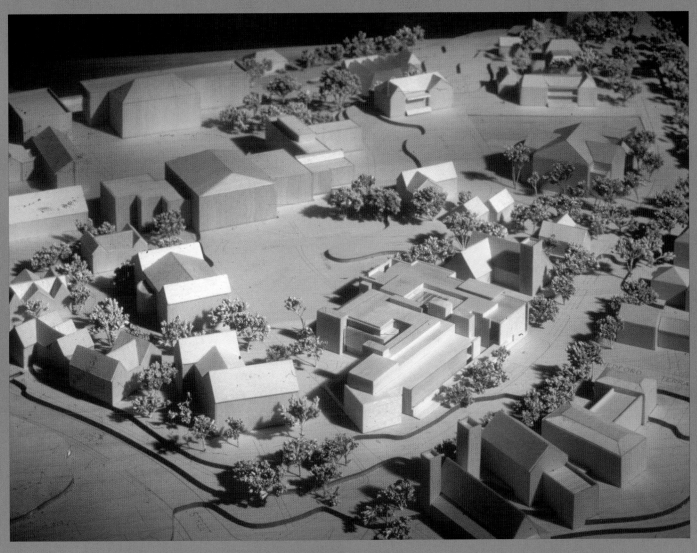

1.11 Massing model of building in campus context.
© Polshek Partnership Architects.

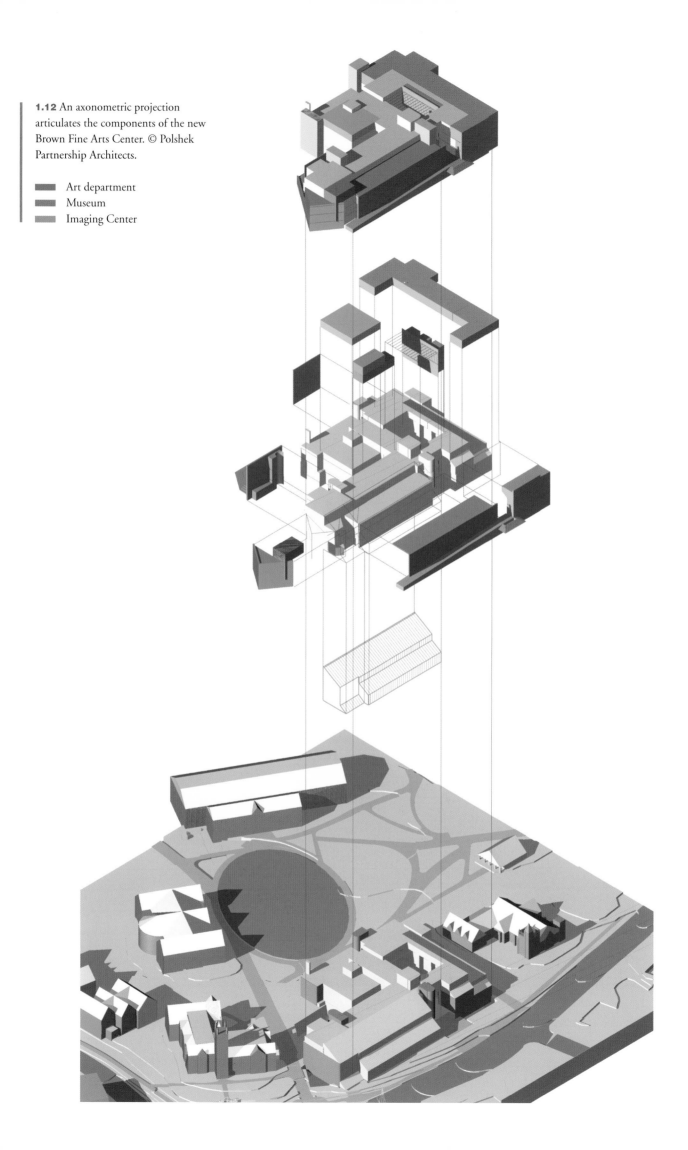

1.12 An axonometric projection articulates the components of the new Brown Fine Arts Center. © Polshek Partnership Architects.

- ▆ Art department
- ▆ Museum
- ▆ Imaging Center

Programming/Planning

The defining challenge in the design of the new Brown Fine Arts Center was to balance the physical constraints of the existing structure with the idealized goal of visually, spatially, programmatically and technologically transforming the facility into a new home for the fine arts at the College. Concurrent with the building analysis, we initiated a programming effort, working with faculty and staff representing the art department, library and museum, to determine the future needs and potential opportunities presented by the renovation and expansion.

During intensive programming meetings, we discussed new pedagogical objectives for the art department, technological advancements in library research and collection management and curatorial aspirations for the museum. We became aware of the impracticality of preserving the building beyond the structural frame. Moreover, to expand and enhance the program for the facility, a more idealized strategy for the organization of space types and adjacencies was required. To this end, the overall organizational dynamic of the center needed to be reconsidered, while still maintaining the original zones of use—Tryon as museum, Hillyer as art department and Graham as lecture hall. This process involved testing various layouts of the program, assessing how each of the three entities within the building would interact and identifying areas of overlap and separation within an expanded building footprint. Ultimately, we sought to unify the center programmatically with shared spaces to make stronger connections between what had once been coexistent entities. This collaborative process defined a program of 164,000 gsf, which added 36,000 gsf to Andrews's original structure. This initial phase of the process laid the groundwork for determining specific objectives that would guide the transformation of the building into the new Brown Fine Arts Center (1.12-16).

1.13 *Basement Floor Plan*

- Art department
- Museum
- Circulation
- Mechanical
- Passenger elevator
- Service elevator
- Entry

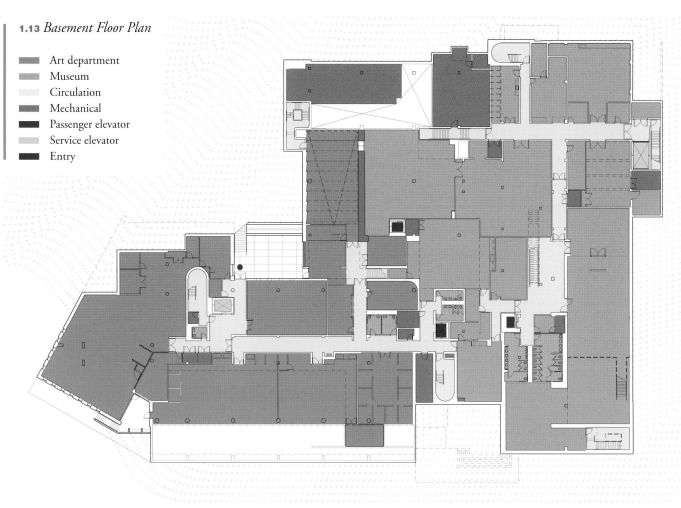

1.14 *First Floor Plan*

- Art department
- Library
- Museum
- Circulation
- Mechanical
- Passenger elevator
- Service elevator
- Entry

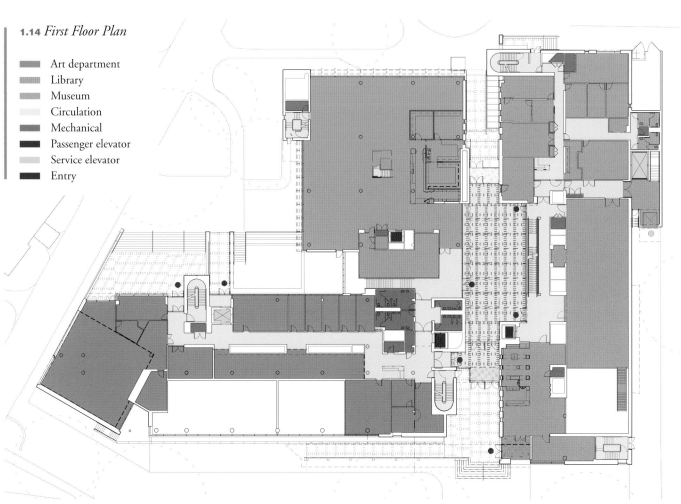

1.15 *Second Floor Plan*

- Art department
- Library
- Museum
- Circulation
- Mechanical
- Passenger elevator
- Service elevator

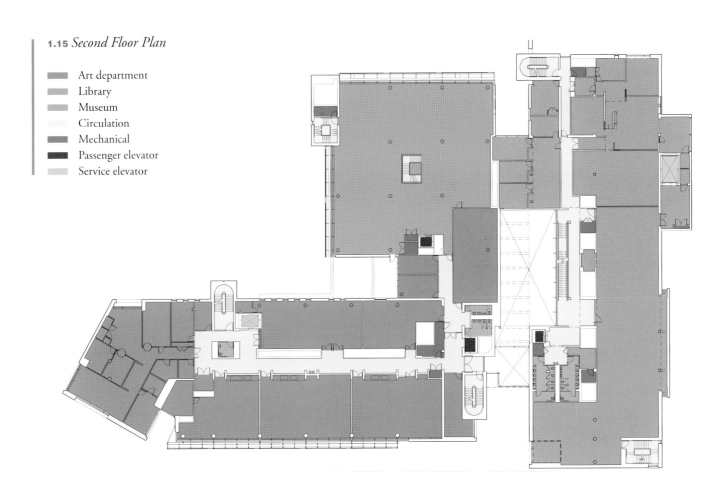

1.16 *Third Floor Plan*

- Art department
- Museum
- Imaging center
- Circulation
- Mechanical
- Passenger elevator
- Service elevator

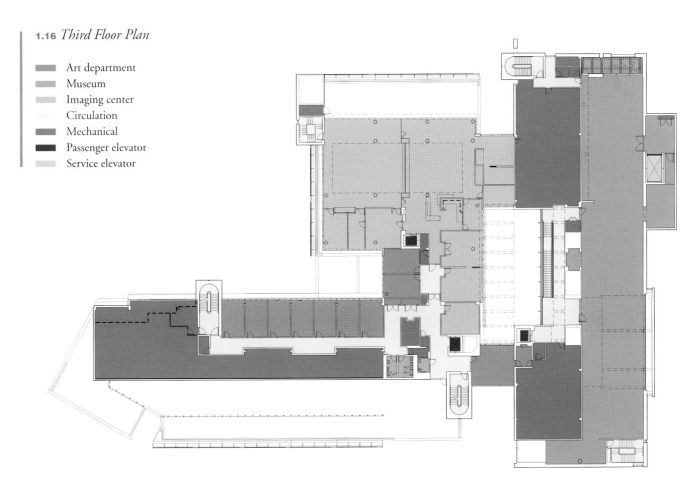

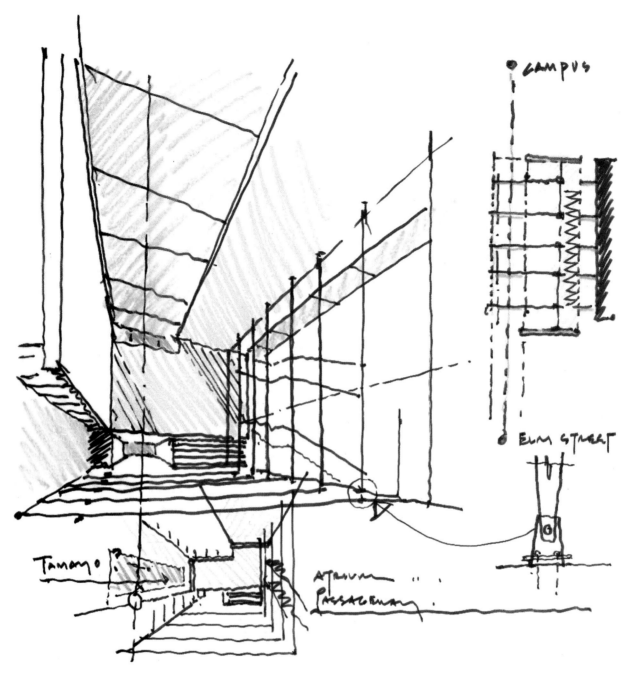

CAMPUS

ELM STREET

TAMAYO

ATRIUM
PASSAGEWAY.

1.17 Study sketches of atrium.
© Polshek Partnership Architects.

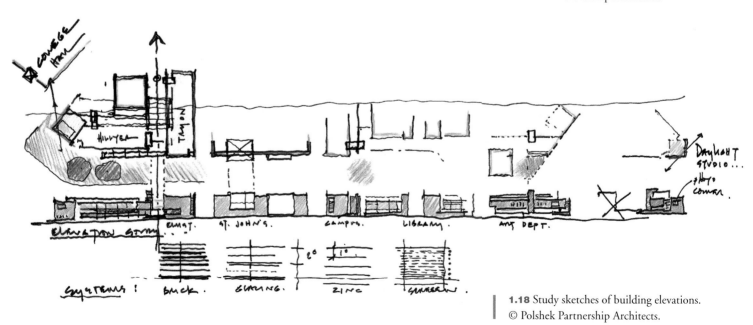

COLLEGE HALL

HILLYER

TAMAYO

DAYLIGHT STUDIO...

ELEVATION STUDY. ELMST. ST. JOHN'S. CAMPUS. LIBRARY. ART DEPT.

SYSTEMS! BRICK. GLAZING. ZINC. GRRREEN.

1.18 Study sketches of building elevations.
© Polshek Partnership Architects.

Design

These parameters and objectives defined our design direction, allowing us to build upon the original structure to create a modern ensemble of forms and spaces— a new visual identity for the Brown Fine Arts Center—through the abstraction of the surrounding material context. Spatially, our intention was to create a three-dimensional framework to foster synergistic relationships among the art faculty, the museum and the library that in turn might inspire scholarship and creativity in students and faculty, welcome alumnae and educate the general public about the museum collection. To this end, enclosing the central courtyard (1.17) has built upon the build-

ing's original design: this strategy has unified the building spatially and programmatically and preserved access through it. Systemically, we sought to create a secure environment that would facilitate the preservation and expansion of the invaluable holdings that support these endeavors.

Careful manipulation of the building's overall form attempts to reduce its apparent scale in order to relate to the adjacent architectural fabric and to reinforce the three primary components of the program: museum, art department and art library. This visual clarification is extended to the existing stair towers that mark each entry and have been reclad in zinc (1.18–22).

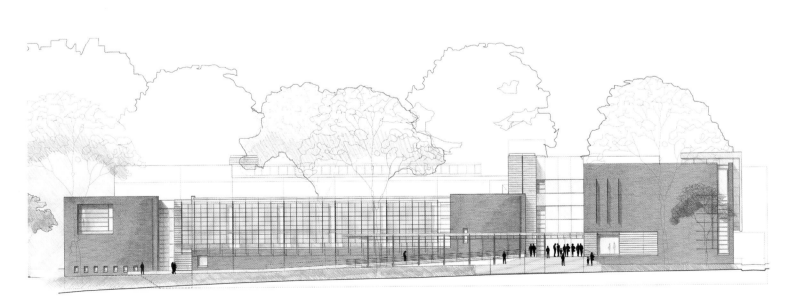

1.19, 20 Elevation study. © Polshek Partnership Architects.

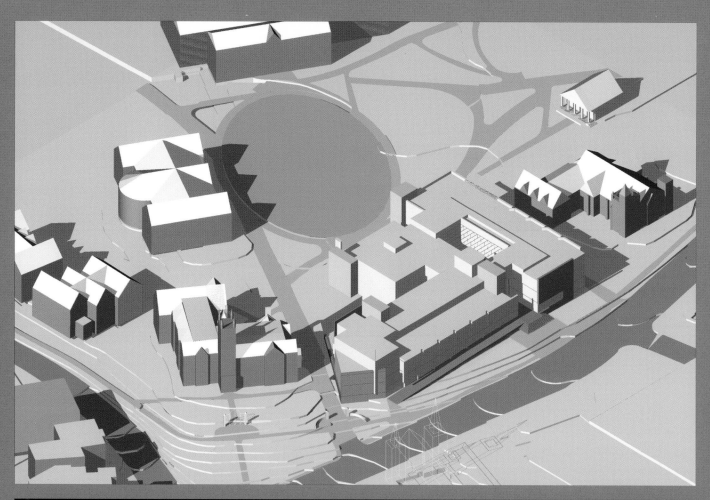

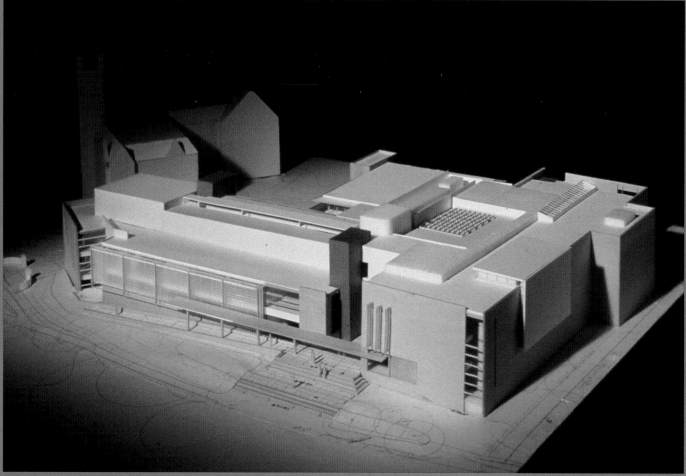

1.21, 22 Manipulation of the building's overall form reduces its apparent scale in order to relate to the adjacent historic architectural fabric and to reinforce the three primary components of the program: museum, art department and art library. © Polshek Partnership Architects.

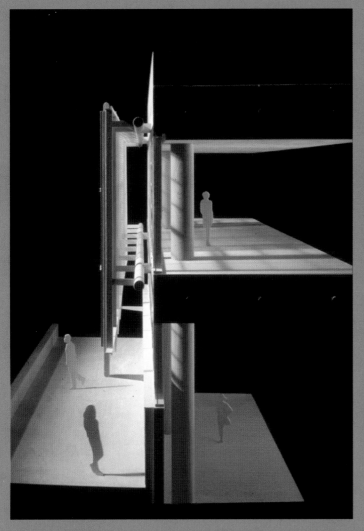

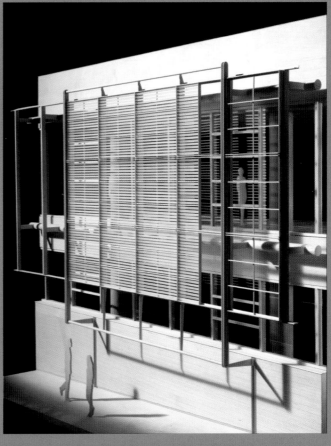

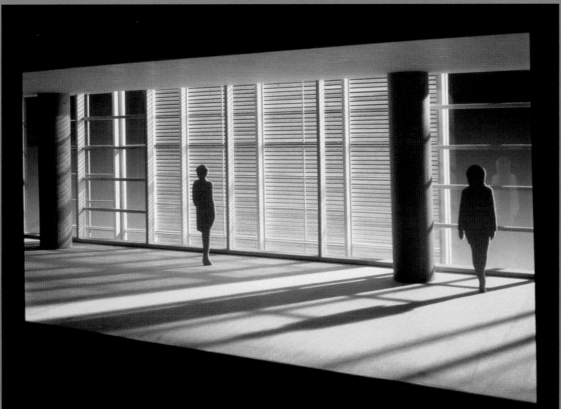

1.23, 24, 25 Metal sunscreens soften the impact of the glass surface when viewed from the exterior as well as filter natural light inside the studios and library. © Polshek Partnership Architects.

1.26, 27, 28, 29 *Building Elevations*

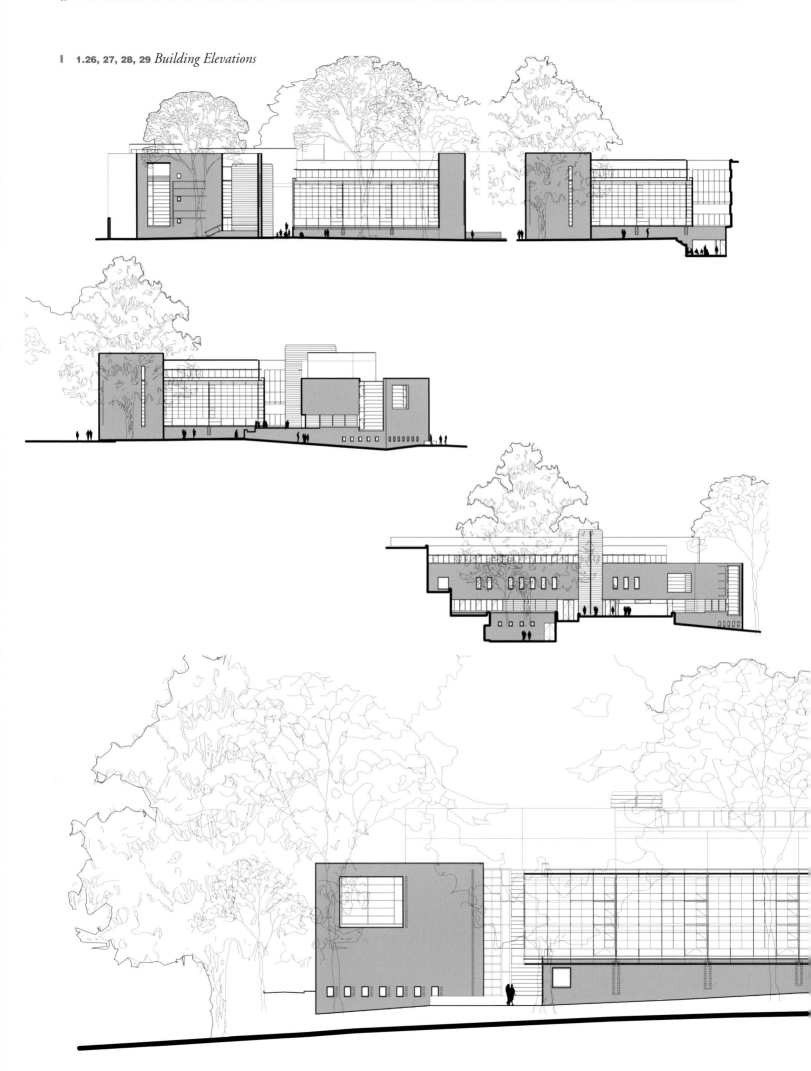

1.30, 31 *Building Sections*

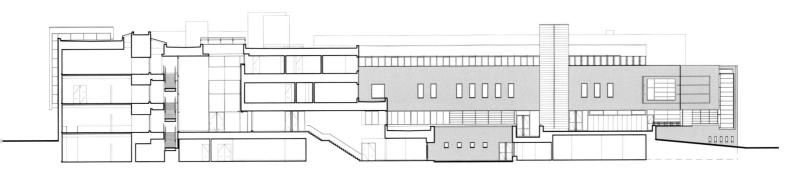

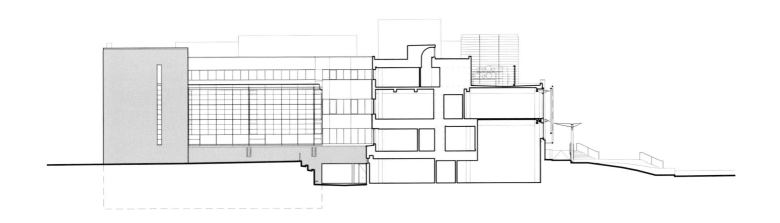

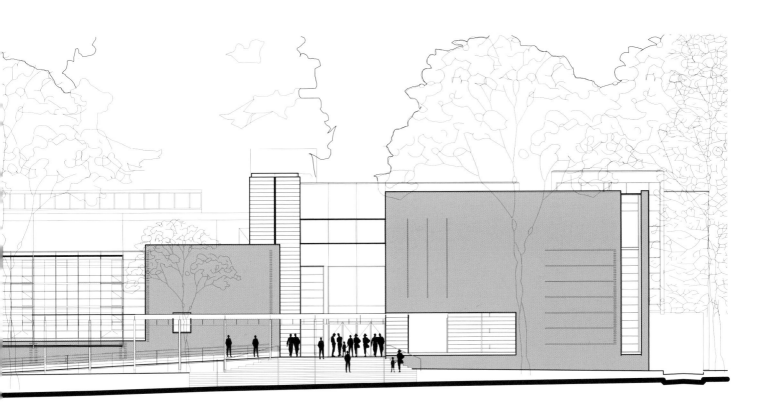

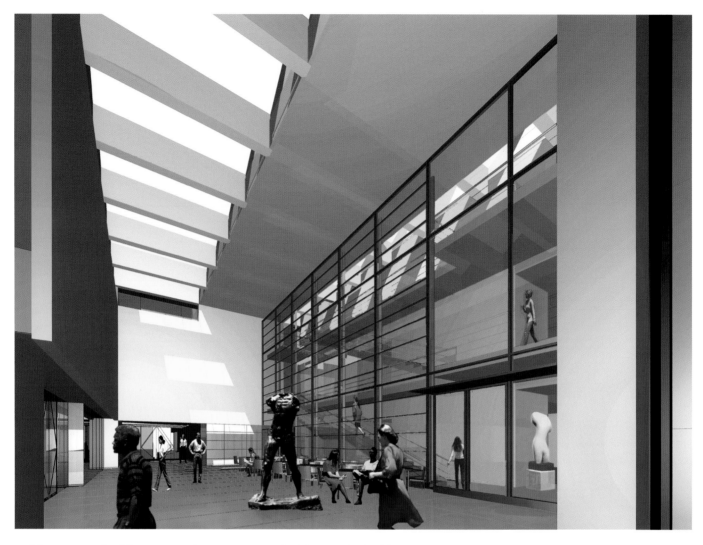

The primary building materials—brick, zinc, glass and metal—reinforce connections to the texture and quality of the surrounding historic context both on the campus and in the surrounding neighborhood. The design depends on a dynamic visual balance between the transparency and reflectivity of glass and the opacity of brick. Articulated planar brick walls in combination with large expanses of glass shaded by an aluminum sunscreen define the overall mass of the building. Selected to match College Hall, the brick is laid in a rich variety of textural patterns. Linear recesses and projections animate the wall surface (1.39–46). The additional layer of the metal sunscreen (1.23–25) serves to soften the impact of the glass surface when viewed from the exterior as well as to filter natural light inside the studios and library. The design of the screen reiterates the structural rhythm of the building and at the same time provides textural relief to its surface. This three-dimensionality echoes the play of shade and shadow and the resultant layered quality of campus architecture and historic Elm

Street buildings. The building's luminous effect in the evening will contribute to a sense of campus security and enhance the celebration of Illumination Night each year.

The transformation of the building extended to a comprehensive upgrading of all infrastructural systems. This included a new mechanical system to provide the appropriate ventilation, temperature and humidity controls, as well as new electrical, data, telecommunications and security systems. Essential to the museum in particular was the new exterior envelope, where advancements in building technology have been incorporated to provide a thermal barrier to ensure the proper operations and control of the interior environment. Overall the building has been reconfigured to make its spaces physically accessible to all.

The museum occupies a discrete three-story brick volume along the northern edge of the Fine Arts Center, which retains its historical name, Tryon Hall. Its two primary facades face Elm Street and Seelye Lawn. Consisting of a three-story addition along Elm Street

1.32 A multi-story skylit volume (the enclosed atrium) allows visual access to all areas of the building, including direct views into the museum's new grand stairway to the north and the library to the south.
© Polshek Partnership Architects.

and a new third floor with an interconnecting stair and elevator, the expansion has increased gallery, classroom, administration, curatorial, public program and collection storage spaces. The addition at Elm Street, which projects beyond the facade of the art department, forms a new entry and lobby and reinforces the museum's public presence on the street. A stair and an accessible path through the landscape lead to a covered sloped walkway, which runs parallel to the face of the art department building. Replacing the original steeply sloped approach, this sequence leads to the main entry of the museum and also provides access to the central atrium, the art department and the art library (1.36, 37).

From the new museum lobby, the double-height gallery and a new gift shop are immediately visible (1.34).

1.33 New third-floor museum gallery. © Polshek Partnership Architects.

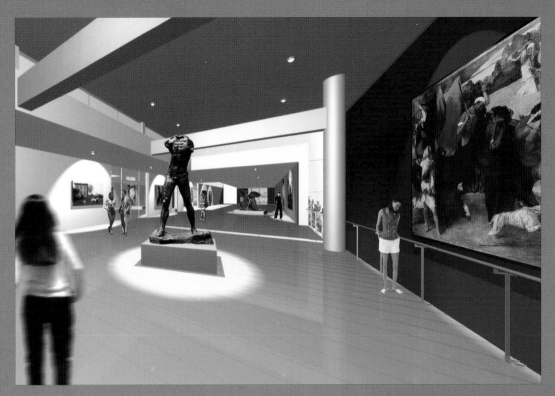

1.34 Museum lobby with view to lower level gallery. © Polshek Partnership Architects.

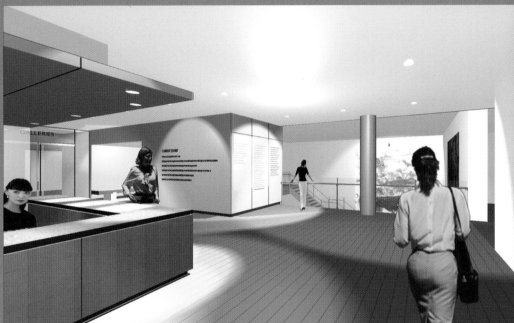

1.35 View of library and museum from Seelye Lawn. Metal sunscreens, similar to those on Elm Street, have been introduced over the perimeter glazing to filter natural light into the space. © Polshek Partnership Architects.

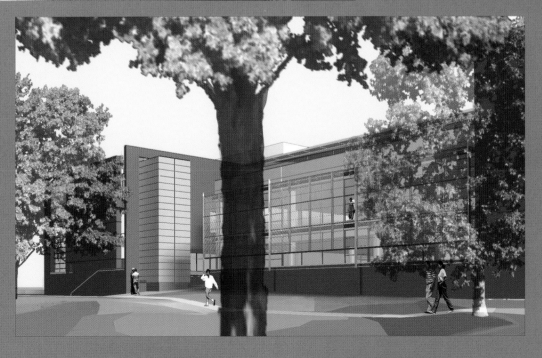

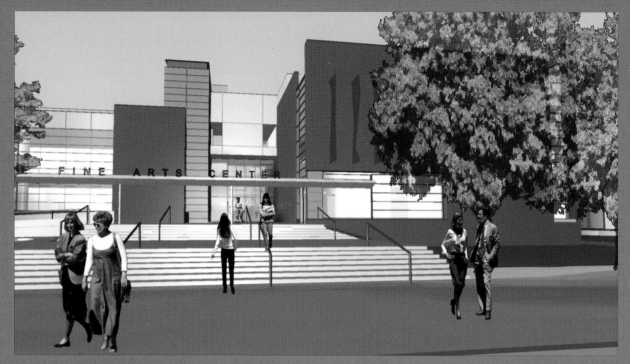

1.36 New entry at Elm Street. The addition at Elm Street projects beyond the façade of the art department, forming a new entry and lobby and reinforcing the museum's public presence on the street. © Polshek Partnership Architects.

1.37 A stair and an accessible path through the landscape lead to a covered sloped walkway, which runs parallel to the face of the art department building. © Polshek Partnership Architects.

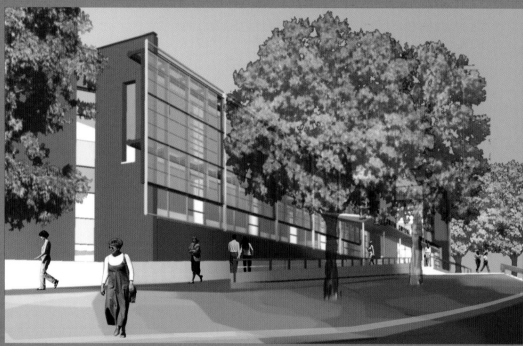

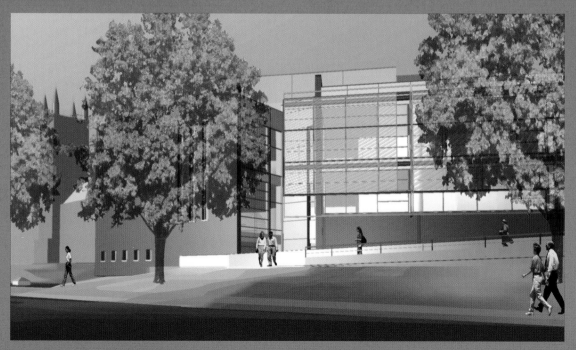

1.38 The art department building, Hillyer Hall, runs perpendicular to the museum building and parallel to Elm Street. The overall mass of this southern portion of the complex has been modified significantly to form a gateway to campus with College Hall. © Polshek Partnership Architects.

The design of the Brown Fine Arts Center depends on a dynamic visual balance between the transparency and reflectivity of glass and the opacity of brick. Articulated planar brick walls in combination with large expanses of glass shaded by an aluminum sunscreen define the overall mass of the building.

Stairways within the galleries, which in the original building were the only source of vertical interconnection between the floors, have been replaced by a new grand stair and passenger elevator. Located outside the secure zone of the galleries and within the original volume of the central courtyard, this vertical sequence is skylit from above and separated from the atrium by a three-story wall of glass and aluminum. The third floor galleries (1.33) take advantage of access to natural light at the top of the building by integrating a north-facing linear skylight along the southern edge. Additionally, a two-story volume projecting beyond the museum's brick mass vertically links the two levels and admits light into the second- and third-floor galleries. An exterior sculpture terrace has been created at the western end of the third floor within the brick enclosure of the building. At the second floor, north light, which illuminates a new study center for drawings, prints and photographs, also filters into both the main study room and an adjacent seminar room. Adjacent storage space and workrooms have also been incorporated. On the lower level adjacent to collection storage spaces are three new study classrooms, which are shared with the art department; original works of art used in the course of teaching may be accessed in these study spaces.

Perpendicular to the museum building and running parallel to Elm Street is the art department building, Hillyer Hall (1.38). The overall mass of this portion of the complex has been modified significantly. The sloping glass studios along Elm Street have been re-moved, and a new portion of the building at the south end has been rotated to align with the geometry of College Hall, forming a gateway. The modification of the Elm Street facade is defined by a two-story glass enclosure atop an articulated brick base with a projecting aluminum sunscreen. Studios for drawing and sculpture occupy this portion of the building, taking advantage of the filtered light in those spaces. The new brick gateway addition opposite College Hall houses the printmaking studio at the lowest level, the architecture studio at the entry level and the photography studio with its corner day-lit studio at the second floor. All have framed views toward College Hall and Elm Street. Facing campus, a one-story brick plane at the second floor wraps the corner opposite College Hall. This surface is punctuated by a pattern of vertical windows. This plane is revealed from the building's brick base by a continuous horizontal glass zone at the first floor. A zinc-clad stair tower at the mid-point of the brick plane marks a new entry to the first floor of the art department via steps and a terrace ("back porch"). A service entry and elevator have been added to facilitate movement of supplies into and out of the building. Within the building, a new student gallery, which connects the campus and Elm Street entries of the building, will be a visual focus upon entering the department. Alternating floors, characterized by the nature of studio activity assigned to the spaces (dirty or clean) have been introduced. The third floor houses art history offices and makes a connection to the new imaging center, located in an addition above the existing library.

1.39, 40 Selected to match College Hall, the brick is laid in a rich variety of textural patterns. Linear recesses and projections animate the wall surface. © Polshek Partnership Architects.

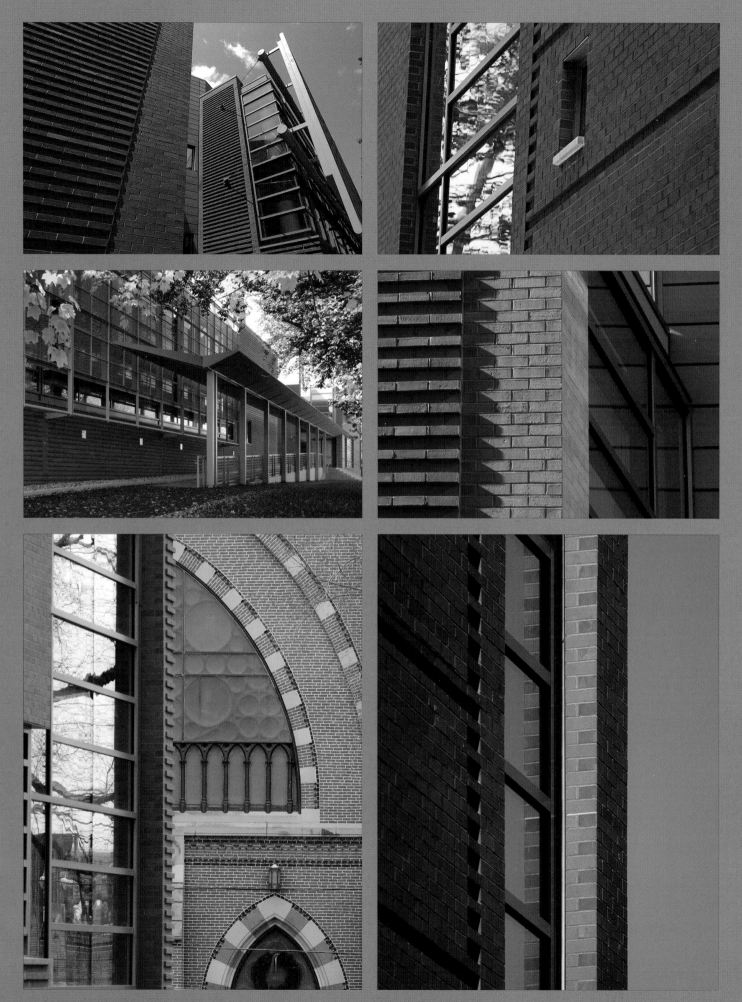

1.41, 42, 43, 44, 45, 46 Primary building materials reinforce connections to the texture and quality of the historic context both on campus and in the surrounding neighborhood. Photographs by Jim Gipe.

The Brown Fine Arts Center is built, to a large extent, on the skeletal framework of its recent past. Its realization validates our belief that respect for an institution's history and context can be reinforced by an architecture of our time.

Framed by the museum and art department, the two main levels of the library occupy a two-story glass volume above a brick base (**1.35**). Square in plan, a brick stair tower punctuates the outside corner. Metal sunscreens, similar to those on Elm Street, have been introduced over the perimeter glazing to filter natural light into the space. Above the art library, an expanded slide library has become a new state-of-the-art imaging center housing the art department's complete visual resources collections, including full digital image facilities. This new structure is set back from the facades of the library as a low mass with a continuous horizontal window system at its perimeter. On the first and second floors, the original open-plan environment of the library has been maintained, while the reorganization of the program within improves the overall functioning of the space. The relationships of study areas, reference materials, stacks and offices and a new elevator improve interaction between staff and scholars as well as accessibility to the collections. Incorporated into the design are the latest reference technologies as well as flexibility for anticipated collections growth. A new auditorium, which retains the original appellation Graham Hall, occupies the lower level of this portion of the building. The auditorium is directly accessible from the lower level of the art department adjacent to a new student lounge and visiting artists gallery as well as by stair from the main floor of the atrium. Expanded library stacks, designed to accommodate high-density compact shelving in the future, are located in the lower level.

The transformation of the building's central exterior space into an interior volume unifies the three elements of the building comprising the Brown Fine Arts Center. This multi-story skylit volume allows visual access to all areas of the building (**1.32**). In particular, there are direct views into the museum's new grand stairway to the north and the library to the south. The space, which includes a café, maintains its role as a passageway from Elm Street to Seelye Lawn and serves as a year-round gathering place and a venue for large events. A new gray granite floor with linear black accents reinforces the structural order of the space. Daylighting from overhead skylights has been maintained, yet reduced, to reinforce the zone of movement through the space. The new three-story glass wall of the museum to the north visually extends the space to its original dimension and provides visual access into and from the adjacent spaces. Slender columns extending from floor to ceiling modulate the wall. Rufino Tamayo's mural *Nature and the Artist: The Work of Art and the Observer,* commissioned by the College in 1943 to honor Elizabeth Cutter Morrow, will be installed on the south wall of the space.

The new Brown Fine Arts Center at Smith College is built, to a large extent, on the skeletal framework of its recent past. Its realization validates our belief that respect for an institution's history and context can be reinforced by an architecture of our time. This has required an approach based on the conviction that architecture must serve to connect the past and the future in specifically verifiable ways.

Smith College Brown Fine Arts Center Project Team

Polshek Partnership Architects
James S. Polshek and Susan T. Rodriguez (Design Partners); Joseph Fleischer (Partner-in-Charge); Joanne L. Sliker (Project Manager); Steven C. Peppas (Project Architect, Design); John Lowery (Project Architect, Construction).

Design Team Yama Karim, Kevin Rice, Niv Ben-Adi, Anya Bokov, Yong Joon Cho, Serge Drouin-Prouve, Rafael Gavilanes, Alan Henschel, Eugeni Huang, Kate Mann, Corvin Mattei, Bruce Nichol, Charmian Place, Eduardo Tapia

Consultant Team Robert Silman Associates, P.C. (Structural); R. G. Vanderweil Engineers, Inc. (Mechanical/Electrical/Plumbing); Towers/Golde (Landscape); Poulin + Morris (Graphics); Cline Bettridge Bernstein Lighting Design, Inc. (Lighting); Shen Milsom & Wilke (AV/Acoustics/Telecommunication); James R. Gainfort AIA (Exterior Diagnostics & Design); Pillori Associates, P.A. (Geotechnical); Fuss & O'Neil (Civil); Ducibella Venter & Santore Associates (Security); Jay K. Lucker (Library); Richard Jansen Architect (Collection & Storage Management); Wolf and Company (Cost Estimating); Robert Schwartz & Associates (Specifications); Rolf Jensen & Associates, Inc. (Building Code); Art Preservation Services, Inc. (Conservation); Photo Lab Fabrications (Photography Lab); Arts, Crafts and Theater Safety (Industrial Hygiene); Iros Elevator Design Services, LLC (Elevator); Campbell McCabe, Inc. (Hardware)

Construction Manager
Daniel O'Connell's Sons Construction Managers & General Contractors

Portfolio

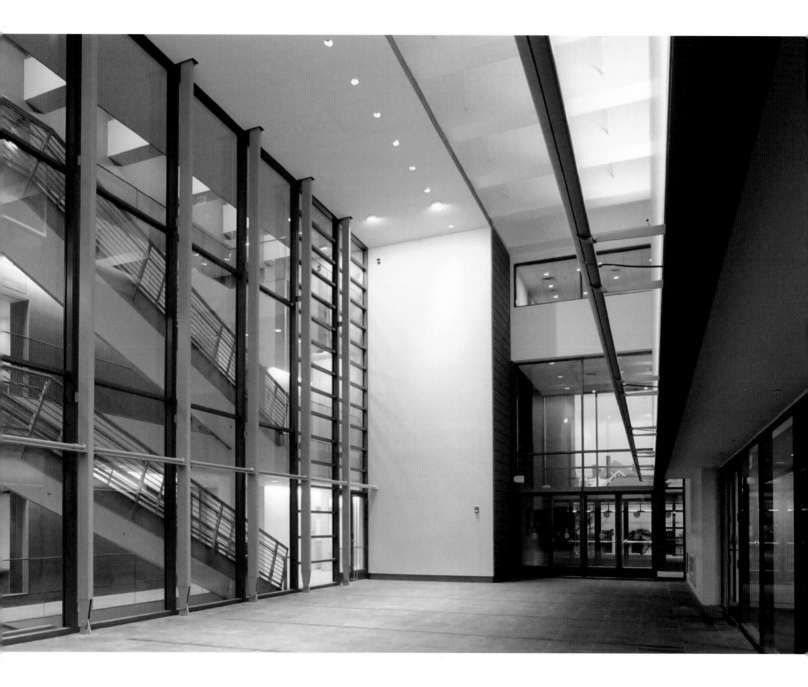

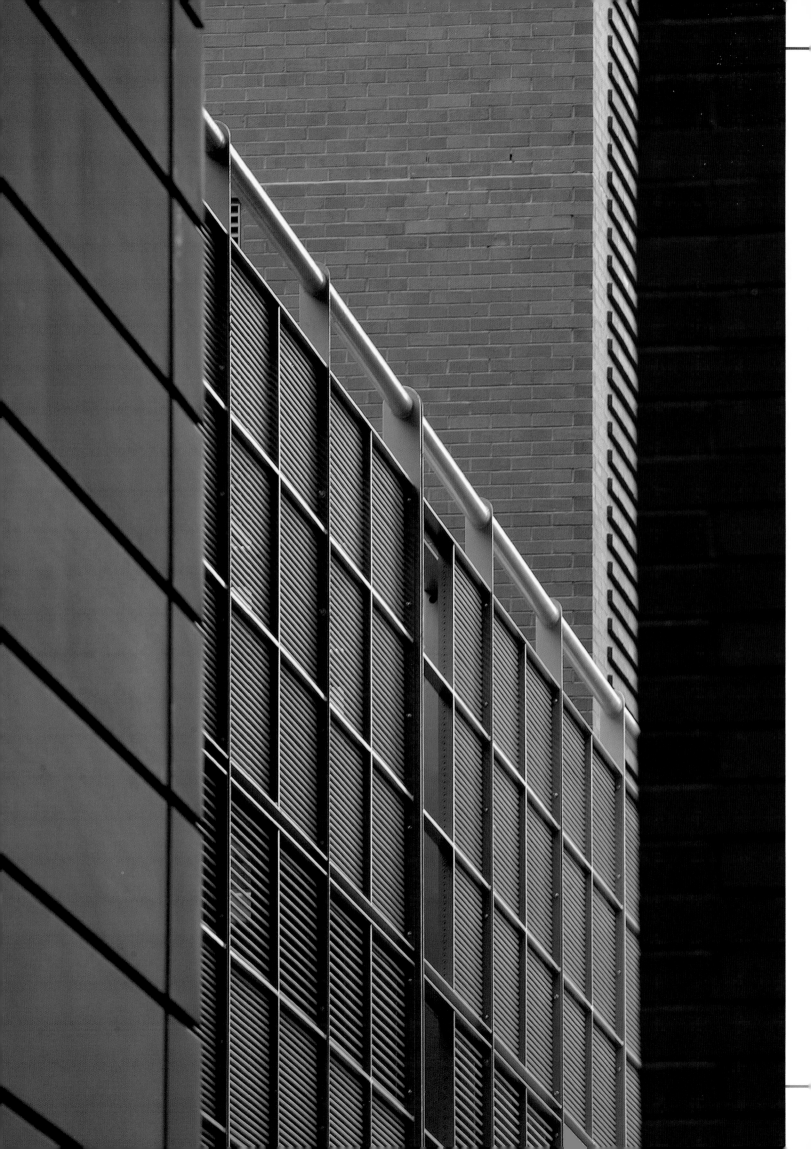

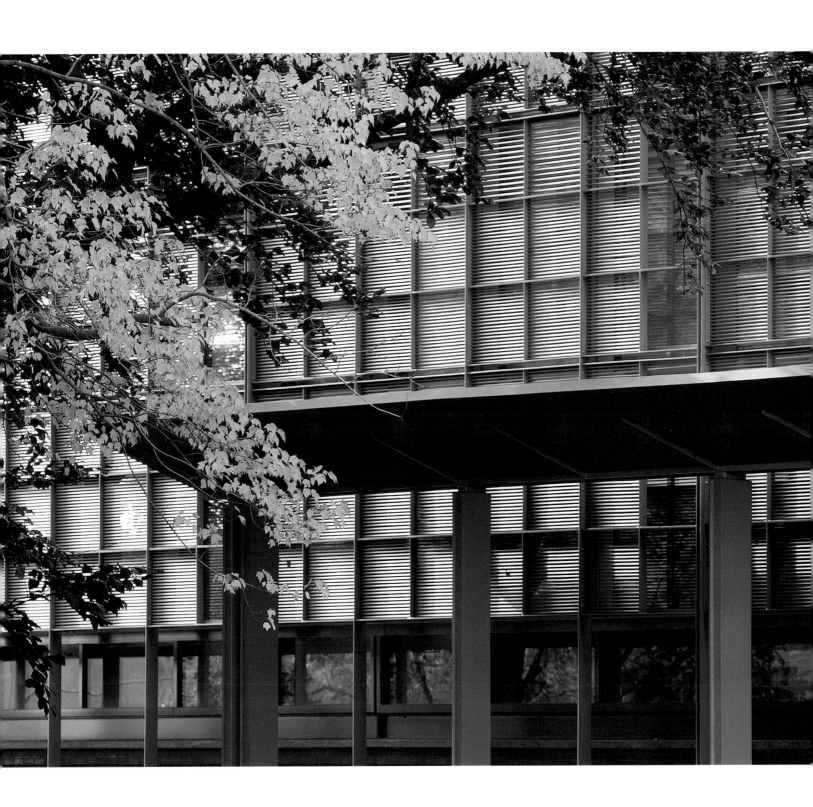

Photographs by Jim Gipe

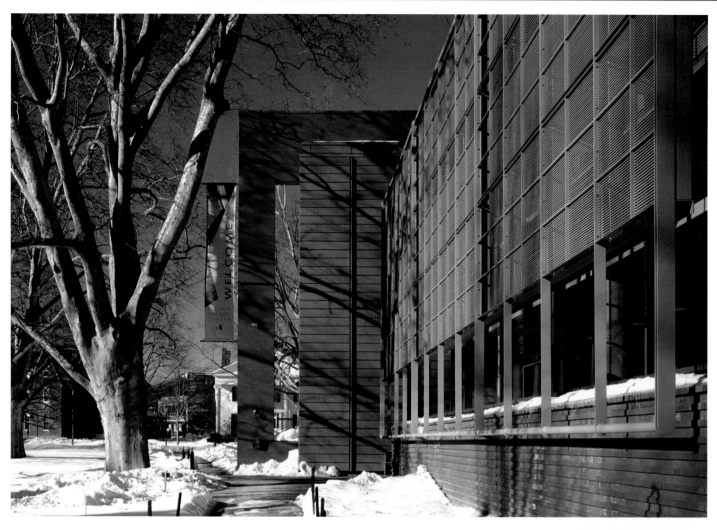

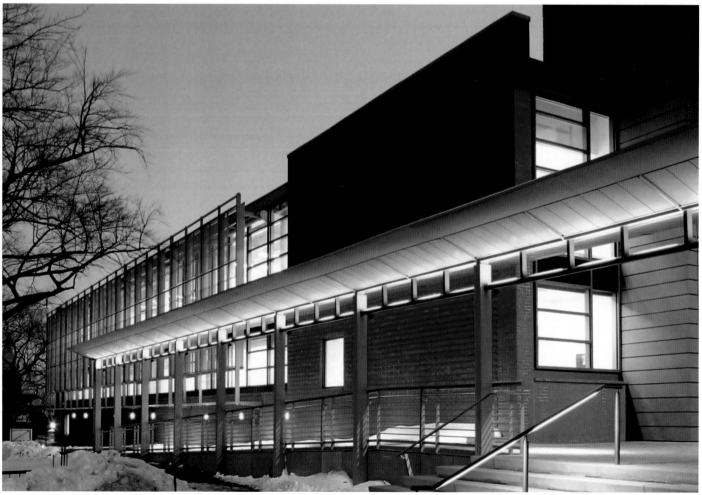

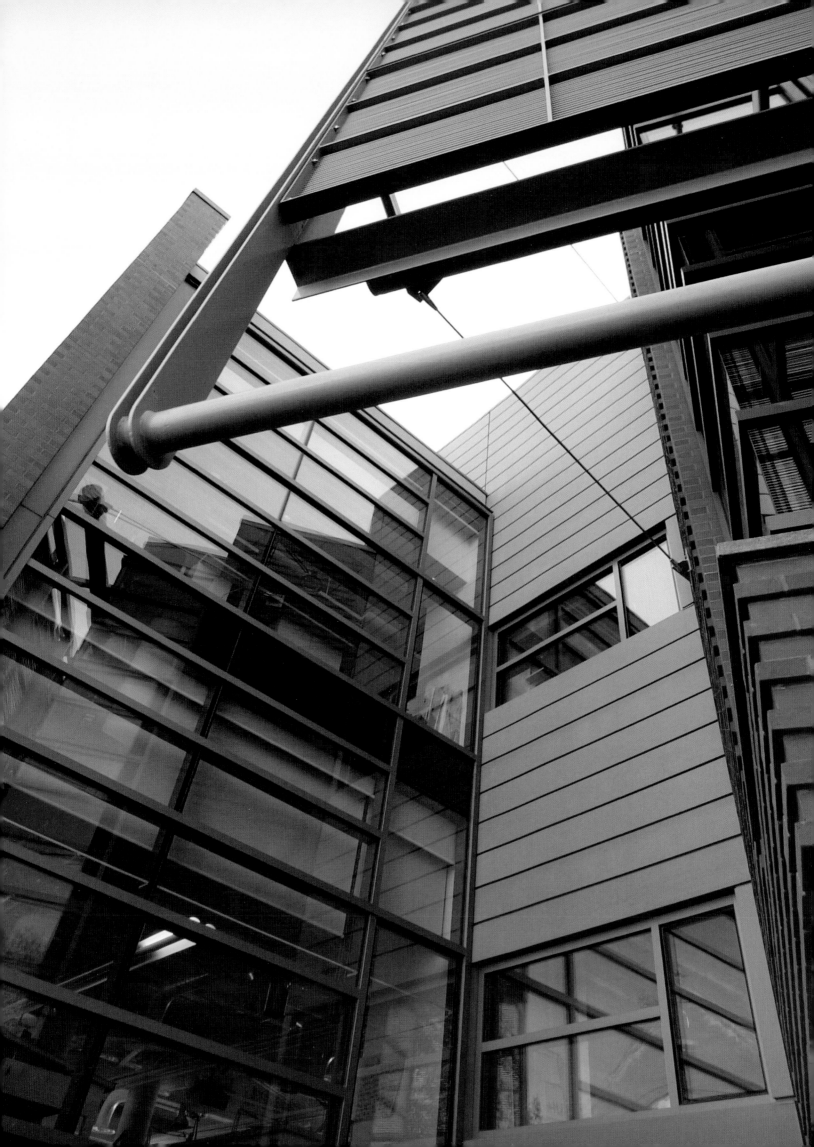

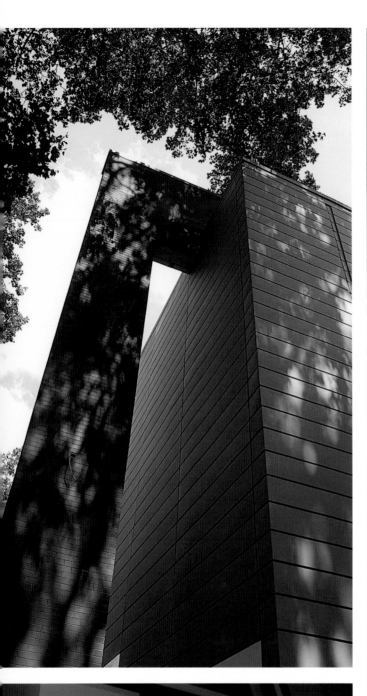

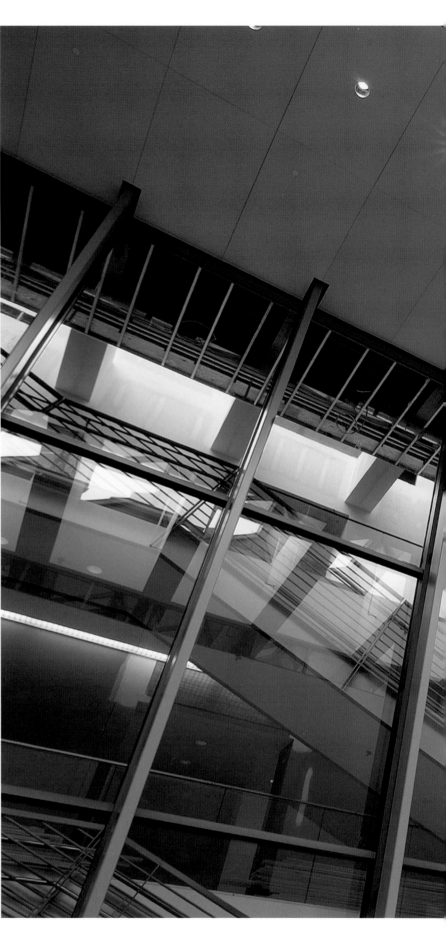

Photographs by Jim Gipe

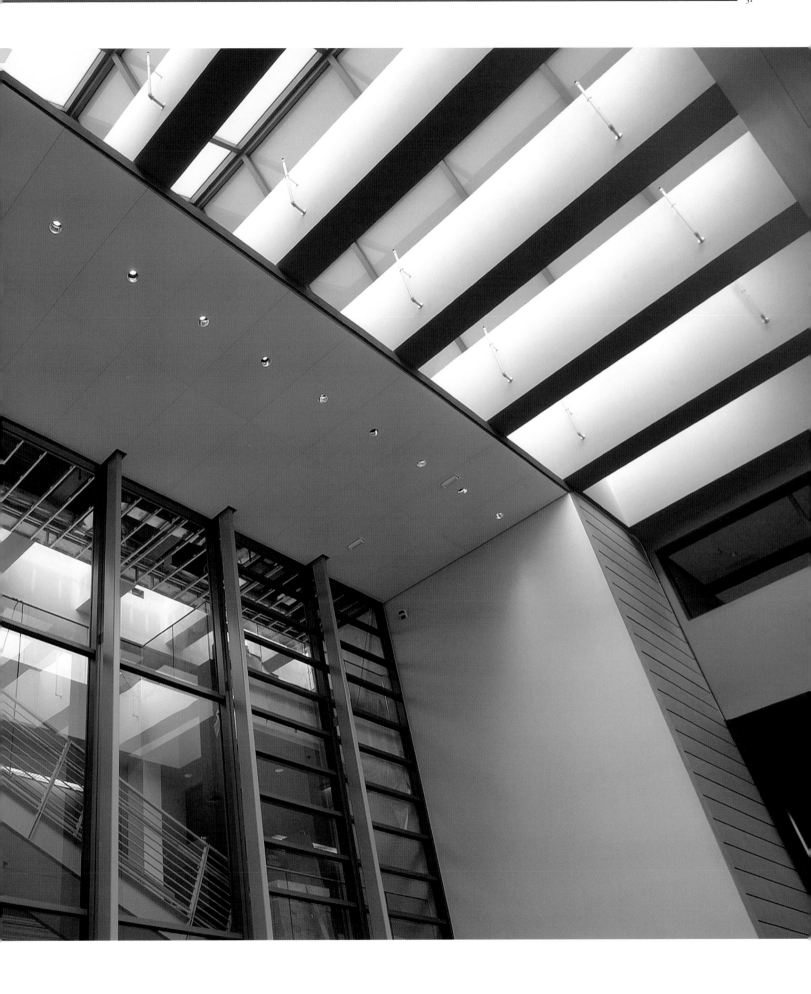

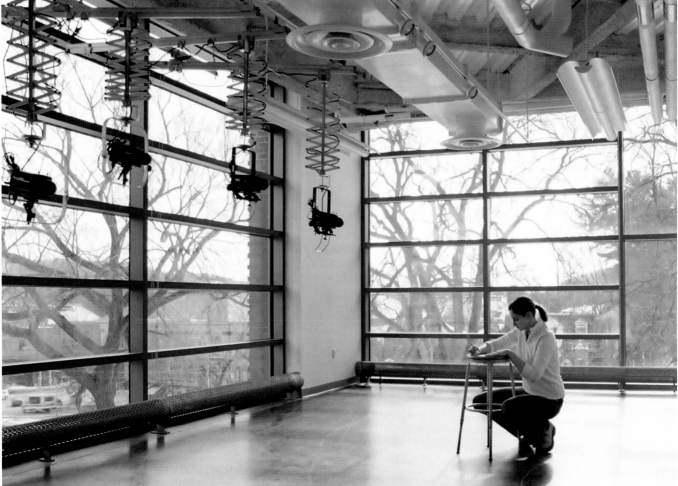

Photographs © Jeff Goldberg/ESTO

Facing page, photograph by Jim Gipe; photographs this page © Jeff Goldberg/ESTO

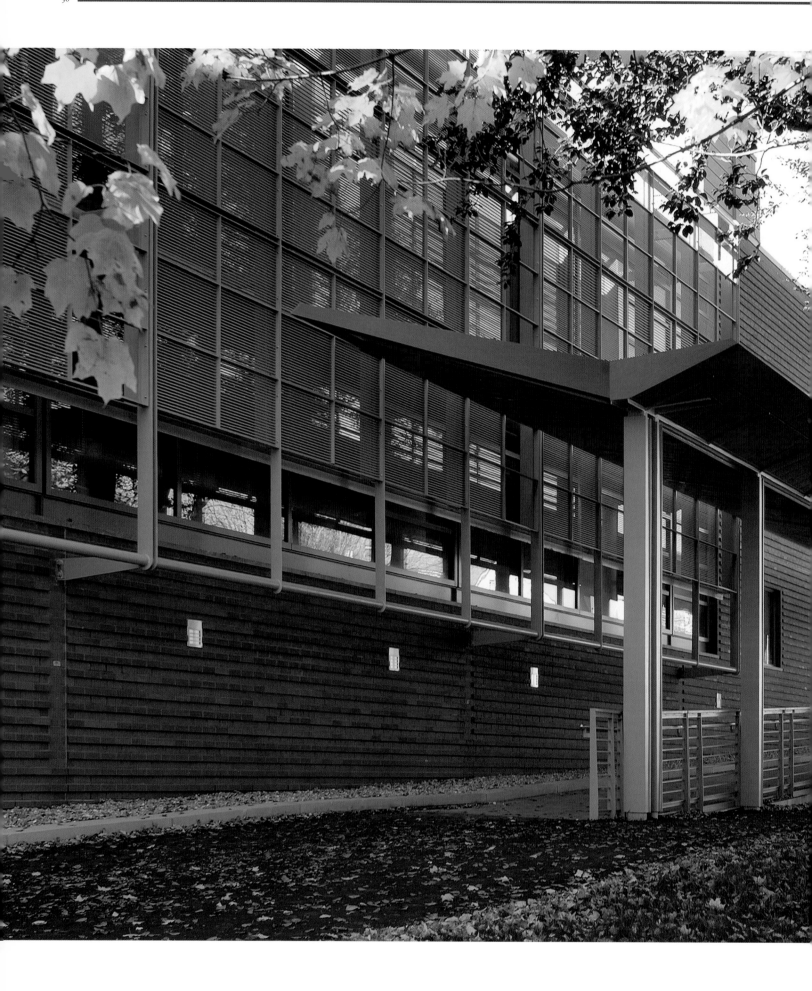

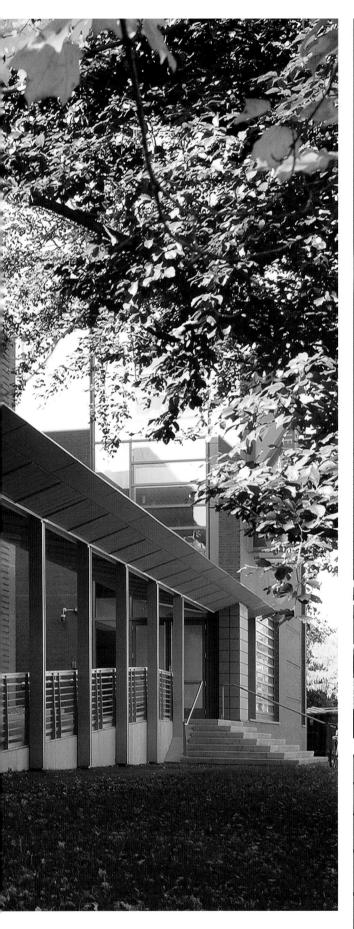

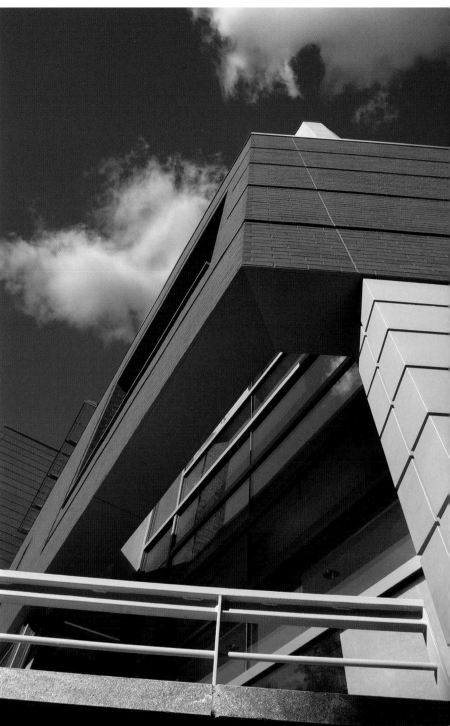

Photographs by Jim Gipe

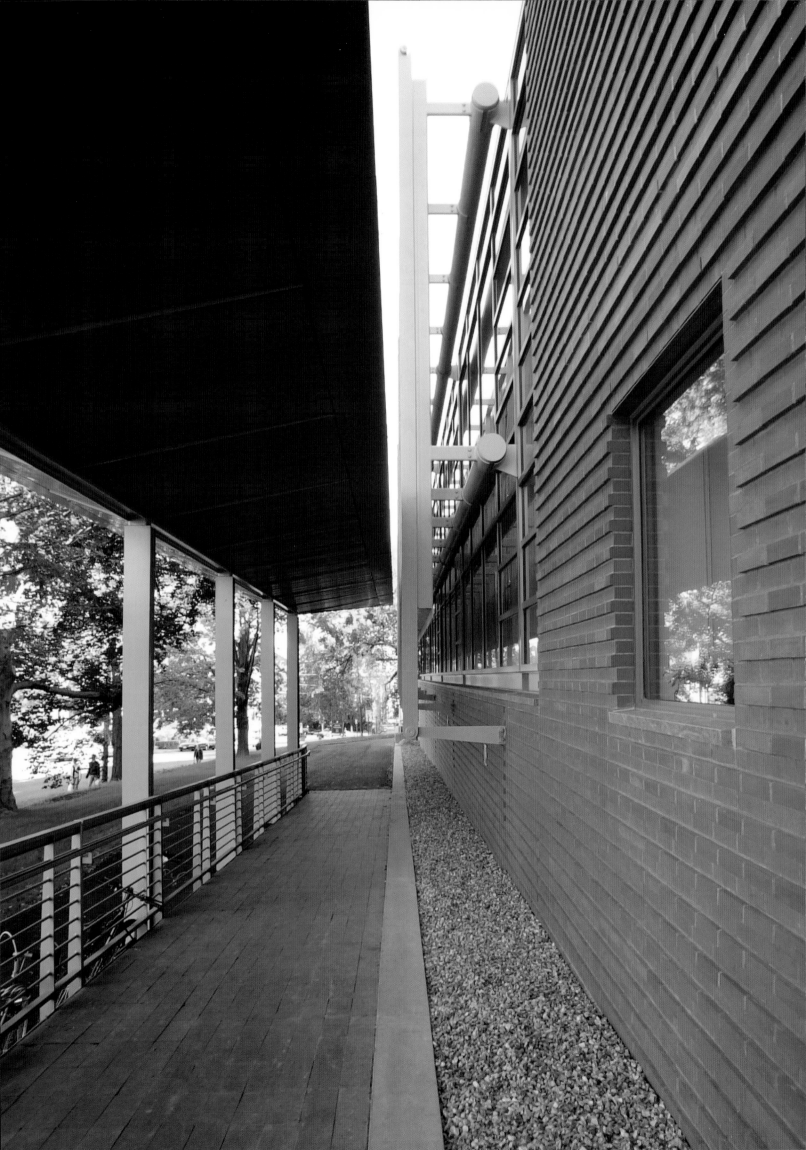

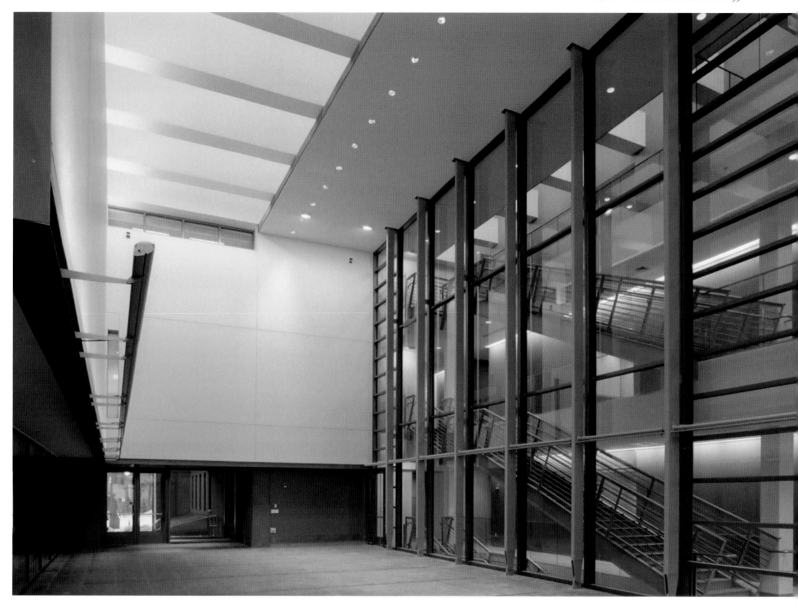

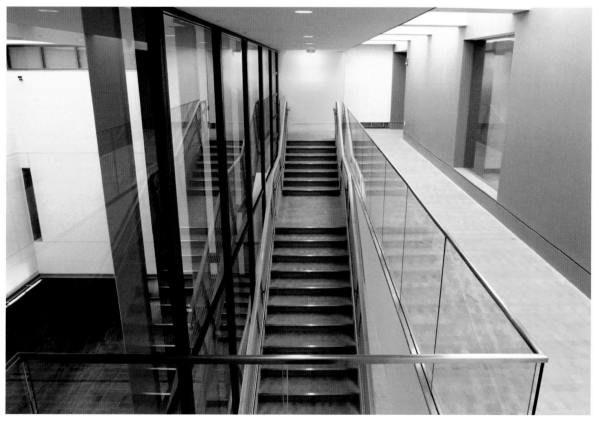

Facing page, photograph by Fish/Parham; photographs this page © Jeff Goldberg/ESTO

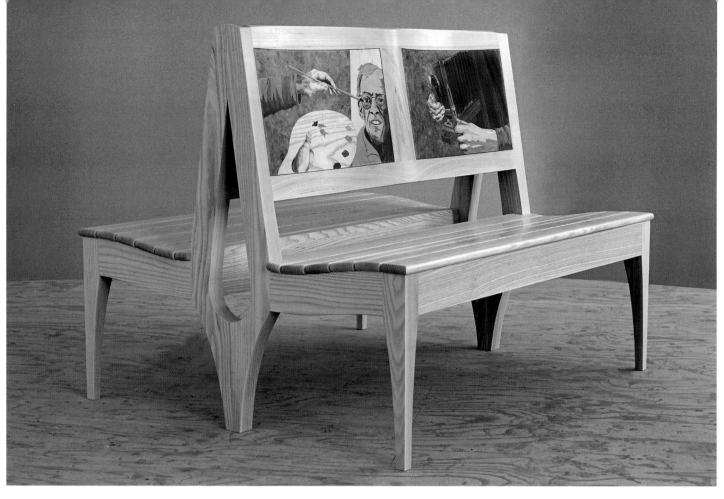

Artist-designed bench in the Museum of Art. Silas Kopf. American, born 1949. *Four Arts,* 2003. Photograph by Jim Gipe.

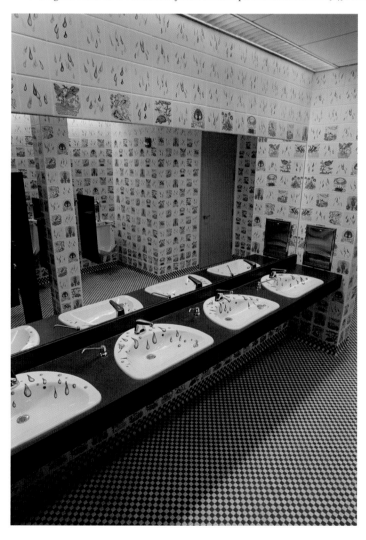
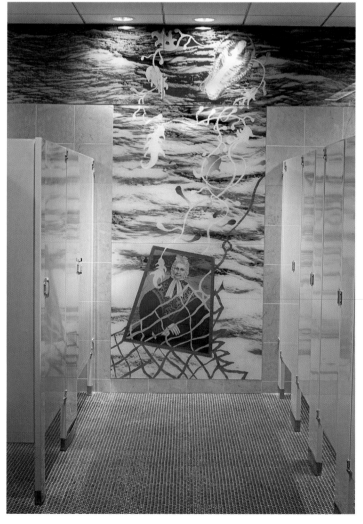

Artist-designed washrooms in the Museum of Art. Left: Sandy Skoglund. American, born 1946. *Liquid Origins, Fluid Dreams,* 2002. Right: Ellen Driscoll. American, born 1953. *Catching the Drift,* 2002. Photographs by Jim Gipe.

These washrooms, created by Ellen Driscoll and Sandy Skoglund, were made possible by funding from the Kohler Trust for the Arts and Education and Kohler Co. The altered plumbing products were created by the artists in Arts/Industry, a program of the John Michael Kohler Arts Center of Sheboygan, Wisconsin. Arts/Industry makes available the industrial pottery, iron and brass foundry, and other facilities of Kohler Co. to artists so that they may create works not possible in their own studios. The plumbing fixtures installed in the Brown Fine Arts Center were donated by Kohler Co.

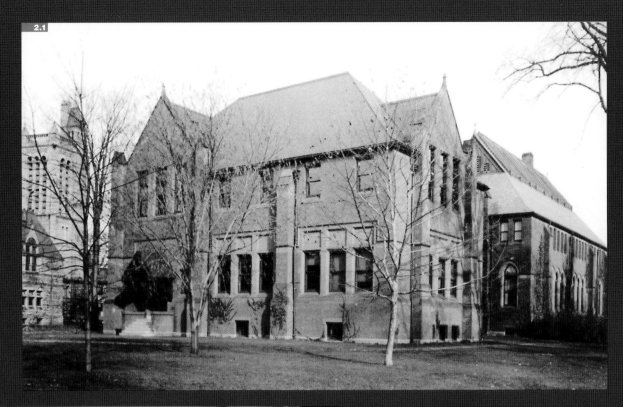

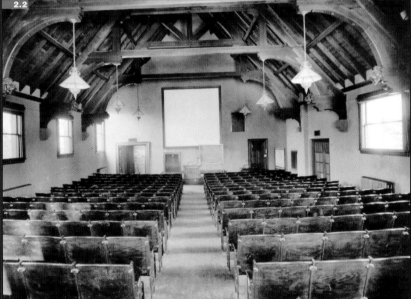

2.1 Hillyer and Graham Hall, 1910.
Smith College Archives.

2.2 Interior of Graham Hall. Smith
College Archives.

2.3 Hillyer and Tryon from Elm Street.

A History of the Art Buildings at Smith College

Helen Searing, Alice Pratt Brown Professor Emeritus of Art

The three buildings designed to shelter the art department and museum at Smith College have themselves represented the larger architectural trends current at the time of their construction. Initially the department and the museum were housed together, until in 1925 the museum moved to a separate, adjoining building. Beginning in 1972 they again shared a single complex that today is undergoing a dramatic metamorphosis, even as it preserves the ideal of a fusion in an academic setting of the creation, understanding and exhibition of works of art.

The first Hillyer Art Building was an important part of the initial ensemble that gave Smith College its proud appearance when, in the late 19th century, it was poised to become one of the major colleges for women. College Hall (1875), the founding building, was the focus of the handsome Victorian group framed by Pierce and Lilly to the southwest and Gateway House and Hillyer to the north, completing the College's face on Elm Street up to St. John's Episcopal Church (2.1, 2.4).

Lilly, by William Brocklesby (1841–1910), the designer of Alumnae Gym, and the four buildings in the group by Peabody and Stearns, are compatibly Late Victorian, a term that embraces the eclecticism characteristic of late-19th-century American architecture. The sources are primarily English Neo-Gothic, of the sort advocated by the influential critic John Ruskin (1819–1900), who preached the values—moral as well as visual—of honesty and integrity in materials and craftsmanship that he had discerned in his analysis of the

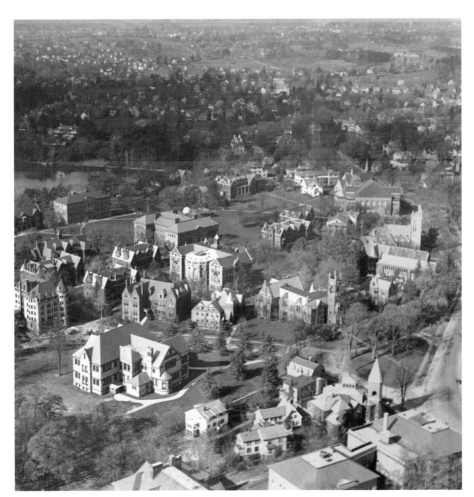

2.4 Aerial view of the Smith College campus, 1920. College Hall in center with Gateway House and Hillyer Art Gallery between College Hall and St. John's Episcopal Church.

monuments of the late Middle Ages. French influences are incorporated as well, especially those deriving from the widely read theorist of medieval architecture, E. E. Viollet-le-Duc (1814–79).

That one of the first classroom structures specifically erected for Smith College (some of the buildings, such as Dewey House, had been constructed earlier and moved to the new campus after the site was selected) was devoted to the visual arts—their practice, history and display—is testimony to their importance in Smith's curriculum from the very beginning. Indeed, College Hall, the first purpose-built structure at

2.5 Floor plan of Hillyer and Tryon.

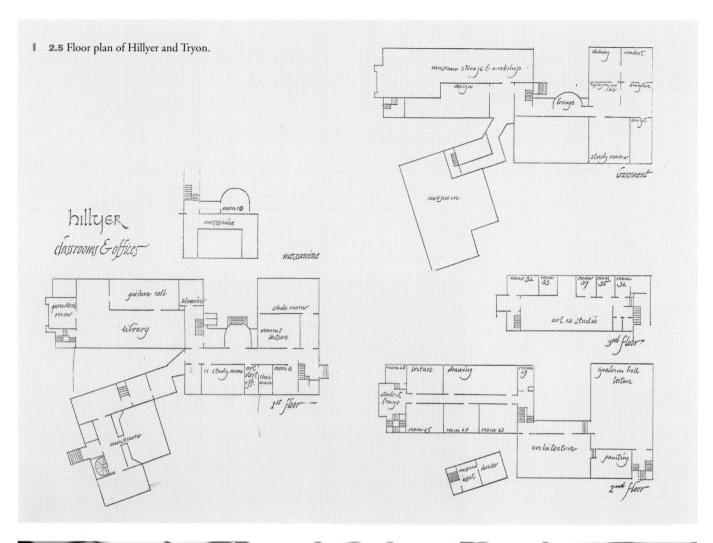

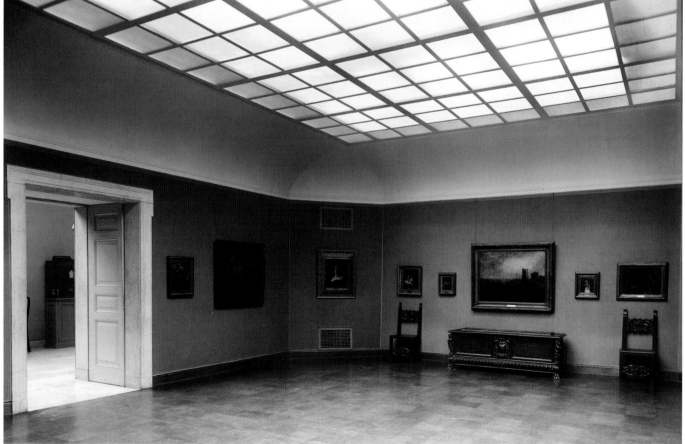

2.6 Main Gallery, Tryon Art Gallery.

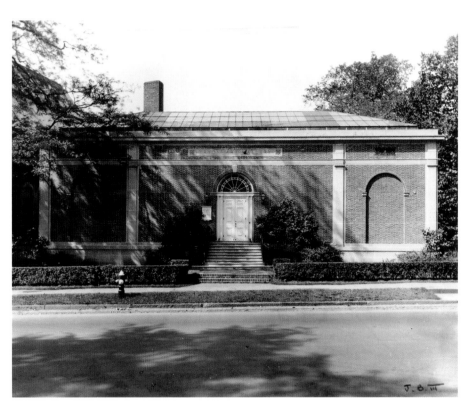

Smith to be completed, originally incorporated an exhibition space for the College's collection of plaster casts and prints, suggesting an early commitment to the visual arts as an integral part of the institution's life and of the student's education.

The selection of Robert Swain Peabody (1845–1917) and John Goddard Stearns (1843–1917) to design College Hall, and subsequently Hillyer, Pierce and Gateway House, was a sound decision. Although their Boston firm had been founded only in 1870, they would rise to the top of their profession in the ensuing years, establishing branch offices in St. Louis, New York City, Pittsburgh and Colorado Springs. They executed buildings of every functional type and did not adhere to a single architectural vocabulary, combining the Gothic, Renaissance, Queen Anne and Colonial Revivals in a lively synthesis. They were noted practitioners of the Shingle Style and Romanesque Revival, assimilating the creative strategies of the slightly younger Henry Hobson Richardson (1848–86), America's premier 19th-century architect. After his untimely death, they emerged as the leading heirs to Richardson's reform of American architecture. The architectural critic Montgomery Schuyler emphasized the importance of the firm in his seminal article, "The Romanesque Revival in America" (*Architectural Record* I, 2 [December 1891]), and Smith's own Henry-Russell Hitchcock noted in 1967 that Peabody and Stearns "were among the abler Boston practitioners of the day, and early acquired a national reputation."

Perhaps it was their building at the Smith Academy in Hatfield that rec-

ommended them to President Seelye, and their work on College Hall in turn engendered other projects in western Massachusetts, such as the Dickinson School at Deerfield (1877–81; demolished), the First Congregational Church in Northampton (1877–78) and Walker Hall in Amherst (1882). At Smith they went on to design residential as well as academic buildings, all handsomely crafted in brick.

Like College Hall, Hillyer served multiple purposes and additions were necessitated within a short period of time (**2.5**). The first art building had been funded by Winthrop Hillyer, and his gift of $25,000 made in 1881 was amplified in 1887 by $10,000 given by his brother and sister for an addition; the building was further expanded by Graham Hall, a large wing housing studios, classrooms, offices and a lecture hall and named for the donor Christine A. Graham (class of 1910), who supplied the funds while she was still a senior at the College (**2.1, 2.2**).

The heterogeneous functions of these buildings are reflected in their complex asymmetrical plans and silhouettes. The subsequent additions further complicated their appearance, resulting in that organic character so prized by the Victorians. Every change in function within signaled an archi-

tectural event without; thus, the varied sizes and shapes of the windows reveal the diverse uses of the interior spaces. However, Hillyer's detailing was sober and straightforward, without the elaborate embellishments to be found on College Hall. Hillyer's charm resided in its massing: the circular volume at the entrance crowned with its conical French "candlesnuffer" top, or the steep pitch of the roofs over the main portion, with their bold glazed surfaces. For an art school, of course, lighting is of primary importance, and Peabody and Stearns handled this aspect ingeniously, introducing large windows and skylights that signaled the particular destination of this academic building. Over the years, Hillyer had to accommodate an art library, a slide room, lecture halls and offices as well as spaces for studio and art history classes, and during its eighty-nine-year existence it did this quite adequately. In the 1940s, it received exterior embellishment in the form of figurative panels sculpted by Randolph W. Johnston (**18.2**).

Although Hillyer provided exhibition space, as the College's collection grew it was determined that a building devoted exclusively to the display of art—i.e., a museum—was needed, and in 1925 this was made possible through the generosity of the painter and Smith

professor Dwight William Tryon and his wife Alice. Architectural taste had changed by this time, and the new Tryon Gallery was Neo-Georgian in style (**2.7**). Its tidy oblong crowned with a hipped roof was visually antithetical to the picturesque, assymmetrically composed Hillyer. Tryon's light-red brick with pale marble trim contrasted with Hillyer's brownish brick dressed with brownstone, but at this time the concept of "contextualism" had not been formulated; juxtaposition was acceptable and the two buildings offered differing meditations on the architecture of the past. Georgian architecture had been part of the 18th-century American tradition, and Tryon provided a visual link with the colonial and Federal houses along Elm Street beyond St. John's Episcopal Church. Tryon's front door, for example, was domestically scaled and matched those of the surviving 18th-century houses. Talbot Hamlin, the leading architectural critic of his day, in an "appreciation" published in the *Bulletin of Smith College Museum* (June 15, 1926), noted that the architect "has chosen a style as expressive in its details as in its general conception….Tryon Art Gallery is purely New England in spirit…a little feminine as befits its position in a women's college; a New England avid for the high gifts of beauty—ready to set the fine arts on their rightful throne."

The architect of Tryon Gallery was Frederick L. Ackerman (1878–1950), who in 1901 had received his architecture degree from Cornell, the third oldest architecture school in the country; he then studied in Paris from 1903 to 1905. On his return he formed the part-

nership of Trowbridge and Ackerman, which lasted until 1920; by the time he designed Tryon he was in independent practice. Ackerman's friendship with Dwight Tryon, as well as his interest in the relation of art to education, may explain the Smith commission, unusual for him; his focus was more generally on residential work both public and private, and indeed he was famous for his contributions to public housing. In consultation with William Allan Neilson, then-president of Smith, and Alfred Vance Churchill, Ackerman handled with sophistication and skill new technical requirements like fireproofing, controlled ventilation and ample lighting without glare. Tryon had two floors of galleries, each with a large central room and two smaller ones to either side (**2.5**, **2.6**). Those on the basement story received natural light from regular windows, those on the main floor from above, via a novel but effective system of skylights called "Ventilighters," with adjustable louvers for control of light levels; below these were electric lights for illumination on dull days or at night. Such technical refinements were to have an increasing impact on museum design, but Ackerman did not let these dominate his design at the expense of those formal qualities so necessary to the art gallery. Although the hipped roof was covered in copper and glass, for example, rather than the traditional slate or tile, its proportions and profile were perfectly in accord with a Georgian vocabulary and fulfilled the demand expressed by Hamlin that "most of all a museum must itself be a work of art. To house beauty in ugliness is an insult, as to house beauty in ostentation is conde-

scending arrogance." It is worth noting that Tryon's Neo-Georgian vocabulary anticipated that of Harvard University's Fogg Museum (1927, by the Boston firm of Shepley, Rutan and Coolidge), an institution that had and continues to have many connections with the art department at Smith.

The charm of these structures notwithstanding, as the number of art majors continued to grow along with enrollment by non-majors, and as such media as photography and silkscreen joined painting, sculpture, drawing, architecture, typography and other forms of printmaking in the studio curriculum, demands grew for an expanded and updated physical plant, which would also respond to the need to accommodate growing acquisitions of books and works of art.

A committee representing the faculty, the museum and the administration was formed to draw up a program for a major fine arts complex. To preservationists' dismay, President Thomas Mendenhall was determined that it should occupy the site of the existing buildings; he never saw the sense of new wine in old bottles. A minority wanted to see the retention of Hillyer/Graham and Tryon through an imaginative design that would add, update and possibly incorporate Stoddard Hall (1899), across Elm Street. There were certainly compelling examples in Europe of such recycling, enhancement and extension; but the arguments by Professors Hitchcock, James Holderbaum, Elliot Offner and myself, then a very junior instructor, were considered impractical, and plans for demolition went ahead. The question then became whether to include in the tabula-rasa

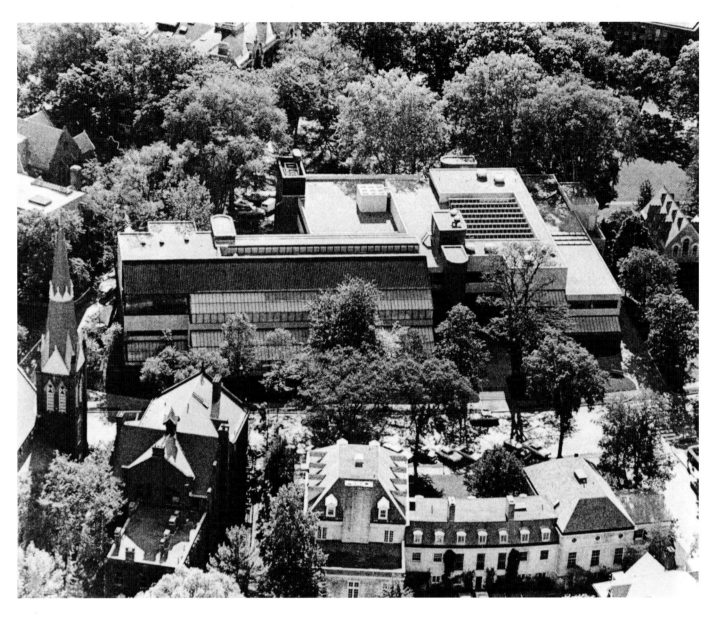

2.8 Aerial view of the Fine Arts Center, 1972. Photograph by Robert P. Foley.

sweep the adjacent Gateway House, the first home of Smith's presidents (subsequently used as offices for the School for Social Work). Letters pro and con flew back and forth, but finally that picturesque Victorian gem also disappeared. The uniqueness of the original ensemble had been diminished, but a spacious and totally new facility rose to take its place on the site.

Much of the art department moved across the street to occupy, from 1969 to 1973, the former chemistry building, Stoddard Hall. The renovated structure served its new function of housing some studios, the library, the slide room, faculty offices and a lecture hall surprisingly well. Meanwhile, a new committee drew up a planning program with the professional assistance of the Cambridge-based firm Dover and Paddock, which quantified the perceived spatial needs preparatory to choosing a designer. Although the name of arguably the most distin-

guished architect of his generation—Louis I. Kahn (1901–74)—was bruited, his tendency to exceed budgetary and time restraints made him a non-contender.

Ultimately, John Andrews was selected. Born in Australia in 1933, Andrews had recently founded a firm in Toronto and was considered a rising young star on the basis of his innovative Scarborough College there; closer to home he was in the process of executing Gund Hall for the Graduate School of Design at Harvard University. Both illustrate his alliance with the movement, originating in England, called Brutalism, a name derived from a preference for raw concrete (*beton brut*) and a realistic, no-nonsense approach to the basic facts of construction and use. Brutalism, influenced by the late works of Le Corbusier (1887–1965), was a challenge to the dominance in the 1950s and 1960s of the elegant and laconic

BASEMENT

DEPARTMENT OF ART

1	Graphics	
2	Introductory	
3	Design	Teaching
4	Independent Work	Studios
5	Sculpture	
6	Typography	
7	Shop	
8	Faculty Studio	
9	Storage	
10	Large Hall	
11	Projection Booth	
12	Lobby	

MUSEUM

13	Conservation
14	Registrar
15	Work Room
16	General Storage
17	Painting Storage
18	Crate & Display Storage
19	Gallery
M	Mechanical
E	Elevator

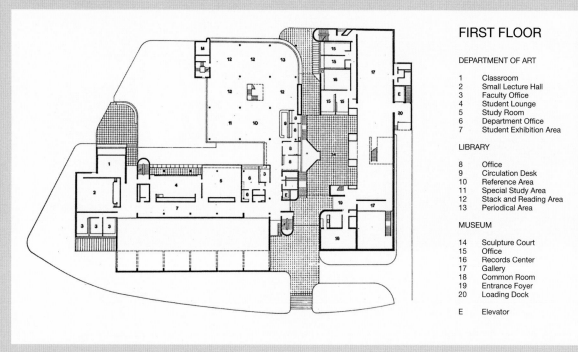

FIRST FLOOR

DEPARTMENT OF ART

1	Classroom
2	Small Lecture Hall
3	Faculty Office
4	Student Lounge
5	Study Room
6	Department Office
7	Student Exhibition Area

LIBRARY

8	Office
9	Circulation Desk
10	Reference Area
11	Special Study Area
12	Stack and Reading Area
13	Periodical Area

MUSEUM

14	Sculpture Court
15	Office
16	Records Center
17	Gallery
18	Common Room
19	Entrance Foyer
20	Loading Dock
E	Elevator

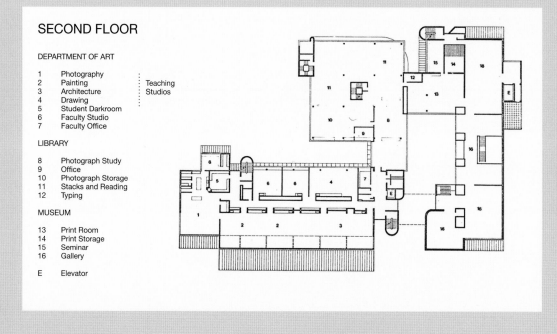

SECOND FLOOR

DEPARTMENT OF ART

1	Photography	
2	Painting	
3	Architecture	Teaching
4	Drawing	Studios
5	Student Darkroom	
6	Faculty Studio	
7	Faculty Office	

LIBRARY

8	Photograph Study
9	Office
10	Photograph Storage
11	Stacks and Reading
12	Typing

MUSEUM

13	Print Room
14	Print Storage
15	Seminar
16	Gallery
E	Elevator

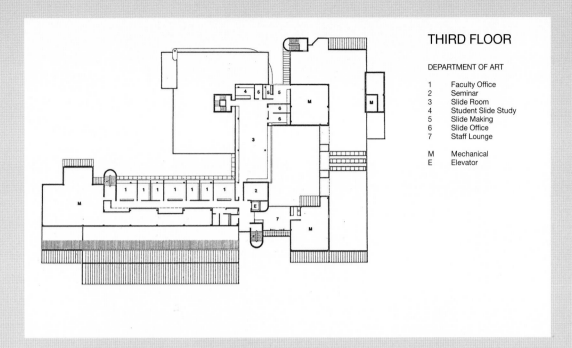

THIRD FLOOR

DEPARTMENT OF ART

1 Faculty Office
2 Seminar
3 Slide Room
4 Student Slide Study
5 Slide Making
6 Slide Office
7 Staff Lounge

M Mechanical
E Elevator

2.10 *Section plans for the Fine Arts Center, 1972*

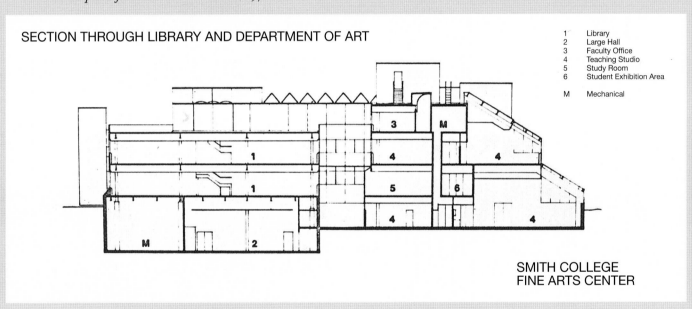

SECTION THROUGH LIBRARY AND DEPARTMENT OF ART

1 Library
2 Large Hall
3 Faculty Office
4 Teaching Studio
5 Study Room
6 Student Exhibition Area

M Mechanical

SMITH COLLEGE
FINE ARTS CENTER

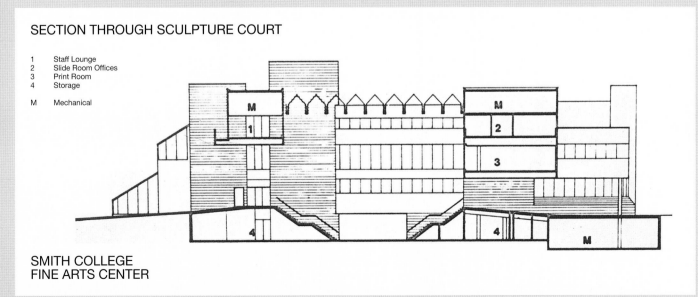

SECTION THROUGH SCULPTURE COURT

1 Staff Lounge
2 Slide Room Offices
3 Print Room
4 Storage

M Mechanical

SMITH COLLEGE
FINE ARTS CENTER

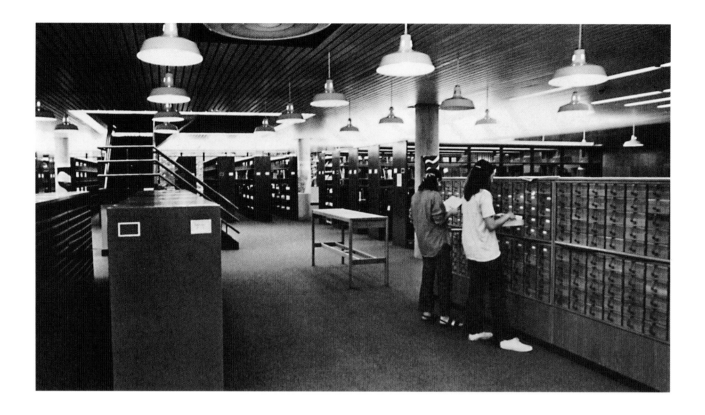

style initiated by Ludwig Mies van der Rohe (1886–1969); the finest example on campus of this latter approach is the Cutter-Ziskind dormitories, designed by Skidmore, Owings and Merrill (the "three blind Mies") in the mid-1950s.

Aggressive in their massing and extremely complex in their sections, buildings by Andrews provide a marked contrast to the simple Miesian boxes, in which sleek envelopes conceal a multiplicity of functions, including mechanical services. Andrews favored interlocking spaces where one looked through glass walls up or down or across into other rooms, for the stories were not uniform in dimension and were therefore of different heights (**2.9, 2.10**). Also characteristic was the choice of tough industrial materials in the building's construction—poured reinforced concrete, often with the metal bolts visible; exposed concrete blocks inside and out; hard quarry-tiled surfaces; tubular metal railings; and frankly exposed ductwork (**2.8, 2.15**).

Although this was still before the era when contextualism became an architectural byword, back when modern buildings frequently stood as isolated, abstract entities divorced from their historical surroundings, aspects of the new art complex, Andrews argued, made some gesture to the remaining Victorian buildings, and there were even a few reminiscences of the old

Hillyer. While its dominant materials of concrete and quarry tile were completely different in scale and texture from the brick and stone used in College Hall, the new Hillyer's cream and terra-cotta colors echoed those of Smith's first building. Furthermore, the new Hillyer shared with the earlier building the principle of expressing varied interior functions through vigorous articulation of the envelope: the complex footprints and silhouettes of both structures immediately convey to the viewer the diversity of interior spaces. And old Hillyer's bold skylights on Elm Street reappeared as well, although in a more extreme form.

The design process led to confrontations between architects and clients. Andrews, partner-in-charge Edward Galanyk and associate Brian Hunt were not noted for their ability to listen to others, but were alternately arrogant and condescending. They insisted, for example, that the studio floors consist of a single undifferentiated area—not the best solution where different types of courses must be taught in adjacent spaces (unlike the Graduate School of Design at Harvard, the firm's earlier project, which was devoted solely to architecture and urban planning). In the final scheme, the studios were subdivided by partitions, which defined discrete areas without fully enclosing them.

With fundraising lagging and strong

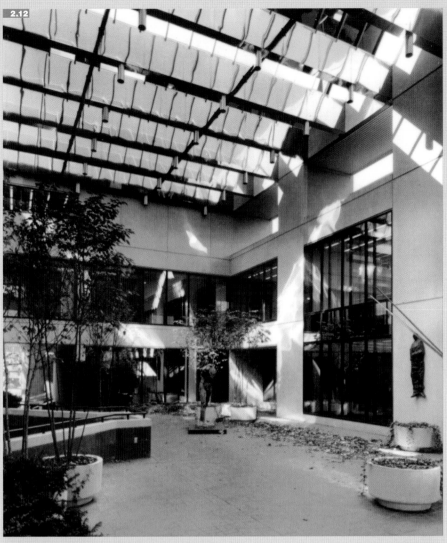

2.12 Elizabeth Mayer Boeckman, class of 1954, Sculpture Court. Photograph by Helga Photo Studio, New York, New York. Smith College Archives.

2.13 Fine Arts Center, students working in the graphics studio with Professor David Stokes. Photograph by Gordon Daniels.

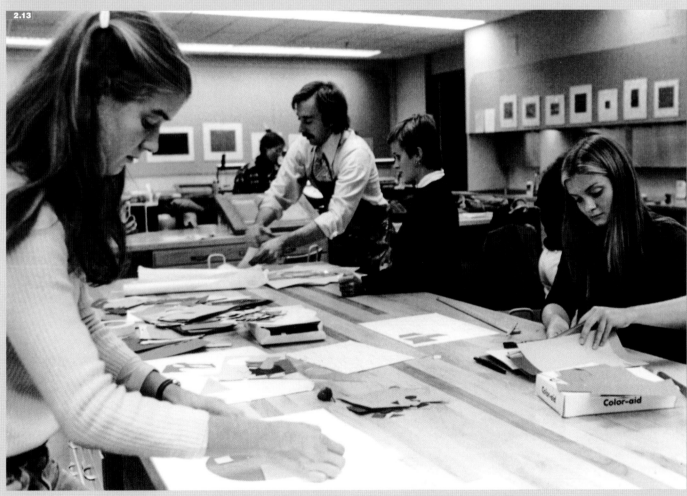

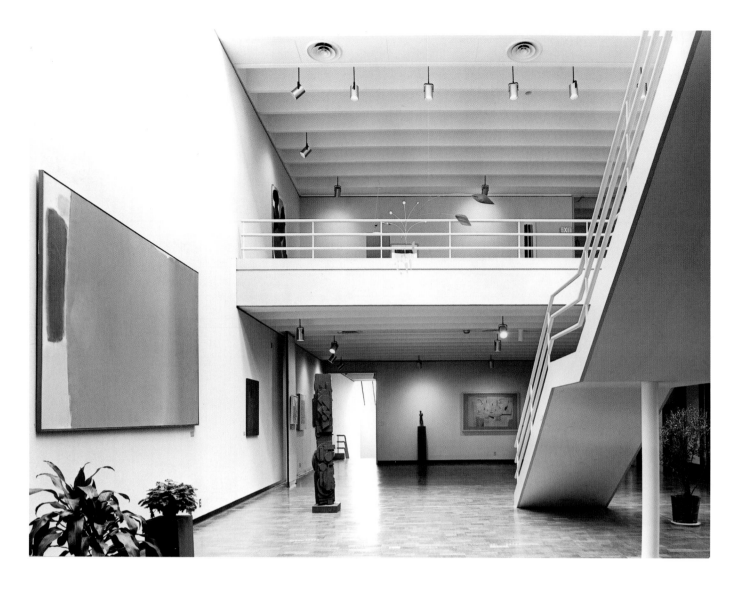

2.14 Doyle Gallery (main floor of museum) with view above to Seasongood Gallery

sentiments against the design within the department (the art historians, especially, disapproving of a model shown in 1969), it seemed at one point that the project was doomed, so much so that Charles Chetham, then-director of the museum, proposed the erection of a separate museum elsewhere on the campus. Eventually Andrews responded to some of the criticisms, and a compromise was reached. Construction commenced in 1970, and the Fine Arts Center, comprising Hillyer Hall, housing one of the largest departments in the College; Hillyer Art Library; Graham Hall (an adjoining underground facility); and Tryon Hall (the Museum, as it is most frequently called) opened in the fall of 1972, a commanding new presence that brought to Elm Street the most current fashion in architecture (**2.8, 2.15**).

Each of the three major units was distinguished on the exterior by the treatment of the elevation, especially the fenestration; by the projecting and receding footprint; and by the articula-

tion on the exterior of the different spaces within. Studios and studio faculty offices/studios were located on the ground (**2.13**) and second stories, the main studios placed in the front to take advantage of the northern light (though because of the orientation of the site, this was not precisely due north). The art historians were placed on the third floor along a corridor ingeniously lighted by a configuration, consisting of a half-concave ceiling with clerestories on one side, derived from the great Finnish modernist, Alvar Aalto (1898–1976), another Brutalist icon. Their offices were adjacent to the slide library, laid out beautifully by Charles Huber, husband of then-curator Erna Huber, whose retirement, sadly, meant that she never worked in the room that bore her name (**2.16**). A darkroom for the making of slides was conveniently inserted into the space, and the slide room itself was directly connected to the library on the second story, one of the more felicitously functional aspects of the building. The seminar room was

immediately next to the slide library; since one often needed to procure additional slides during class, this was another well-conceived juxtaposition. Also on the third level was the faculty lounge, the scene of infinitely numerous and lengthy department meetings, informal lunches and departmental receptions.

The second level of the library accommodated the Visual Resources Center for the department's historic collection of reproductions and photographs. Access to the library (**2.11**) was on the first floor, where there were also offices, the reception area and a corridor for temporary displays (a department committee selected changing shows of the work of alumnae, faculty and local artists).

A special study room was dedicated to the introductory survey course (**3.1, 27.2**), perciently located next to the

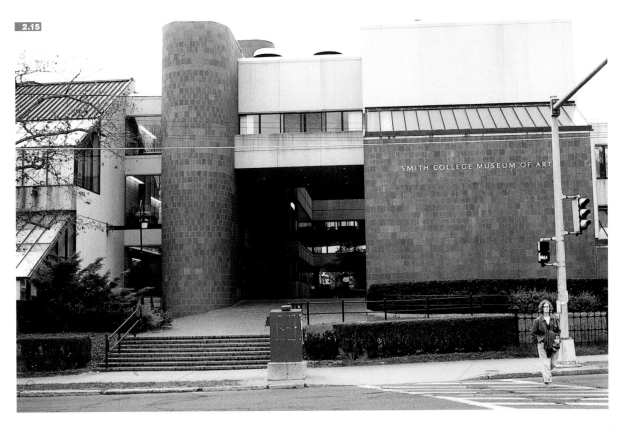

student lounge, where students could fortify themselves for all-night vigils before exams. Within the confines of this room, its canvas-clad walls lined with mounted photographs, members of the course could quiz each other about the stylistic differences between Duccio and Giotto, memorably described by James Holderbaum; the architectural qualities of the Pantheon as set forth by William MacDonald, author of a popular book on the monument; the intricacies of the medieval manuscripts delineated by Robert Harris; the artistic qualities manifested by "that guy [who] could really paint," as Richard Jay Judson insightfully expressed it; and the distinction between Renoir's and Monet's interpretations of Impressionism, as analyzed by Jaroslaw Leshko.

Hillyer was linked to Tryon by a large courtyard, covered with a glazed roof, which served as the connector between the central campus and Elm Street (2.12, 2.15). Those passing through could look into the first floor gallery and be enticed inside for a visit; the courtyard also displayed such sculptures as Rodin's imposing *Walking Man* (24.5).

Tryon Hall was designed to the exacting specifications of director Charles Chetham. Andrews had not previously designed a museum, and the guidance of Chetham, so knowledgeable and experienced about the unique needs

2.15 The Museum of Art from Elm Street.

2.16 Dedication of slide room with, from left to right, Professor Searing, Charles Huber, Professors Leshko and Kellum.

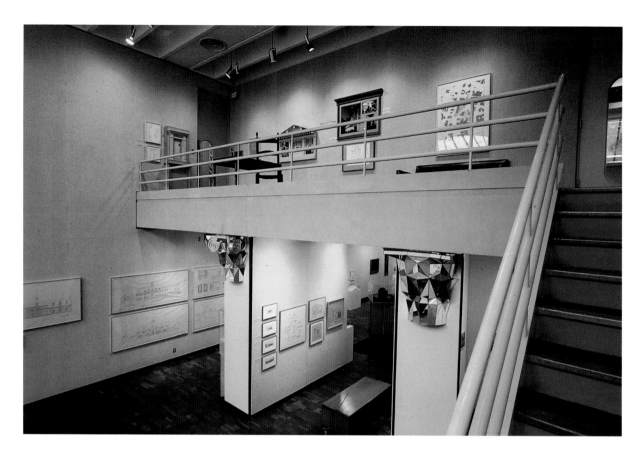

of a contemporary gallery that should be a community as well as a college resource, was critical to the architect's creation of a variety of large and small, monumental and intimate spaces, capable of even further flexibility through a system of movable partitions. Many problems generic to museums that were not foreseen when the first Tryon was erected were solved in the new Tryon Hall. Facilities such as the delivery platform and large service elevator that accommodated the busy flow of art objects to and from the museum were a response to the increasing popularity of traveling exhibitions. At last the museum had at its disposal environmentally sound and spatially generous storage areas, permitting faculty and students to study works in the collection that were not currently on display.

The composition of the three floors of galleries vividly illustrates Andrews's penchant for interlocking volumes that provide exciting views, and for single-height levels that flow via prominent stairs into lofty vertical rooms (**2.17**). Thus one entered the lower gallery from the main level via a balcony, where small works could be displayed, then descended to the soaring area beneath, top-lighted ingeniously on the Elm Street side, which then diminished to a one-story level at the rear. Over the years, this dramatic sequence of

spaces accommodated not only large, site-specific installations, but also entire exhibitions. It also performed splendidly for the legendary concerts hosted by the museum, where members of Smith's acclaimed music department offered musical feasts to an appreciative community.

In counterpoint, the flexible main floor gallery also had a balcony accessed by a stair, but here the journey began as an ascent (**2.14**). The second-floor balcony overlooked the space below on three sides and led to galleries fore and aft. (Similar spatial conceptions are found in Hillyer—in the library and in the first-floor corridor—where windows look down to the sculpture studio.) The rear gallery behind was windowless and therefore ideal for exhibitions of fragile and light-sensitive works. Also at level two was the print room, designed especially for works on paper and named in memory of Eleanor Lamont Cunningham (class of 1932), the gift of her husband, the noted museum director Charles Cunningham, and their daughter Priscilla (class of 1958).

Increasingly important in attracting visitors to the museum are receptions held on the occasion of openings and Members' Day. For years these were elegantly arranged in the main and lower level galleries by the incompa-

2.17 Architecture show, *Speaking a New Classicism* (1981), installed in Dalrymple Gallery by David Dempsey.

rable Constance (Connie) Ellis. Most of all, though, the museum is a place for viewing and understanding art, and Tryon's design made large groups, small enclaves, and the individual student feel very much at home.

Yet for all its success in serving the visual arts at Smith, integrating the study of art history with the display and creation of works of art, the Fine Arts Center, after less than twenty-five years, had in its turn become obsolete. At first the administration argued that it would be sufficient merely to repair the deteriorated envelope. But other architectural deficiencies along with new programmatic needs were revealed and in late 1995, at the department's behest, President Ruth Simmons called for a detailed study of the arts complex. This would result in the ultimate transformation of the Fine Arts Center by the Polshek Partnership, initiating a new chapter in the history of the art buildings at Smith College.

3.1 "The Wall": Students studying for an Art 100 exam in Hillyer Hall, 1979. Photograph by Joseph G. Brin. Smith College Archives.

"True Proportion": Teaching the History of Art at Smith College

John Davis
Chair, Department of Art

Henry-Russell Hitchcock (**3.2**, **9.1**, **23.1**), Adolph Katzenellenbogen, Oliver Larkin (**8.1**), Rensselaer Lee, Phyllis Williams Lehmann (**4.3**), Charles Rufus Morey, Edgar Wind: The names of the art historical "greats" that pepper the individual essays that follow constitute a daunting intellectual roster, of which any world-class university would be proud. That these and other renowned scholars chose to make a liberal arts college for women their academic home (for short periods or an entire career) is cause for both wonder and celebration. Some arrived at the Grécourt Gates through the fortunes of war, others may have been attracted to Smith's developing museum collection. All, no doubt, developed a keen appreciation for the seriousness with which President Seelye and his successors treated the history of art and architecture—as a rigorous humanistic discipline as worthy of support as the study of literature, mathematics, or botany. It would not have taken them long to discover a similar seriousness—and capacity for work—which their Smith students brought to the classroom.

For these students, art history at Smith began early, but somewhat fitfully. A number of instructors (usually artists who were periodically persuaded to leave their studios and enter the lecture hall) offered a handful of courses in the 1880s and 90s; some of them are detailed in the essays by Caroline Houser and Craig Felton in this volume. In 1905, however, the College took a step toward regularizing these academic offerings by creating the first permanent professorship in "the history

and interpretation of art" and offering it to Alfred Vance Churchill, then a faculty member at Columbia Teachers College (**21.1**). While Smith was not the first college or university, or even the first women's college to create a full-time position in art history (Vassar, Wellesley, and Bryn Mawr can claim precedence here), it was still in the vanguard. According to a survey conducted by E. Baldwin Smith in anticipation of the 10th International Congress of Art Historians, which took place in Rome in 1912, Smith was one of only sixty-eight American institutions of higher learning with a professorship in art history, out of a total of around 400 colleges and universities surveyed.

When Seelye made his offer to Churchill, he wrote in explanation, "We desire a resident teacher who will give special attention to the history and interpretation of art,—not merely for those who are engaged in practical work but for the benefit of all who wish to have an intelligent appreciation of the art treasures which the world contains." This institutional commitment to a broad education in art history, for majors and non-majors alike, has characterized the program throughout the ensuing century. Churchill's first two courses, Art 10 ("Art Interpretation: The work of art as an organism; the principles of order which underlie all beauty") and Art 11 ("History of Art: The masterpieces of architecture, sculpture, and painting, considered as a record of the thought and feeling of the race from the earliest times to the present day"), were an auspicious beginning. Their titles suggest an understanding of the work of art not as a stale relic but as a living

object—infused with an underlying system of meaning that could be made to yield to a student's intelligent study and sensitive looking.

In today's vigorously interdisciplinary climate, we often imagine that the art historical pedagogy of our distant predecessors must have been somewhat constrained: dry, dusty, composed of overly neat narratives of stylistic progression and little else. At Smith, however, there seems to have been a sustained effort to move beyond the notion of the rarified aesthetic object, divorced from its time, and to integrate the history of art (its commissioning, its making, its reception) into a larger program of cultural study. In 1933, Larkin (then chair of the department) described his colleagues' goals in an essay in the *Smith Alumnae Quarterly*. He bemoaned the development of "artificial barriers to unified thinking" in the study of art. In contrast, Larkin explained,

> The present teaching staff of our Art Department has determined to break down these pedagogical compartments which make teaching so easy and learning so difficult, in order that its students may emerge at the end of four years with the beginnings of a sound and consistent point of view not only toward art itself but toward man's other activities in which he embodies similar ideals, uses similar faculties of mind and hand, and is affected by the same economic, political, philosophical, and social factors.

However, this broad view of what Larkin called "art knowledge" was not achieved at the expense of formal principles. Since so many of the first professors of art history (Churchill, Larkin,

Clarence Kennedy) were also artists, we can be sure that the visual, material, and technical aspects of the work of art were not neglected.

Kennedy also contributed an essay to the *Alumnae Quarterly* in 1933, and in it he reflected on this need for pedagogic balance. As a historian with a primary interest in the Renaissance, he worked in a period that might seem remote to some students (6.1). He recognized the natural attraction toward the modern and the contemporary felt by young people, and he championed Smith's early commitment to the systematic study of recent art. "That we should attempt to apply to modern art the same criteria that are used in judging the art of the past was a policy established by Professor Churchill while the idea was still new in collegiate circles," he noted. Yet Kennedy insisted upon the need for a thorough historical grounding in earlier periods. "If contemporary culture has any value to us," he wrote, "we must see it clearly, and the past, which helped to make it what it is, is infinitely illuminating. Even if we were content not to know

the origins of modern concepts and modern habits of thought, if we should ignore the heritage of the past we would be impoverishing ourselves in the most wanton manner, for works of permanent and enduring beauty have been created throughout the course of civilization."

The need for balance (of approaches, of periods, of cultures) is nowhere more salient than in art historical teaching at the introductory level, and it was here that Larkin, Kennedy, and their colleagues put their ideals into practice. Thousands of Smith alumnae have taken an introductory art history course within the walls of Hillyer Hall. For most of them, it was either Art 100, or its predecessor, Art 11. These survey courses came to acquire legendary status at Smith, for both their grand sweep and their demanding intensity. However, a given student's experience of one of these courses is necessarily singular, and the "legends" that developed over the years created a somewhat false impression of a monolithic survey course, an unchanging Smith "monument" that was always and would

3.2 Henry-Russell Hitchcock with student. Photograph by Hanson Carroll. Smith College Archives.

always be the same. The introductory art history course was certainly a monumental undertaking, even a rite of passage, but it was also, by necessity, a dynamic and ever-changing entity. Only by being adaptable could it serve the department's pedagogic mission as well as it has for so many years.

In the early days, for example, the art history survey went by a variety of titles and course numbers (Art 11, Art 22); some of these courses were for a semester, some for a year; some were team-taught, some not. Even after the 1920s, when the course developed its characteristic format as a year-long, team-taught survey, it continued to evolve as new faculty joined its ranks and new areas of art history were added to the curriculum. While expansion regularly occurred, Art 11 and (as of 1966) Art 100 remained primarily surveys of Western art and architecture. It was not until the late 1980s that the

In today's vigorously interdisciplinary climate, we often imagine that the art historical pedagogy of our distant predecessors must have been somewhat constrained: dry, dusty, composed of overly neat narratives of stylistic progression and little else. At Smith, however, there seems to have been a sustained effort to move beyond the notion of the rarified aesthetic object, divorced from its time, and to integrate the history of art into a larger program of cultural study.

department resolved to attempt a world survey of art. This was an ambitious plan, as well as an early step in the direction of the global curriculum that would come to characterize Smith's mission in the 1990s. A few historians volunteered to give up some of "their" material and, instead, prepare lectures on Islamic art and architecture. Other gaps were filled through visiting lecturers. Marylin Rhie, who had already been offering upper-level coursework in Asian art for some fifteen years, also joined the Art 100 roster. Finally, the department convinced the College to redefine an existing faculty line to create the position in African, Pre-Columbian, and Native American art currently occupied by Dana Leibsohn. The resulting mix of material provided exhilarating intellectual opportunities for cultural comparisons, and even traditional areas of Western art were transformed (with new attention, for example, to the art of nomadic peoples in ancient and medieval Europe).

The art department spent a decade refining this expanded Art 100; however, in 1997 President Ruth Simmons launched a College-wide initiative to reconfigure the faculty workload in an effort to keep Smith competitive in its search for the very best professors. Under the new plan, the department realized that in order to continue offering Art 100, each of the ten full-time art historians would have to devote 50 percent of his or her teaching to its lectures and discussion sections. This, we concluded, would do irreparable damage to our intermediate and advanced art history offerings. There was also some sentiment among the faculty that the decreasing enrollments in Art

100 necessitated a rethinking of the course. Where enrollment had occasionally broken 300 in the 1980s, it had dropped to 145 in 1998. Many suspected that the year-long commitment of the survey kept many non-majors from taking it (our numbers of majors had not declined noticeably), and this was particularly troubling since the department had always insisted upon its goal of providing a general education in art history to all Smith students, regardless of major.

These developments need to be put in the perspective of College-wide (and national) changes in teaching during the 1980s and 1990s. In most colleges in the United States, there has been a general evolution away from large lecture courses. Rather, contemporary pedagogic theory places a premium on writing and speaking exercises, Socratic dialogue, small-group discussion, and shared learning. Smith students have come to expect these more personal and individual learning opportunities, and one by one, the major introductory courses at the College have been modified. Looking at any Smith catalogue from the 1950s, one finds over thirty year-long, introductory survey courses, one for almost every discipline in the College. A glance at subsequent catalogues indicates that many of these were dropped in the revolutionary year of 1968, and quite a few of those remaining disappeared by the early 1980s. Art 100 lasted longer than most, but it too eventually succumbed to the trend. Now in 2002, for better or worse, there are no longer any grand, two-semester survey courses in the Smith curriculum (only the introductory European language courses are still year-long).

For many alumnae who got so much from these courses, this is undoubtedly a disappointing development, but it can also be seen as an opportunity for new creativity on the part of the faculty. The art historians at Smith consulted with the President and Provost in 1999 and decided to undertake a two-year experiment and replace the Art 100 survey with a series of one-semester colloquia entitled "Approaches to Visual Representation," with no more than twenty students per class. These courses (examples include "Art and Death," "The Home as a Work of Art," and "Realism: The Desire to Record the World") would be organized around different topics or themes, but each would include the basic tools of description, visual analysis, and interpretation, as well as exposure to painting, sculpture, and architecture and works of art from different cultures and time periods. As one-semester offerings, they would provide students with much greater flexibility in organizing their already full schedules.

At the end of the two-year period, the faculty was delighted to learn that enrollments in 100-level art history courses had increased by a very healthy 57 percent. Clearly, we had found a way to reach the many non-majors who were unable or unwilling to take the year-long Art 100. Our task, however, was not done, for it remained to assess the pedagogic and intellectual effectiveness of the colloquia. This we did during the academic year 2000-01, with the help of Smith's Office of Institutional Research. We designed a student survey and polled students who had taken Art 100 and those who took the new colloquia. We also met

regularly to discuss teaching techniques and propose a variety of models of introductory teaching (we started with no fewer than eighteen models, and winnowed the list in subsequent months). In the end, a majority of the art historians concluded that as successful as the colloquia had been, they still lacked the breadth and coverage that a survey course provides. Our final decision was to keep the colloquia, which had struck such a strong chord with students, but to add to them three one-semester survey courses: one on Western art, one on Asian art, and one on the indigenous arts of Africa and the Americas. Majors and non-majors alike are encouraged to take several of these courses, benefiting from a variety of formats. Our newly balanced curriculum, instituted in fall 2002, inaugurated the renovated Brown Fine Arts Center.

This recent history, and the debates that inspired it, might seem to be a phenomenon unique to our contemporary climate of professionalized pedagogic research and renewal, but as the department takes this opportunity to reflect on the history of the arts at Smith, we have often discovered how little of what we do is truly "new" and how often our predecessors figured things out long before we even thought about broaching a given question. The year of curricular deliberations recently completed by the art history faculty was important and fruitful, and in the end we achieved a satisfying mix of content-driven coverage and skills-building analysis. Yet, our task might have been completed a bit sooner had we taken a trip to the archives to examine the papers of Alfred Vance Churchill. It turns out that Smith's first art historian had already thought about all of these issues and had encapsulated them in a cogent memo to his fellow teachers. Churchill's wisdom about "true proportion" in teaching is as meaningful now as in 1921 when he wrote the memo. It seems only fitting to give him the last word.

Dear Colleagues:

We promised to bring to each others' notice helpful ideas and readings. So I retail certain things, and you may take them for what they are worth or for what you can make of them.

A student who has an excellent reputation said the other day that all the teachers in the college that she had had, with only one exception, went too fast and covered too much ground. Most of the teachers, she said, seem to have an ideal that compels them to present the subject. At the end of the course the number of impressions has been so great that confusion results. At the end of a year or two the course has practically vanished.

Such remarks would not be perhaps worthy of notice except that they came from a girl of intelligence, and character, beyond the ordinary.

All this brings us back to a few principles, which we can hardly overemphasize. I am making a new resolve to adhere to them.

1. Make few, but deep impressions.

2. Enforce and repeat fundamental ideas (changing the form of the statement, using new illustrations, allusions, etc. and connecting up with other subjects, and recalling that the idea under discussion has been met with elsewhere, in college and in life).

3. Have fewer main topics in the course, treat fewer artists, use fewer works, but have these typical.

4. Have readings less in quantity, but more intensive.

5. Keep as one of the final aims and tests of success—

 a. The student's love of the subject and interest in it.

 b. The permanent results in the student's mind. (Reflect what the student's attitude will be probably towards your subject, for example, ten years from now.) The student's education is not completed in college but only begun. The successful teacher is known by the healthy state of the seed he leaves in the mind, of future development.

6. It is not at all necessary to cover the "whole subject," and anyway there is no such thing as a whole subject.

7. To get "true proportion" in a given subject is not as important as it is often thought to be, not at least in college. Its importance comes later in life. It is better that a student in college should get a living sense of the power and the beauty, for example, of *one play* of Shakespeare than to "cover" Elizabethan drama, keeping all ideas in "proportion."

8. Do not teach, in *general courses,* things that only specialists know or care about.

9. Finally, to get hold of truths is valuable, but to learn to think is more valuable.

Alfred Vance Churchill, 1921

The History of Ancient Mediterranean Art at Smith College

Caroline Houser, Dean of the Senior Class
Professor of Art

Ancient art was fundamental to the curriculum of Smith College from the time President L. Clark Seelye first planned the academic program here. The plaster casts of famous statues so often mentioned in this volume as being present at Smith from 1877 onward were largely taken from works of the ancient Mediterranean world (**4.1**, **21.2**). In addition to illustrating major masterpieces for studying the history of art, the casts served as models in studio courses with the expectation that the ancient compositions would inspire students to improve their own work.

Teaching the history of ancient art at Smith focused at first on Greek sculpture and architecture: all first-year School of Art students were required to take one course in Greek art. From 1881 to 1885 Richard H. Mather came from Amherst College to offer a course in the history of sculpture that emphasized masterpieces created in ancient Greece, and in 1886 Smith College hired Thomas Davidson as Lecturer on Greek Sculpture.

Modification of the art curriculum in 1897 relegated courses on the specific areas of the history of art to general courses "supplementary to the practical study of art." A broad survey, History of Painting and Sculpture, however, taught by Mary R. Williams until 1905, gave special attention to ancient art, highlighting Greek sculpture and now also including Egyptian, Assyrian, and Roman monuments.

An important commitment to teaching ancient art at the College

4.1 Students in the school of art working with casts of statues.

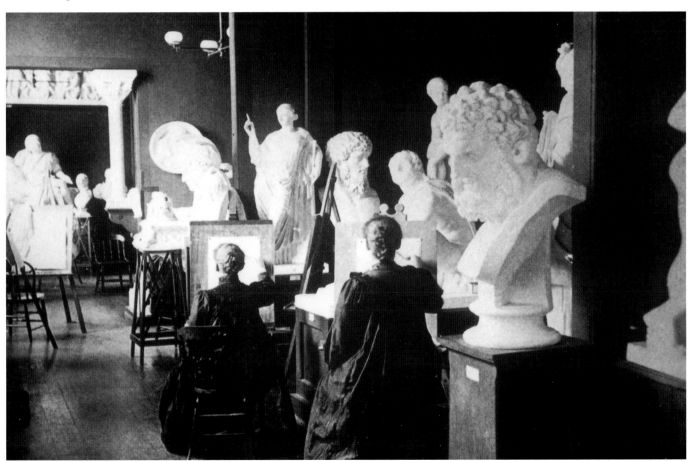

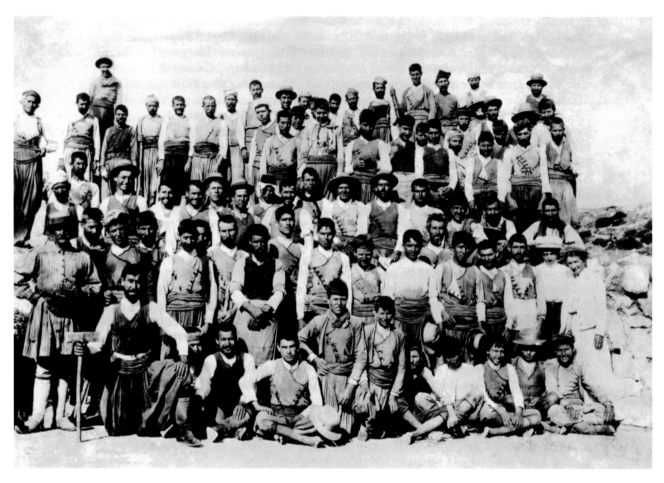

4.2 Harriet Boyd Hawes (class of 1892) with her excavation team in Crete.

was made in 1900, when Harriet Boyd (later Harriet Boyd Hawes, class of 1892; M.A. 1901; L.H.D. 1910) returned to teach at her alma mater after spending four years in Greece at the American School of Classical Studies in Athens, years interrupted by field work on Crete as well as by service as a volunteer nurse with the Greek army. At that time women were prohibited from participating in the excavation portion of the American School's program, so Boyd organized her own team to excavate Minoan sites in eastern Crete (**4.2**). As the first woman to organize, direct, and publish an excavation and as the first American to excavate on Crete, Boyd quickly earned international acclaim for her expertise in Bronze Age civilizations, and archaeologists continue to hold her pioneering work in high regard. While on the Smith faculty, Boyd first taught art and archaeology as well as epigraphy and modern Greek under the auspices of the Classics department. Later she established a new department of archaeology, where she was freer to concentrate her courses on the art and archaeology of Greece and

Rome. Boyd used the casts in the Hillyer Art Gallery, photographs, squeezes, and original antiquities whenever possible to illustrate her lectures, which covered virtually all aspects of visual form, from monumental architecture to gems. In 1906, she married and moved to Boston. For fourteen years, she gave up teaching and dedicated herself to her husband and two children. During this time, however, she not only worked for numerous political and social causes but continued to write about Crete. Eventually she went on to teach at Wellesley College, where one of her students was Phyllis Williams (later Mrs. Karl Lehmann), who would become an influential professor in classical art at Smith.

Meanwhile, the art department that replaced the former School of Art considered ancient art of paramount importance. Alfred Vance Churchill, professor of the history and theory of art and the first director of the Tryon Art Gallery (**21.1**), proclaimed Greek art to be "the essential prerequisite for any story of art." Certainly by 1907 ancient art occupied a large portion of The General History of Art (Art 13); this course was described as "masterpieces of architecture, sculpture and painting, considered as a record of the

thought and feeling of the race. The course begins with Egypt and follows the main stream of European civilization to the Italian decadence. The Greek and Renaissance periods receive the chief emphasis." Except for changing its number to Art 22 in 1916, this course remained virtually unchanged until 1939.

Both the history department and the Greek department (which merged with Latin into a Department of Classical Languages and Literatures in 1938) offered specific courses on ancient art during the first half of the 20th century. In the Greek department, Sidney N. Deane taught courses on Greek art for thirty-three years beginning in 1912; then, for two years (1945 to 1947) Emily Shields taught those courses. The history department picked up the archaeology courses instituted by Boyd; for twenty-nine years (1918 to 1947), William Dodge Gray taught Greek and Roman Archaeology, which continued to use the course descriptions written by Boyd. By 1924 both Deane and Gray gave lectures in the survey art history course (Art 22, later Art 11), and by 1926 both their names appear in the list of art department faculty with references to their own departments. Once (in 1930–31) F. Warren Wright

from the Latin department joined the art survey course to teach Roman art.

Perhaps the most revealing statement about the attitude toward teaching ancient art at Smith in those years comes from Clarence Kennedy, who wrote in *The Smith Alumnae Quarterly* (November 1933),

> Scholarship in the field of the art of the classical period—the architecture, sculpture, and minor arts of Greece and Rome—has the advantage of a longer tradition. In many colleges even where a department of art would have been considered a suspicious innovation, courses in Greek and Roman archaeology had a recognized place in the curriculum. At Smith, too, these courses were first given hospitality by the departments of Greek and History, and from them we still borrow our instructors….Greek sculpture, perhaps the most influential of all the arts in the development of European culture, has a course to itself, in which what remains to us of the masterpieces of a great age are analyzed with the help of photographs and casts.

4.3 Phyllis Williams Lehmann reviewing the day's excavation work on Samothrace.

In 1946, the art department made a major commitment to ancient Mediterranean art by hiring Phyllis Williams Lehmann to teach ancient and medieval art. The history department declared it was "willing" to withdraw History 22; the Classics department sent word it would "acquiesce" to withdraw Greek 37; and the primary responsibility for teaching ancient art was thereby transferred to the art department. In addition to a survey course on the art of Greece and Rome from its prehistoric background to the late antecedents of Christian art, Lehmann offered courses in Greek Sculpture, Greek and Roman Painting, The Ancient City (later Cities, Sanctuaries, and Royal Residences, taught with Cornelius Vermeule III), as well as courses in medieval art and a famous seminar combining study of the Antique and the Italian Renaissance, which she taught with Ruth Kennedy. In the summers she excavated in the Sanctuary of the Great Gods on Samothrace with her husband, Karl Lehmann (professor at the Institute of Fine Arts, New York University); the Lehmanns often took Smith students to work with them on the site (**4.3**).

Under Lehmann's leadership, the study of ancient and medieval art (which was soon made a separate area) flourished, and other distinguished scholars came to Smith to join her. In recognition of the importance of Roman art, Cornelius Vermeule III began commuting in 1961 on a part-time basis from the Museum of Fine Arts in Boston to teach in his areas of expertise, especially Roman sculpture and coins. The Roman position became full-time in 1965, when Lehmann served a term as dean of Smith College, and William L. MacDonald joined the art department faculty as a specialist in Roman architectural history. As one of the department's architectural historians, MacDonald also had occasion to introduce students to Renaissance and Baroque architecture.

As interest in art of the ancient world continued to expand, Judith Lerner came to Smith in 1972 to teach the art of the Ancient Near East and of Egypt. In addition, Lerner regularly offered a course that examined art and architecture in prehistoric Europe and the Near East, together with that of the North American Indians, Oceania, and societies south of the Sahara.

After Lerner left Smith in 1976 and Lehmann retired in 1978, the art department hired two historians whose primary interest was ancient Greece. Holly Lee Schanz came to Smith in the fall of 1978 and I came the following year. Schanz usually taught the art of the Aegean Bronze Age, the ancient Near East, and Egypt until her departure in 1985. I have offered courses on various aspects of Greek art, including Greek Sculpture, Cities and Sanctuaries, the Aegean Bronze Age (lately combining Aegean art with that of ancient Egypt), Art in the Age of Alexander the Great, as well as introductions to the history of Greek art. Most of my seminars study specific aspects of Greek art; Originals, Copies and Fakes, however, examines questions of connoisseurship, working with unidentified or undocumented objects in the Smith College Museum of Art.

Barbara Kellum came to Smith as our Romanist in 1981 after MacDonald left the College. She regularly offers courses in Roman and Etruscan art and the City of Pompeii; though her wide interests have also led her to teach courses in popular culture, women in antiquity, Film Studies, and art-historical methodology.

In addition to at least two scholars teaching in each of our general areas over the past four decades, a number of visiting scholars have enriched the art department's program for shorter spells: among others, Martha Leeb Hadzi (Greek), Iris Love (Greek), Guy P. R. Metraux (Roman), Diana Buitron-Oliver (Greek vase painting), Diana Wolfe Larkin (Egyptian), and Margaret Miles (Greek and Roman architecture). In art of the ancient Mediterranean—what is often called the classical world—we have historically concentrated on the arts of Greece and of Rome, the two areas that have had the greatest influence on the art of our own time.

Medieval Art at Smith College

Brigitte Buettner, Priscilla Paine Van der Poel Associate Professor of Art History

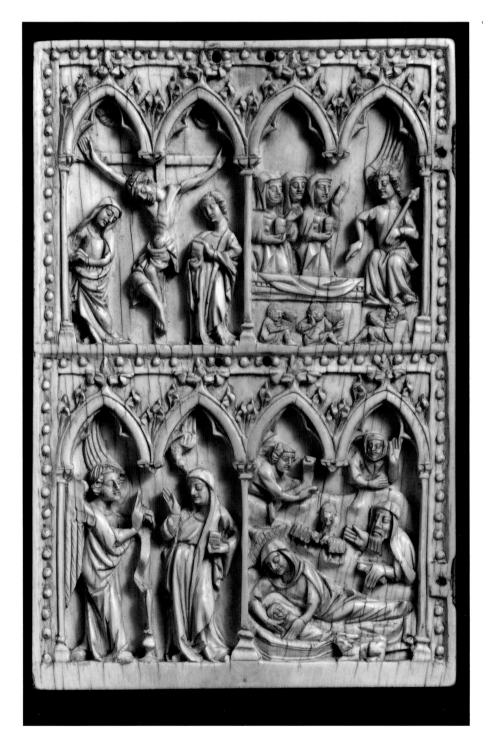

5.1 Flemish. *Four Scenes from the Life of Christ*, c. 1375. Ivory, 6 5/16 × 4 5/16 in. (15.9 × 10.9 cm). Smith College Museum of Art. Purchased, 1961. Photograph by David Stansbury.

While the teaching of medieval history has been an integral part of the curriculum since the earliest days of Smith College's existence, the first permanent position in medieval art was that of Robert Mark Harris, appointed only in 1958. Before that date, however, medieval art had received some consideration either as a component in larger survey courses or in independent courses taught either by other members of the department or by the occasional—but often prestigious—visiting professor.

From the time Alfred Vance Churchill (**21.1**) was appointed as the first incumbent of the newly created chair of the History and Interpretation of Art in 1905 (though an artist and critic first, he was to remain for many years the College's only art historian), medieval art had been a component of the yearlong introductory course (Art 22). Like other art historians of his generation, Churchill believed that Greek art was the essential prerequisite for any study of art. More surprisingly, he considered Renaissance art as a subject unsuitable to start with, on account of what he deemed to be its "derivative nature"; Gothic art, on the other hand, "must be thought of as absolutely essential to a sound foundation in the knowledge of our common inheritance," for in his view it still provided

Gothic art, wrote Alfred Vance Churchill, "must be thought of as absolutely essential to a sound foundation in the knowledge of our common inheritance," for in his view it still provided the spiritual nourishment for modern life.

the spiritual nourishment for modern life. Thus, in Churchill's detailed *Outline for a General Course in the History of Art* (1916), ample space was made for the arts from early Christian times up to those of the Gothic cathedrals. Quite remarkably, too, his syllabus encompassed not only monumental arts but also the so-called minor arts, all silhouetted against the backdrop of the larger medieval intellectual and historical landscape.

The Middle Ages were included in two other general surveys on the decorative arts, offered, quite predictably, by two women, Priscilla Paine Van der Poel (7.1) in the 1930s, preceded by Elizabeth M. Whitmore, who also taught the first independent course (from 1921 to 1924) on the arts "from the decline of ancient Rome through the fourteenth century." Whitmore supplemented her teaching at Smith proper with talks at her home "on more intimate phases of history and art," where one presumes a more mature audience was invited to "meet my lord and his lady and their household as shown in French chronicles and miniatures of the later Middle Ages" or confront the blending of "East and West and barbarian North, with the romance of a Princess [Galla Placidia] in whose life all three had their share" [quoted from a brochure in the Sophia Smith Archives folder].

Smith students nevertheless had very little exposure to medieval art on a more advanced level, with

the exception of late medieval art, regularly taught from 1926 on by the department's specialist in 17th-century Dutch art, Alphons P. A. Vorenkamp. His renowned colleague in Baroque art, Rensselaer Lee (at Smith between 1941 and 1948), likewise taught portions of the medieval survey, as did José López-Rey, between 1942 and 1947. After "Rens" left Smith to join the art department at his alma mater, Princeton University, medieval art went into a curricular limbo, in which it was covered only sporadically, albeit by eminent visiting faculty: during the academic year 1944–45, Princeton professor Charles Rufus Morey (author, among many other publications, of the first authoritative survey books in his field in English, *Early Christian Art* and *Medieval Art,* both published in 1942, as well as one of the founders of the College Art Association and its publication *The Art Bulletin*); in 1949–50, Harry Bober (a specialist in late medieval illuminated manuscripts); and, eventually, the distinguished German refugee Adolph Katzenellenbogen (*Allegories of the Virtues and Vices in Mediaeval Art,* 1939, and *The Sculptural Programs of Chartres Cathedral,* 1959), then professor of medieval art at Vassar College, who commuted to Northampton to give one evening seminar in the fall of 1956 and of 1957. Meanwhile, members of the Smith art department continued the tradition of stretching outside the boundaries of their own field of specialization—the classicist Phyllis Williams Lehmann (4.3), in particular, picked up the medieval surveys at various junctures.

The 1958 appointment of Robert Harris initiated a stable period of continuous coverage of medieval art at Smith College. An uncommonly cultivated person, equally versed in music, literature and the arts (he studied Romanesque manuscripts and was an accomplished painter, too), Harris typically taught two semester-long surveys plus an advanced seminar. These offerings were frequently expanded with courses by colleagues or visiting faculty (such as William MacDonald, Sheila Edmunds, Amy Lou Vandersall, and Dorothy Gillerman), so that at times there were up to three faculty members teaching in the medieval period. In 1987, Arnold W. Klukas was appointed as a replacement for Harris (who had died in 1986). Klukas left in 1989 to study for the ministry, and was succeeded by Brigitte Buettner, another specialist in illuminated manuscripts.

Art History: Renaissance and Baroque

Craig Felton, Professor of Art

True to the wishes of Sophia Smith, the trustees of Smith College stated in their prospectus of 1872, "…more time will be devoted than in other colleges to aesthetical study, to the principles on which the fine arts are founded…." As a result, the teaching of the history of art began in 1880 with a course on the history of sculpture taught by Richard H. Mather of Amherst College; in 1881 he was joined by John H. Niemeyer from the Yale Art School, who taught a course on Italian art and also one on the art of Germany, Holland, and France.

The following information concerning early course offerings and descriptions comes from the Smith College circulars and catalogues. The history of art in the following decade was guided by several remarkable women; each began to teach in the indicated year: 1885, Louise Both-Hendricksen; 1887, Mary Louise Bates; and 1894, Mary R. Williams, who introduced a course in the history of painting and sculpture. In 1900, Herbert E. Everett added the history of decorative arts to the curriculum and in 1902 a course in the history of painting; Williams continued her course in the history of sculpture. All of these courses had segments covering the arts of the European Renaissance period. In 1905, Williams's course on sculpture included works from Italy and France as well as ancient Assyria, Greece and Rome; while Alexander T. Van Laer taught an art history course that was "a study of the growth and development of painting, including the Italian, Spanish, Flemish, Dutch, French, English, and Modern Schools."

The year 1905 also saw the appointment of Alfred Vance Churchill (21.1), who began teaching the following year; in 1920 he would become the director of the Hillyer Art Gallery. In the academic year 1906–07, Churchill inaugurated what was to become Smith's most famous course, which was to go through various transformations in content as well as numbering until its cancellation in 1999: Art 11 (History of Art: "masterpieces of architecture, sculpture and painting from earliest times to the present day." The following year, this offering was reconstituted as a two-part course: Art 10 and Art 11 (Art Interpretation). To these were added Art 13 (General History of Art; "the Greek and Renaissance periods

receive the chief emphasis") and Art 14 (History of Painting), all of which included material from the European Renaissance and Baroque period. These courses were offered in various configurations by Churchill through the 1915–16 academic year. In 1916, Clarence Kennedy joined the art faculty, adding to the curriculum Art 31 (History of Italian Painting) and Art 37 (History of Architecture); Churchill continued offering Art 11 (General History of Art, "from Egypt and Greece to the Italian decadence"). Presumably "decadence" refers to the Baroque, at that time a pejorative term that would be held as such in many art-historical circles throughout the coming "Berensonian era," so-called for the famous

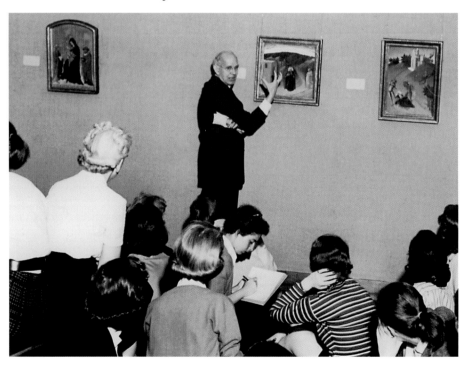

6.1 Clarence Kennedy, 1950s/60s, lectures on Italian paintings, Yale University. Smith College Archives.

art historian and connoisseur Bernard Berenson, who viewed the Baroque period as a denial of the stylistic achievements of the Renaissance.

Ruth Wedgwood Doggett, who married Clarence Kennedy in London in 1921, was appointed to the faculty of Smith College in 1919. Although her education was in economics—she held degrees in that field from Radcliffe College and Oxford University—she was appointed lecturer in art in 1933 and began team-teaching Art 21 (Italian Painting) with Clarence Kennedy in 1942 (6.1, 2; 17.1). The Kennedys had resided chiefly in Florence, Italy, from 1925 until 1933, during which years they took Smith students abroad for study in art, something they would continue to do, periodically, after World War II, until 1965. In a manuscript hand-written in Torcello and Venice and dated August-September 1962, Ruth Wedgwood Kennedy wrote, "…Italy will always be our second home and will always have half our hearts."

During the 1930s, Clarence Kennedy was working on his stereophotography project with Edwin H. Land of the Land Wheelwright Laboratories in Boston. Kennedy's hopes to revolutionize photographic images, and the study of art, by the use of three-dimensional projection, was destined not to be practical for classroom instruction. He would become one of the most renowned photographers of European sculpture, both of antiquity and the Renaissance and Baroque periods. His photographs were used to illustrate *The Chapel of the Cardinal of Portugal 1434–1459 at San Miniato in Florence*, published in 1946, with text by Frederick Hartt (who was a visiting lecturer at Smith College and acting director of the museum in 1946–47) and the Italian art historian Gino Corti. Clarence and Ruth Wedgwood Kennedy became synonymous with Renaissance and Baroque art history at Smith until their retirements in 1960 and 1961, respectively. An anonymous gift estab-

lished an endowment in their name in Renaissance Studies, which since 1974 has brought distinguished scholars to the Smith campus.*

In 1922, Churchill was joined by Lucy Lord Barrangon in the teaching of Art 11. Also in 1922, Art 22 (History of European Art) became, for the first time, a yearlong course team-taught by Churchill, William Dodge Gray (Professor of History), Sidney Norton Deane (Professor of Greek), Meyric R. Rogers (Professor of Art), Kennedy, and Barrangon, who soon became the general director of the course for many years, as well as offering her separate courses in Renaissance and Baroque.

Alphons P. A. Vorenkamp was appointed to the faculty in 1926, teaching in the areas of late medieval art and Northern art in the Renaissance and Baroque periods; this arrangement freed Kennedy to offer, for the first time, Art 26 (Art of the Italian Renaissance). Vorenkamp brought the subject of art north of the Alps to the syllabus of Art 22; in the following years he would offer various courses in Northern European art—Flemish, Dutch, and German—of both the early Renaissance and the later Baroque periods, while Kennedy would begin to develop further his soon-to-be-famous course on Italian sculpture, Art 39.

In 1930 Delphine Fitz Darby joined the team-teaching of Art 22 and picked up courses previously offered by Kennedy, who was in Europe. She added Art 26 ("Italian Painting from Cimabue to Leonardo da Vinci") and Art 32 ("Italian Painting from Leonardo to Tiepolo, and Spanish Painting of the Same Period"). Kennedy returned to the faculty in 1932, teaching courses

in Italian Renaissance sculpture and painting; in 1938, his courses were taught by Katrina Van Hook, who the following year took over some of the courses in Northern art, freeing Vorenkamp to teach advanced specialty courses.

In 1941, Rensselaer Wright Lee joined the Smith faculty, teaching courses on French and Spanish painting of the 17th and 18th centuries, Italian Baroque painting, and in 1946 assuming the directorship of Art 22.

Both Vorenkamp and Lee were involved in matters of great cultural significance during World War II and shortly thereafter. In May 1945, Vorenkamp was asked by the Dutch government to become "the chief Netherlandish officer in charge of the restitution of Dutch works of art." He spent thirteen months in Europe directing these efforts, for which he was decorated as a Knight of the Netherlandish Lion by HRH Prince Bernhard, on behalf of his mother-in-law Queen Wilhelmina of the Netherlands. In gratitude for Vorenkamp's work and that of others in the United States, the Dutch government sent fifty recovered paintings on exhibition to American museums; they were shown at the Smith College Museum of Art in 1947. In 1948, Vorenkamp became the director of the Boymans Museum in Rotterdam, a position he held until his death in 1953. In 1944, Lee was the executive secretary of the American Council of Learned Societies on the Protection of Cultural Treasures in War Areas. The following May he became a consultant to the American commission established for this same purpose as well as to make maps of "historic buildings of cultural importance." He left Smith in 1948 and concluded his distinguished career as Emeritus Professor at Princeton University.

José López-Rey came to Smith in 1942 (departing in 1947), where he offered courses in medieval art and the art of England, France and Italy; in the following year, he and Lee offered courses covering European art of the 17th and 18th centuries. In the 1946–47 academic year, López-Rey, unusual for that time, added a course on the art of Latin America.

In 1944, the internationally acclaimed scholar Edgar Wind was named William Allan Neilson Research Professor, a position he held until 1948, when he became Professor of Philosophy and Art. He left in 1955 to accept an appointment as the first chair in the history of art at Trinity College, Oxford University. During his Smith years, Wind lectured widely on diverse subjects in art, philosophy and classical studies. His research led to such significant publications as *Bellini's Feast of the gods, a study in Venetian humanism* (1948) and *Pagan Mysteries in the Renaissance* (1958).

After World War II, the art history curriculum in Renaissance studies was greatly expanded by the inclusion of seminars on such topics as "The Medici as Patrons" and on individual Italian artists—Donatello, Botticelli, Michelangelo, Raphael, Leonardo da Vinci, Verrocchio, Titian, and others—taught by Clarence and Ruth Wedgwood Kennedy; and on Dürer, Grünewald and Holbein, as well as English art of the 18th century, taught by Edgar Wind. In 1949–50, Wind offered a seminar on "Iconography of the Renaissance and Reformation Periods." Also that year, Harry Bober directed a course on advanced studies in Northern art, and Martha Leeb taught two courses that would have a long-term effect on the curriculum: "The Art of the Seventeenth and Eighteenth Centuries: Rome as a Cultural Center" and "Paris as a Cultural Center"; these were the forerunners to the Great Cities series continued and greatly expanded by Helen Searing and later by John Moore. Also in the heady course offerings of the 1949–50 academic year, Clarence Kennedy teamed with Phyllis Williams Lehmann (4.3) in a course entitled "The Antique and the Italian Renaissance" and in another with Ruth Wedgwood Kennedy, an instantly popular course: "Art of the Italian Renaissance."

In 1954, Art 11 changed from "An Historical Introduction to Art" to "Introduction to the History of Art"; the Smith introductory course was by then one of the most famous art history courses in the United States. It was taught by members of the art department and was directed by William Coe, a specialist in Northern art who had joined the faculty the previous year. This course continued to have a major segment devoted to the architecture, sculpture and painting of the European Renaissance and Baroque periods, both north and south of the Alps. In 1954–55 Thomas McCormick taught Art 311 ("Italian Art of the Seventeenth and Eighteenth Centuries"); in 1955–56, Jay Richard Judson became a member of the faculty, where he remained until 1974: he would develop the Northern art courses, bringing to the curriculum his great knowledge and passion for the Dutch followers of Caravaggio.

During the 1950s and 1960s, a number of scholars joined the art history faculty for varying periods of time. Included among them were Robert Owen Parks (23.4), also director of the Smith College Museum of Art from 1955 until 1961 ("Seventeenth-Century Art in Italy, France and Spain"); Henry-Russell Hitchcock (3.2, 9.1, 23.1) ("Baroque and Rococo Architecture"); William MacDonald, following Hitchcock's retirement in 1969 ("Baroque Architecture"); Iris Hofmeister Cheney ("Italian Art of the Sixteenth Century"); and Konrad Oberhuber ("Northern Painting and Graphic Arts of the Sixteenth Century" and "Art of the Seventeenth Century in Italy, France and Spain").

James Holderbaum, a scholar dedicated to the art of the Renaissance and Baroque periods, arrived at Smith in 1960. His enthusiasm for the material and his love of teaching led to the development of a wide variety of courses in Renaissance studies as well as the largest segment in the by-then legendary course Art 11 (eventually to become Art 100). The thousands of students and faculty who heard them will never forget Holderbaum's lectures on Duccio, Giotto, Donatello, Michelangelo, and Bernini, among others. A major event in the history of the Department of Art was instigated by Holderbaum; he joined the global efforts to rescue art treasures after the disastrous November 1966 flood in Florence. (Former Smith faculty members Lee and Hartt were also leaders in the flood efforts.) Members of the art faculty and others donated works of art for an auction, the proceeds of which were used for Florence relief efforts (6.3). Holderbaum devoted his professional life to research on sculpture and to his teaching; in 1993 (seven years following his retirement from Smith) he was given the Distinguished Teaching in Art History Award by the College Art Association.

Charles Talbot and John Pinto joined the faculty in 1976. Talbot, who remained at Smith until 1986, devel-

oped the courses on art north of the Alps; Pinto, who remained until 1988, taught a variety of courses on the history of city planning, landscape studies, Renaissance and Baroque architecture (on occasion the Baroque course was also taught by Lisa Reitzes), and art in the 17th century in Italy, France, and Spain. Beginning in 1984, when I came to Smith, and continuing to the present time, I have offered courses in the art of the Renaissance and Baroque periods, with some concentration on the Spanish Habsburgs as well as 17th-century Italian, Spanish, and French painting in general. I also continue in the tradition of the Kennedys and Holderbaum in developing courses on various topics of the Italian Renaissance, focusing primarily on Florence, Venice, and Rome of the High Renaissance.

With Charles Talbot's departure from Smith, the position in Northern art was dropped; since 1986, occasional courses in that area of study have been offered by Patricia Emison, Marta

Renger, and various of the Kennedy Professors in Renaissance Studies. John Moore began his teaching at Smith in 1989; he offers courses in Renaissance and Baroque architecture, Eighteenth-Century Studies across Europe, and various topics in the Great Cities series.

* Kennedy Professors in art have included Charles Mitchell (Bryn Mawr College), 1974–75; John Coolidge (Harvard University), 1982–83; Henk W. van Os (University of Gröningen), 1987–88; George Kubler (Yale University), 1989–90; Susan Donahue Kuretsky (Vassar College), 1991–92; Diane De Grazia (The National Gallery of Art, Washington, D.C.), 1993–94; Larry Silver (Northwestern University), 1994–95; Andrée Hayum (Fordham University), 1994–95; Annamaria Petroli Tofani (Galleria degli Uffizi), 1997–98; Keith Christiansen (The Metropolitan Museum of Art), 1999–2000; Phyllis Pray Bober (Bryn Mawr College), 2000–01.

6.3 James Holderbaum and students with art works donated by members of the Smith College community to be sold at auction to benefit relief efforts following the November 1966 flooding in Florence, Italy. February 1967. Smith College Archives.

7.1 Priscilla Paine Van der Poel (class of 1928) advising a first-year student. Smith College Archives.

7.2 Jaroslaw Leshko and Richard V. West, Director of the Santa Barbara Museum of Art, standing in the Fine Arts Center courtyard beneath a banner announcing the exhibition *Orbis Pictus: The Prints of Oskar Kokoschka*. The exhibition was organized by the Santa Barbara Museum of Art and was seen at the Nelson-Atkins Museum of Art in Kansas City and later at SCMA February 5–March 20, 1988. Professor Leshko was the curator of the exhibition and author of the catalogue.

7.3 View into the exhibition *Orbis Pictus: The Prints of Oskar Kokoschka*.

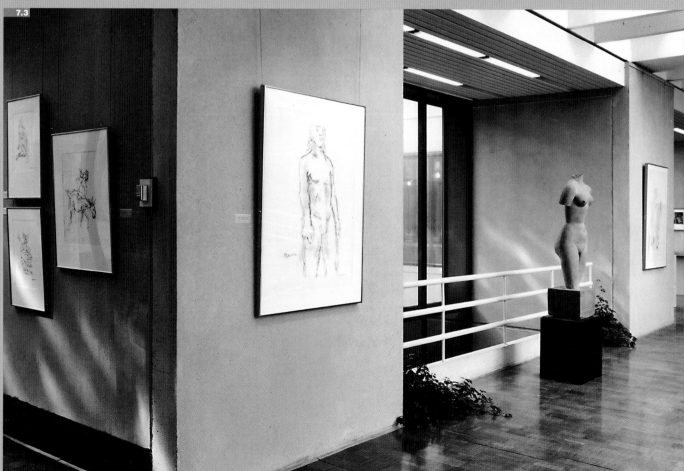

Modern Art at Smith College

Jaroslaw Leshko. Professor of Art

Alfred Vance Churchill (**21.1**) taught the first modern art course at Smith in 1916. The catalog description reads, "The development of painting and sculpture as regards subject, aesthetic content and technique from the 17th century to the present." Admittedly, any definition of modern art that encompasses the Counter-Reformation is rather expansive. Yet the very fact that it was deemed vital to the young program to explore the creative enterprise up "to the present time" is a testament to the farsightedness of the art experiment at Smith.

To put this history into perspective: it was only three years earlier, in 1913, that America had been awakened to the existence of modern art by the notorious Armory Show in New York. That exhibition of European avant-gardists perplexed, provoked and, in rare cases, delighted audiences. Not until 1929 did the Museum of Modern Art in New York open its doors.

It is not possible to talk about modern art in the Smith curriculum without recognizing its close link to the emergence of the Smith College Museum of Art. Churchill became its director in 1919–20, and made the far-reaching decision to focus its collecting on contemporary European and American art. To have one person building the collection and teaching modern art was an enriching experience for both. When in 1932 Jere Abbott (**22.1**) came to the Smith College Museum of Art from MoMA as Churchill's successor, both the museum and the teaching of modern art were significantly enhanced. It speaks volumes about the high regard in which the art world of the day held the SCMA and the art program as a whole that an individual of Abbott's abilities made the choice to come to Smith. His close contact with the art world and his unerring eye brought many key works into the museum's collections. His involvement in the modern art course during the late 1930s and mid-1940s meant that modern art was brought quite literally to the students of Smith College. Abbott's and Churchill's legacies continue to the present day.

During the 1930s and early 1940s, Lucy Lord Barrangon taught the modern art courses most consistently. By 1947 Priscilla Van der Poel (**7.1**) took over the field. She represents another important example of the interconnectedness of the department. She began in the studio wing where she taught courses on applied design, among others. During her tenure, in 1965, courses on the 19th and 20th century were uncoupled. Among other areas of interest she incorporated into the curriculum the modern art of Mexico and the history of decorative styles. From 1971 until the present I have taught courses in 19th- and 20th-century art.

Modern art, which focuses mainly but not exclusively on European painting and sculpture, is part of a large archipelago of courses at Smith that deal with the rich visual history of the last 200 years. There is, for example, an important intersection of interests with American art, especially in art since 1945, when the center of the modern experiment shifted to this country.

Another key link is with modern architecture. The cross-fertilization of ideas among these fields was vividly displayed in Art 100, the legendary survey course at Smith. For example, Helen Searing (**9.3**), who taught architecture, and I would coordinate our lectures so that the vital contact between modern painting and architecture was clearly established.

The modern field is unique in its chronological open-endedness. In my tenure at Smith I have seen Andy Warhol transformed in stature from cutting edge avant-gardist to old master. Building on the experiments of early modernists, new generations of artists have profoundly transformed the field. The vitality of these innovations has made the art of the last decades of the 20th century and the emerging 21st a discrete field, contemporary art. The word modern, which was formerly used interchangeably with contemporary, has begun to acquire a historical finiteness.

As the 21st century unfolds, it is clear that the 20th century produced the most exciting revolution in the visual arts since the Renaissance. The Smith student was exposed to these exhilarating and provocative innovations through myriad courses and a rich art collection earlier and more comprehensively than most of her peers in other colleges. The art program at Smith came into being in large measure to better understand the modern world.

American Art History: The Legacy of Oliver Larkin

John Davis, Alice Pratt Brown Professor of Art

American art has been a part of the Smith story almost from the day the College opened its doors in 1875. As Michael Goodison recounts in his essay, President L. Clark Seelye made it his mission to acquire fresh examples of American painting by going directly to the artists of his day. Some of them, such as Thomas Eakins, were young and unproven at the time; the purchase check from Smith must have represented an enormous vote of confidence for these rising professionals. Indeed, the degree to which the institutional patronage of Smith College was far ahead of any similar organization in the field of American art in those early decades is still not widely appreciated, even among scholars.

However, the discipline of art history, though it came into existence during those same years, would wait much longer to recognize the art of the United States as a subject worthy of study. In this it was pushed, prodded, and led forward by the intellectual labors of Oliver W. Larkin (**8.1**, **28.14**), who pioneered the teaching of American art history not only at Smith, but in colleges and universities throughout the United States. His influence was effectively carried far beyond the classroom through the publication of his magisterial book, *Art and Life in America*, which won the Pulitzer Prize in history in 1950, the first (and only) art history book ever accorded that honor.

The ignorance and indifference to the visual culture of the United States that prevailed in our institutions of higher learning when Larkin was plan-

ning that book is scarcely imaginable today, so swift have been the advances in the field over the last generation. This may come as a surprise to many who read this volume or have spent time at Smith, as students, professors, or members of our extended community. The College's superb collection of American art and its six-decade tradition of offering instruction in the arts of the United States make American art history seem like a natural component of any liberal arts curriculum, but this was certainly not the accepted view before Larkin began his quest to encourage serious study of the subject.

Larkin, born in Medford, Massachusetts, in 1896, arrived in Northampton as an assistant professor of studio art in 1924. Initially his courses were focused in the area of design—in his first year, for example, he offered classes in The Problem of Form and The Problem of Color. He was promoted rapidly at Smith, and as his responsibilities grew, so did his teaching interests. In 1929, he taught his first art history course, with the long title "The Development of Furniture, Textiles, Ceramics, and other minor arts from 1450 to the present day, with special attention to the adaptation of decorative forms to the civilization of their period." Already at this early date two themes emerge in that course description: a commitment to treating the art of the 20th century (at least the first quarter of it that had happened by that point!) and a grounding of the study of visual culture in the larger forces of civilization.

Just two years later Larkin became a full professor and chairman of the art department, a position he held three times, for a daunting total of fourteen

years. By far the most significant development in this story took place later that decade in 1939, when Smith inaugurated a new interdisciplinary major in American Culture. The major in American Culture sought to provide a constellation of courses in a variety of departments that would enable students of American civilization to look at society as a whole—"to present a more integrated picture of American culture," to quote from the course catalogue. The program provided a novel curricular outlet, and when it was first announced, it promised a groundbreaking offering in art history, to be given for the first time in the fall of 1940: Larkin's lecture course, Arts in America. The description of this course reads almost like a synopsis of his later book: "Painting, architecture, sculpture and minor arts as an expression of American thought and taste from the colonial period to the present."

The art department soon embraced this addition, and it became a regular offering for art majors—often team-taught with Larkin's colleague, Priscilla Van der Poel. In 1944, he enlarged the course to a two-semester offering, breaking at the Civil War, exactly as the American survey is taught today at Smith. And in 1949, the year of the publication of *Art and Life in America*, Larkin offered a seminar in American art for the first time. The topics of his regular seminars—"American Painting in the Age of Jackson" or "The Hudson River School"—were almost certainly the first such focused, upper-level American offerings in any college or university in the nation. Larkin gradually began to teach more and more art history, and the transformation of his

8.1 Oliver Larkin displays an engraving after George Caleb Bingham's *County Election*. Smith College Archives.

"professorial identity" became complete in 1951, when he taught his last studio course. Thereafter, he would only offer instruction on the history side of the department, although he continued to produce his witty watercolors, his locally celebrated marionettes and stage sets and his hilarious graphic parodies of famous works of art.

The mood of Larkin's joyous art spilled over into the classroom. The several generations of Smith students lucky enough to have studied with him remember his dry wit, and as Barbara Lewis (class of 1948) put it, his "wonderful little wry smile." He was affectionately known as "Larkie," "Ollie," or simply "Owl," a reference to his wisdom and to his large glasses, as well as a play on his initials. Larkin was an engaging lecturer who fostered a climate of intellectual earnestness in his classes. Time after time, his former students commented on the way in which he made these young women feel like serious, thinking adults, regardless of

their gender. Kitsy Chalmers (class of 1934) remembered him as the professor who most instilled in her the sense of self-confidence that she carried with her for over sixty years. "He treated me as an individual, not a girl," she said. The one other commonality in the experiences of Larkin's students is their reverence for *Art and Life in America*. Many still treasure their copy and return to it again and again.

The sheer scope of *Art and Life in America* is as staggering as the ambition so simply expressed in its title. The book is not a quick read, and no survey since its publication has even approached the comprehensiveness of its treatment. Larkin essentially molded a vast shape for the field that had not existed previously. He sifted through unimaginable amounts of primary materials, working directly from original sources, and created a sweeping narrative that holds up remarkably well decades later. His frequent use of letters, sermons, literary excerpts, and news-

paper reviews—many still little-known and fresh in the insights they offer today—moved his story out of the studio and into the streets, the churches and the parlors of the early United States. His pithy prose and incisive eye would seize on the telling formal element and read it in a way that moved beyond iconography to capture the social and political nuance invested in even the slightest detail of the material world.

How did Larkin become an expert in a field that had not yet entered the Academy? In the Hillyer Art Library, he left an almost archaeological trail of his self-education on the check-out cards still tucked into their snug pockets in some of the oldest books on American art. No matter how obscure the volume—it might be Neal's *Observations on American Art* or French's *Art and Artists in Connecticut*—one usually finds Larkin's name on its card, sometimes six or seven times, evidence of his repeated dipping in and checking of sources—and following his are often several signatures of David Huntington, the gifted Frederic Church scholar, who arrived at Smith in 1955 and gradually took on the duties of teaching American art (**8.2**).

Larkin's scholarship was resolute in its attention to the social context and in its engagement with politics; Huntington's work was no less contextual, but its emphasis was more cultural than social. In particular, he was an early champion of connecting the religious history of the United States with its art, a fitting role for the son and grandson of Congregationalist ministers. When Huntington wrote and lectured about the landscape paintings of Church and Thomas Cole, his words took on both

8.2 David C. Huntington. Photograph by Frederiks-LaRock. Smith College Archives.

the rhetorical passion and the layered intellectual denseness of the best 19th-century sermons; his work often seemed to mirror the title of a 1972 exhibition he organized at the University of Michigan Museum of Art, *Art and the Excited Spirit*. During the eleven years that Huntington taught at Smith, he concentrated his courses in the fields of English and American art of the 18th and 19th centuries. His seminars were usually devoted to American landscape painting, and it was his work on Church, then a surprisingly neglected artist, that constituted his greatest achievement. In his last years at Smith, before moving on to the University of Michigan, Huntington spearheaded the successful campaign to preserve Olana, Church's magnificent home in Hudson, New York.

For the next twenty-five years, there were a number of talented Americanists who continued the path-breaking work of Larkin and Huntington. Following the latter's departure in 1966, Jules Prown and Theodore Stebbins, two eminent historians who went on to extremely distinguished careers at Yale University and the Museum of

Fine Arts, Boston, respectively, each taught for a year at Smith. Later, another future museum curator, Martha Hoppin, also filled in for a year, in 1983. Longer terms of service were provided by a trio of energetic young scholars: Donald Keyes (1975–82), Lisa Reitzes (1983–88) and Mel McCombie (1988–92). While at Smith, Keyes organized an exhibition on the art of the White Mountains. Reitzes provided curricular strength in two distinct areas, American architecture and 19th-century women sculptors; and McCombie boldly pushed the offerings of the art department into the contemporary realm, with regular courses in American art since 1965.

It is safe to say that this record of three generations of pedagogy in the young field of American art history is an intellectual feat unequaled by any other college or university, and I was extremely conscious of this humbling legacy when I arrived at Smith in 1992. In my own specialized teaching, I have tried to continue some of the strengths of my predecessors (landscape painting, 19th-century women artists, coursework in American studies) while also developing some new areas (architecture and urbanism in New York City, African-American imagery). What is clear is that no matter how the curriculum has shifted over the years, its greatest product has been the steady stream of graduates going on to distinguish themselves in the field of American art as curators, teachers and collectors. This astonishing network of Smith-trained professionals ensures that the impact of the initiative Larkin began in 1940 will continue to make itself felt for some time to come.

Architectural History at Smith College: The Building as a Work of Art

Karen Koehler, Lecturer in Art

Smith has a unique and historic role in the teaching of architectural history, theory and practice to women. Indeed, one could argue that the appreciation of architecture has been built into Smith's curriculum from the very beginning. Sophia Smith, in her last will and testament of 1870, called for the teaching of the "Useful and the Fine Arts." In 1874, President L. Clark Seelye lectured on "The Need for a Collegiate Education for Woman"; he wanted to alleviate fears that educating women would remove them from the domestic sphere and put them exclusively into the professions. According to Seelye, for Smith graduates—schooled in language, history, art, and philosophy—"Home in all respects will become more attractive. A refined taste will make its presence felt in the selection and arrangement of the furniture; in the pictures on the walls; in the patterns of the carpets; in the folds and colors of the curtains. There is nothing pertaining to household arts which may not be perfected and beautified by the richer life imparted to its mistress."

This quaint emphasis on the "Useful Arts" and "Home in all respects" may have contributed to the desire to teach architectural history. In 1877, the College circular includes "Lectures on Architecture," amended in 1879 to include "Household Decoration." Throughout the 1880s, special studies for seniors included "architectural styles," while in the 1890s architectural history was subsumed into a general course on the history of art. Drawing courses included the examination of the history of different types of architectural ornament.

From these early offerings, the teaching of architectural history broadened at Smith in the first two decades of the 20th century. In 1904–05 Herbert Everett introduced a full-fledged course on the history of architecture; Alfred Churchill's instruction in art appreciation and the history of art included architectural topics; and a course in the Department of Economics and Sociology was called The Growth of Cities. In 1916–17 Clarence Kennedy's History of Architecture covered "early times to the present day" with "attention to the principles and practice of modern architecture...." In 1919, "The Development of House Furniture from Greece and Rome to the Early Nineteenth Century" was taught by Elizabeth Whitmore, and in 1927 Catherine Koch began to teach a History of Landscape Architecture. In 1925, Meyric Rogers, an architect who was at that time chair of the art department, introduced The Principles of Architecture, a course that combined studio practice with historical analysis, and that continued to form the core course in architectural history for decades to come.

In the 1930s the curriculum went even further. Advanced courses in architectural history and urban planning were complemented by new surveys of historical periods and geographic areas, which included architecture (e.g., medieval art, the Renaissance and Baroque in Italy, American art, etc.). Modern art and architecture, however, were now taught in two separate courses. Beginning in 1939–40, Karl Putnam offered Modern Architecture, which was a study of the "materials, functions and methods of design in the fields of building, the theater, transportation, lighting, and the industrial arts in general, with reference to the economic, social, and cultural conditions since the industrial revolution." A course in Decorative Styles, which focused on what was then called "interior architecture," was taught by Priscilla Paine Van der Poel (B.A. 1928, M.A. 1937) from 1935 until her retirement in 1972.

The emphasis on architectural history—particularly modern architectural history—as a separate field of inquiry was more fully developed under the direction of Henry-Russell Hitchcock (9.1, 3.2, 23.1), widely regarded as the most important American historian of modern architecture. His presence at Smith from 1948 to 1968 testified to the significance the College placed on architectural history, and corresponded to a period in which a paradigmatic shift took place in the teaching, study and practice of architecture. Hitchcock is best known for *The International Style: Architecture Since 1922,* a groundbreaking exhibition he organized in 1932 at the Museum of Modern Art in New York with Alfred Barr and Philip Johnson. Both Barr and Johnson acknowledged their debt to Hitchcock's first book, *Modern Architecture: Romanticism and Reintegration* (New York, 1929) and to his astute reception of modern buildings. It was, in fact, in his role as a connoisseur of buildings that Hitchcock had the most lasting influence on architectural history in the United States. Presented in the classroom in his infamous booming voice, his visually discerning lectures impacted many generations of students at Smith in a myriad of courses that now

included both 19th- and 20th-century architecture, as well as American colonial architecture and other specialized topics.

Hitchcock arrived at the College in a dual capacity, as both museum director and professor. His graduate and undergraduate training at Harvard had refined his interest in the formal poetry of structures and objects, and his insistence on the first-hand experience of real buildings was curiously balanced by his curatorial interest in the representation of them in drawings, models, and photographs. His numerous publications and exhibitions—on topics as diverse as English Victorian architecture, the Crystal Palace, H. H. Richardson, the architecture of the German Renaissance, and American vernacular buildings—were all touched by his sensitive perception of volume and space (**9.2**). Hitchcock's influence on the practice of contemporary architecture was also profound. He insisted in a 1961 article in the *Hampshire Gazette*, "I'm not purely and simply an art historian"—he was also didactically interested in the critical evaluation of the architecture of the present.

9.3 Helen Searing in front of College Hall, November 1978. Smith College Archives.

9.4 Cover of catalogue for the exhibition *Speaking a New Classicism: American Architecture Now* organized by Helen Searing, guest curator, and held at SCMA April 30–July 12, 1981. Photograph by M. Richard Fish.

In contrast, Helen Searing emphasized in an interview with the *Hampshire Gazette* in 1982, "I am not a critic, I am an historian." Searing, who taught modern architecture at Smith from 1967 until 2000, has also had a lasting influence on the scholarship and methodology of architectural history, through her many lectures, publications, and exhibitions (**9.3**). Like Hitchcock, her combined interests in European and American architecture, in modern and contemporary building, and in writing and curating, illustrate the diversity of her concerns. "I teach students how to decode a building," Searing stated, "to read it as a social history of a given time and place. I try to make mute things speak." Searing has been responsible for many prestigious exhibitions: *New American Art Museums* (Whitney Museum of American Art, New York, 1982) focused on museum typology; *Speaking a New Classicism: American Architecture Now* (Smith College Museum of Art, 1981) (**9.4**) presciently isolated the contemporary return to historicism; and, most recently, the exhibition *Equal Partners: Men and Women Principals in Contemporary Architectural Practice* (also at Smith, 1998) identified the increased importance of women in architectural firms—as exemplified, by the way, by the partnership of James Polshek and Susan Rodriguez in the Brown Fine Arts Center. These projects indicate Searing's command of current practice, an expertise that she brought into the classroom in her many surveys, colloquia and seminars.

Smith College has long been at the forefront of architectural education for women, from the preparation of their

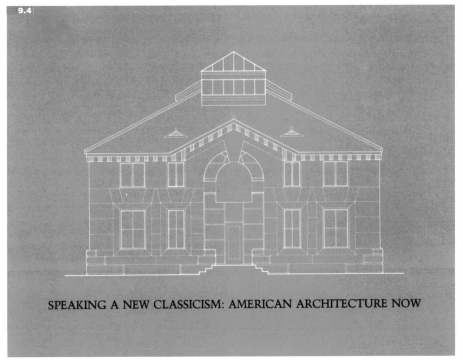

SPEAKING A NEW CLASSICISM: AMERICAN ARCHITECTURE NOW

"refined taste" in the 1870s to the many positions of prominence that alumnae have achieved in the fields of architectural history, theory and practice in the 21st century. As a lecturer in modern art and architectural history, I am honored to contribute to this remarkable legacy.

10.1 Attributed to Maruyama Okyo.
Japanese, 1733–1795. *Winter Landscape.*
Ink and wash on paper with silk brocade
borders, 19 3/4 × 25 in. (50.2 × 63.5 cm).
Smith College Museum of Art. Gift of
Charles Lang Freer, 1917.

Asian Art at Smith College

Marylin M. Rhie, Jessie Wells Post Professor of Art
Professor of East Asian Studies

An early encounter with Asia at Smith College came in the late 19th and early 20th century, a result of the connection between Dwight W. Tryon and Charles Lang Freer (1854–1919), the noted Asian art connoisseur whose collection now comprises the core of the Freer Gallery of Art of the Smithsonian Institution in Washington, D.C. Freer appreciated Tryon's paintings and his artistic sensibilities, and Tryon is considered to have been one of Freer's three closest friends.[1] This friendship likely prompted Freer's gift in 1917 to the Smith College Museum of Art of the 18th-century Japanese black ink landscape painting (**10.1**). It depicts a recluse in a humble cottage in the mountains, a theme first used by the Zen monk artists of 14th-century Japan to inspire meditation.[2]

It was not until much later, however, that Smith began offering classes in the history of Asian art. Charles Whitman MacSherry, who had joined the history department at Smith in 1953–54, teaching a year-long introduction to Far Eastern civilization, in 1956–57 began to teach two courses per year on Far Eastern art history in the art department. These were Oriental Art: The Art of China and Oriental Art: The Art of Japan, which he subsequently offered every year until his retirement in 1973–74. At some point MacSherry made a trip to visit the Buddhist sites of India and Pakistan and also visited Japan; and slides that he took during these trips and later gave to the art department are still being used in our courses. MacSherry, a tall, distinguished gentleman whom I had the pleasure to meet once at a confer-ence, built up an impressive collection of slides, books and photographs on Asian art for the department. I was impressed to find these fine collections when I came to teach at Smith in the fall of 1974, especially since very few colleges were seriously teaching Asian art at that time. Today, the library, photograph and slide resources at Smith rival those of major universities in this field. While I have continued to teach the two original courses on the Art of China and the Art of Japan, I have also added various courses on the art of India, Tibet, Korea, Central Asia and Buddhist Art. A semester-long introductory survey on Asian art will be offered for the first time in 2003–04. Over the years I have also taught a number of interdisciplinary courses in collaboration with members of the history and religion departments at Smith. One of these, Thought and Art in China, which I teach with Daniel Gardner of the history department, explores the close relationship between Chinese intellectual thought and Chinese art, particularly painting, from antiquity through the prolific period of the Sung Dynasty (960–1279). Since its inception in 1986, this course has become a yearly mainstay of the curriculum.

The teaching of Asian art was enhanced by the establishment in the early 1980s of the East Asian Studies Program, which shares the Asian art position with the art department. The recent creation of a major in East Asian Studies is but another step in increasing access and training related to the cultures of Asia at Smith College, in which the discipline of art history continues to hold a prominent place.

Notes

1 T. Lawton and L. Merrill, *Freer, A Legacy of Art* (Washington, D.C.: Freer Gallery of Art and New York: Harry N. Abrams, 1993), 160–62.

2 In many ways this painting is also reminiscent of the Japanese garden with its tea hut near Paradise Pond, which was created for Smith during the presidency of Jill Ker Conway and remains a popular spot for students and visitors.

The Arts of Africa, Oceania and the Americas at Smith College

Dana Leibsohn, Associate Professor of Art

For many people, the arts of Africa, Oceania and the Americas call to mind the high modernists of Paris and New York—Pablo Picasso, André Breton, Robert Goldwater—who collected and wrote about "Primitive Art." Although known to Europeans since the first colonial enterprises of the 16th century, these materials have really just begun to play an integral role in the curriculum. Less than twenty years ago, the art department listed no courses that focused upon any of these regions or their visual arts. Today, there is a tenured member of the faculty in Latin American art history, and regular course offerings in African and Native American art and architecture. Across the past two decades, the Smith College Museum of Art has also increased its collections in, and commitments to, African and Latin American arts. The picture at present, then, differs notably from that of the recent past.

Taking a broad view, Smith's commitment to the art history of Africa, Oceania and the Americas (AOA) parallels the path that these disciplines have followed in academia and museums in the United States in general. For instance, Ph.D. programs in the U.S. developed serious commitments to scholarship in the art history of African, Oceanic and indigenous American art and architecture only in the 1960s and 1970s. And Smith was one of many liberal arts institutions to expand its purview into these areas in the decades that followed.

This is not to say that Latin American, African, or native North American art never surfaced in the curriculum. Looking back only a few years, we find that in the 1960s and '70s, modern Mexican art was listed in course catalogues as a component of contemporary art history. And another class of the early 1970s, "Art of Prehistoric and Traditional Societies," surveyed materials from Africa, Oceania and native North America along with those from the Near East and Europe. But both of these curricular interests seem to have disappeared before the decade was out.

Indeed, it was only in the late 1980s, with the appointment of N.C. Christopher Couch, that Smith began to consistently teach Latin American and African art history. Five years later, significant additions had been made to the art department image collections and the College's art library. Within a decade, the curriculum included seminars in Pre-Columbian and African art, as well as lecture courses on Native American, Sub-Sarahan African, and Mesoamerican and Andean art history. Colloquia on museum exhibitions were also offered, with students working collaboratively on exhibitions of AOA in the Smith College Museum of Art.

At present I am the only tenured member of the art faculty who specializes in the art history of AOA, yet Smith's interest in developing a more ambitious program remains firm. Through external grants, donations, and support from the College's Fund for the Development of a Multicultural Curriculum, there now exists a good collection of digital images, slides, and library holdings. Interdisciplinary connections have been forged, with depart-mental courses cross-listed in African Studies, American Studies, and Latin American and Latino/a Studies. And for the first time, in 2003, an introductory course will be offered explicitly focused on the arts of Africa, Oceania and the Americas.

The SCMA has also begun to more actively pursue contemporary Latin American art, and African and native North American works from the late 19th and early 20th centuries. Recent grants from the Andrew W. Mellon Foundation and the Museum Loan Network have made it possible to borrow materials for display and teaching. Along with gifts and the recent purchases, these grants have offered Smith students, from across the curriculum, access to visual arts that were, for many years, barely visible on campus.

11.1 Diego Rivera. Mexican, 1886–1957.
The Knight of the Tiger (replica of a detail from
The Battle for Cuernavaca, from the frescoes
in the Palace of Cortez, Cuernavaca, Mexico),
1931. Fresco, 41 × 52 1/2 in. (104.1 × 133.3). Smith
College Museum of Art. Purchased, 1934.
© 2002 Banco de México.

The Teaching of Film, Historiography and Theory in the Art Department

Barbara Kellum, Professor of Art

Members of the Smith College Department of Art have long been devoted to film, a medium that, in a 1934 lecture, the eminent art historian Erwin Panofsky dubbed one of the few living visual arts. In 1938, Jere Abbott (**22.1**), the director of the Smith College Museum of Art—and the former associate director of the Museum of Modern Art in New York—became one of the founding members of the College's new committee on motion pictures, which to this day selects films and film series on campus. Abbott served on the committee for several years, as did other department members, including the Americanist Oliver Larkin (**8.1**).

Beginning in 1953, the artist George Cohen, who also taught in the art department, became a member of the committee and served on it continuously until his retirement in 1978. Cohen was the first person at Smith to teach the history of film, Art 259b (Art of the Film: The Moving Image), which he offered each year from 1970 to 1978. He brought filmmakers to campus and even shared some of his own Super 8 films with his students while teaching them to write about film. From 1972 to 1974, Smith students were also able to take a studio course, Art 386, Film Making, taught by the photographer David Batchelder.

After Cohen's retirement, film was not taught again until 1985, the year I offered a historical film survey entitled The Motion Picture as Art Form. Although I am a historian of ancient Roman art, I have a strong avocation for film, as my father was a sound technician at R.K.O. and my grandfather held one of the first patents on a sound motion-picture system. In 1985–86 I became one of the founding members of Smith's interdisciplinary Film Studies program and have on occasion served as its director. Courses offered in the program include an Introduction to Film Studies, Film Theory, Video Production, and such thematic subjects as The Western and American Identity, British Film and Television, Nazi Cinema, and Film and Art History: En-Gendering Stardom.

Critical theory and the historiography of art history have also been a part of the art department's curriculum. In 1960, two years after his arrival at the College, the medievalist Robert Harris became the co-director of the honors program and began to reshape the second-semester honors coursework into a unit called Problems in the History of Art. Here students read and thought critically about texts by major figures in the field of art history in preparation for graduate school. Although on occasion he shared the directorship with James Holderbaum (**6.3**) and others, Harris was the chief architect of the honors program in the art department throughout his career at Smith, until his untimely death in 1987. In 1988, I proposed the department's first art-historical methods course, which was intended to spark debate among both art history and studio majors about a wide variety of texts on everything from connoisseurship to semiotics. Brigitte Buettner joined the faculty as medievalist in 1990, and soon became a methods instructor, as well, adding more French critical theory to the mix. When Dana Leibsohn, the department's Latin Americanist/ Mesoamericanist, became a member of the faculty in 1994, she, too, taught Methods, bringing anthropological literature and post-colonial theory to the table. The course is one of the few which is offered every year and attracts students from other majors and from throughout the Five Colleges.

12.1 Art 100 April Fools' Spoof: Barbara
Kellum, James Holderbaum, Robert Harris
(from the *Sofine*, spoof of student newspaper
The Sophian, April 2, 1984).

Critical theory and the historiography of art history have long been a part of the art department's curriculum. The department's art-historical methods course was intended to spark debate among both art history and studio majors about a wide variety of texts on everything from connoisseurship to semiotics, French critical theory, anthropological literature and post-colonial theory.

The Study and Practice of Art at Smith College

Elliot M. Offner, Andrew W. Mellon Professor in the Humanities (Art) and Printer to the College

The remarkable history of the Department of Art at Smith College began at the founding of the College over 125 years ago, when art was heralded as a serious subject to be pursued with the same intellectual vigor as other studies. From the earliest days of the College, students both studied the history of art and practiced it in the studio, working from plaster casts and autotype reproductions that might be considered the foundation of what became the collection of the Smith College Museum of Art. Smith's is among the few American art departments that have consistently put to didactic use actual works of painting, sculpture, drawing, graphic art, photography and rare books. The Department of Art has been renowned as well for its distinguished faculty, many of whose scholarly and artistic accomplishments have stood in the first rank of national and international achievement.

In 1872, three years before Smith accepted its first students, the trustees offered the presidency to Laurenus Clark Seelye, a young minister and professor of English at Amherst College. Turning them down at first, he accepted the position the following year, when the offer was tendered again. Little that we know of the background of Seelye foreshadows his determined efforts to accord the study and practice of art an unprecedented place in the collegiate curriculum. He destroyed his papers upon his retirement and there is nearly no extant written evidence about his interest in the subject. Prior to assuming the presidency, however, he spent six months visiting the leading educational institutions in Europe, a journey that would have afforded him the opportunity to see first-hand the great works of art and architecture in England and on the Continent.

Even Harriet Seelye Rhees, Seelye's daughter and biographer, reveals very little about the origins of Seelye's interest in art, though she wrote of "the personal effort of the President to open their (students') eyes." She also mentions that Seelye's wife was among the first Smith College painters. It is probably a good guess that Mrs. Seelye was the inspiring force behind her husband's creative devotion to the arts at Smith College.

The official circular for the College, disseminated in 1876 and written by Seelye, announced the courses of study of art and music as follows:

> The study of Art and Music has been made, as will be seen by reference to the curriculum, a part of the regular intellectual work of the College. It is not an extra and its cost is included in the regular tuition.
> An Art Gallery already has been furnished with casts of noted statues and several hundred autotype copies illustrating the different schools of painting. These are so arranged in alcoves as to present in epitome the characteristics of the best painters and the schools they represent.
>
> Lectures on the history and principles of the Fine Arts, and the works of the most celebrated musicians and painters, will be given to all the students, and practical instruction will also be furnished in Drawing, Painting, and Music to those who have the requisite talent and taste for it.
>
> These practical studies in Art and Music are optional studies, but are as truly part of the collegiate course as the other optionals

The new Brown Fine Arts Center builds on many lessons learned over the years. Exceptional facilities and equipment are essential to the life of Smith art students, permitting them both to observe and participate in the artmaking process. Perspicacious presidents seem always to have understood when it was time to move forward, providing a finely equipped house for the teaching of art.

with which they are associated. No student, however, will be allowed to prosecute these studies who, in the judgment of the teacher, lacks the ability essential to success in such work.

James Wells Champney, an accomplished New York artist, was the first instructor of art at Smith, arriving in 1877 to teach studio courses as well as to offer a course and lectures on the history of painting and sculpture. The unfinished third story of College Hall became the studio where a first class of "Fourteen Young Ladies worked in charcoal borrowed from the incipient art gallery," as Rhees wrote (among them was her mother). The young president then reached out to leading American artists to buy their pictures, forming a collection of original works of art to be used for teaching.

In 1880, at the behest of the faculty, the trustees decided to eliminate the study of art and music from the regular college curriculum. Instead, they established separate schools of music and art within the College. Apparently, the schools were permitted to accept non-matriculating students with special aptitude in the arts but with far less academic training than Smith undergraduates. Art and music students were required to take some "collegiate studies in those branches they were qualified to pursue," while Smith undergraduates were able to take courses in the art and music schools. While the evidence must be pieced together, it is clear that the faculty wished to separate art and music from the academic curriculum and to accord art and music lesser status.

The schools continued to exist for

twenty years before being dissolved into the academic departments again, restoring what Helen Rhees called "President Seelye's idea for the coordination of the fine arts with other college courses."

Mary Augusta Jordan, professor of English and one of the eminent women of the early Smith years, wrote that "[Seelye] dreamed of the friendly recognition of science, music and art as integral values in education and accepted the 'schools' because he was compelled to the compromise by prejudice and faulty imagination in his teachers."

With the establishment of the art school in 1880, Smith's second professor of art, John Niemeyer from Yale, was appointed director. He taught painting and drawing. Frederick Honig of the (Yale) Sheffield Scientific School was listed as an instructor in perspective, Richard Mather of Amherst a lecturer on Greek sculpture, and Mary Louise Bates an assistant teacher of drawing and painting. In 1886, in what proved to be a prescient choice for the future of art at Smith, Seelye appointed the distinguished painter and learned artist Dwight William Tryon to teach as well as serve as director of the art school and the Hillyer Art Gallery (14.2). Tryon and Seelye developed a deep and enriching friendship, and their shared vision for art at Smith in turn enriched the institution. Upon Tryon's retirement, he wrote to Seelye, "I am sure there has been no single influence so uplifting as your kindly and intelligent appreciation. Without such appreciation I could never have persisted in the work and I am sure that the high standard which Smith has achieved in

this Department would not have been achieved."

In 1916 Clarence Kennedy (6.1) was appointed to the art department faculty. Originally trained as an architect at the University of Pennsylvania, he earned a Ph.D. at Harvard writing on "Light and Shade and the Point of View in the Study of Greek Sculpture." Perhaps because of a personal identification with the artists and writers of the Italian Renaissance, he moved into that world as scholar and photographer. But it was his photographic achievement that secured his place in history as a 20th-century creative genius. Although his appointment was to the history wing of the department, his interests blurred the lines of division. His seven portfolios, *Studies in the History and Criticism of Sculpture*, published by Smith College from 1928 to 1932, are among the finest photographs of Renaissance sculpture ever made and are a unique achievement in combining scholarship, photography and book design. He photographed landscapes and architecture as well and intermittently taught special studies students before introducing one of the first college courses in photography, beginning in 1952 until his retirement in 1960, using a darkroom in College Hall.

Kennedy was also a gifted typographer and printer who was an important influence on the traditions of the book arts at Smith College. Kennedy and his wife Ruth Wedgwood Kennedy (6.2) had a private press in their basement at home with which they printed books and ephemera of their own design. Students were invited to their house to work on books issued under the Kennedys' imprint, Cantina Press, setting

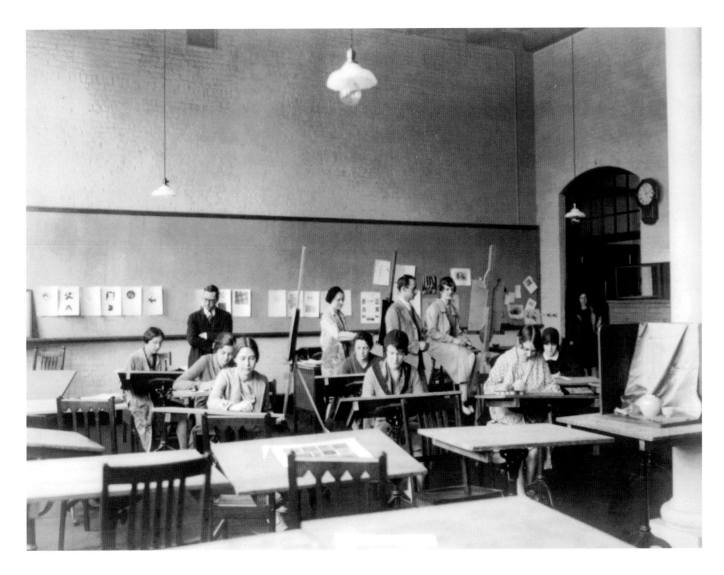

13.1 Art class, 1928 or 1929. Smith College Archives.

the stage for the department's teaching in this area later on (**17.1**). The Kennedys were scholars of Renaissance inscriptions and letter form as well, and they encouraged my own introduction of a studio course in lettering and calligraphy in the 1960s.

In this early era studio courses often had a lecture component, and the department allowed faculty to shift across fields. Alfred Vance Churchill (**21.1**), who had been appointed in 1905 as Professor of History and Interpretation of Art, also taught studio courses. In 1924 Oliver Waterman Larkin (**8.1**) was appointed as assistant professor of art, teaching mostly studio courses with such titles as "Elements of Drawing the Painting," "The Problem of Form," "The Problem of Color" and so forth. In time Larkin left the studio wing of the department altogether for art history.

In 1932 Larkin, assisted by members of the department from both sides, be-

gan to teach a new survey. Two already existed: Art 11, called Art Interpretation (a "study of structure, content, and qualities in sculpture and painting"), taught by Churchill, and Art 22, a general history of art ("the development of architecture, sculpture, and painting from their origins to the present day"), taught by various departmental art historians. These two courses developed into Art 11, the general history of art taught by all members of the history wing of the department, arguably one of the most famous courses in the annals of American higher education; and Art 13, the analysis and interpretation of the artistic issues of form, light, structure, color and design in painting, sculpture, drawing and the graphic arts. Art 13 was required for a studio art major until it vanished from the curriculum in 1975, to be replaced by more specific drawing and design requirements. It was a year-long course with a one-hour lecture per week plus six

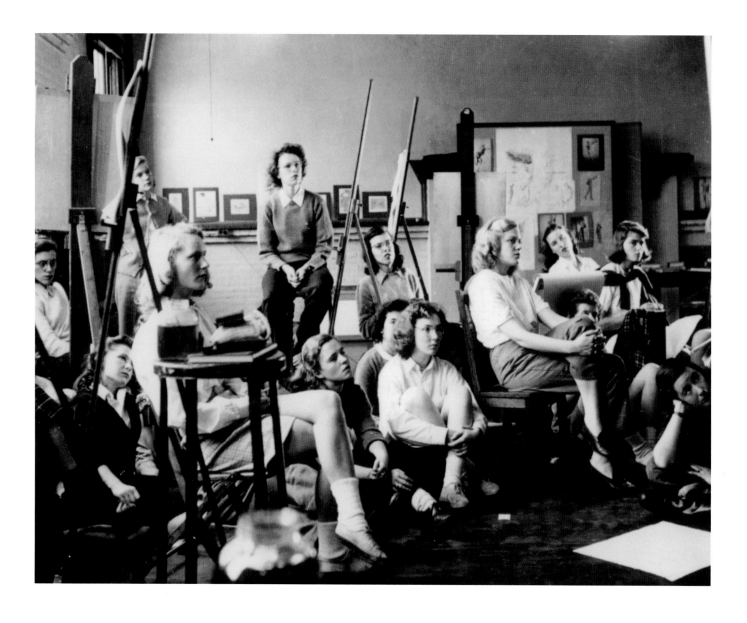

hours of studio work taught by all the studio faculty.

In the 1960s the art department decided to require all art history majors to take at least one studio course. As the basic studio requirement, Art 13 had recently been dropped from the curriculum, but colleagues felt that there was a need for more choices than the remaining basic courses, drawing and design. To meet that need, "Materials of Art," first taught by Ed Hill and then by the writer, was added to the curriculum. It is a course divided into four segments: painting, sculpture, drawing and graphic art, which requires students to produce one or more projects in each of the four major mediums. Study from original works in the museum is supplemented by visits to foundries, studios and workshops.

By the 1960s Hillyer Art Gallery, which housed both art history and studio, had become inadequate in virtually every respect. The new Fine Arts Center, which opened in 1972, presented many problems; some were overcome at great expense, while others defied solution. Still, there was now a true sculpture studio complete with welding equipment and mechanical tools; typography, which had been taught in a grotto-like segment of the basement passageway to the printmaking studio now had its own room, with space enough to accommodate several hand presses and twelve to fourteen students. The printmaking studio, which previously could hold only one ancient lithography press and one small etching press, now had a large room with multiple presses for etching, silkscreen and lithography. The arrival of Dwight Pogue (**15.4**) in 1979 presaged new and multicolored developments in lithography, which he taught on fine presses that he had encouraged the department to acquire. In 1953 Leonard

Baskin re-introduced woodcut as a graphic art subject. It was not yet a formal course, although he had many interested students. He also founded the Apiary Press for students, which gathered national acclaim. Through the 1950s and 1960s his graphic arts course and special studies included etching, wood engraving and copper engraving. With Baskin's departure in 1974, I began to teach woodcut and have continued to do so until the present day. By far the largest body of prints produced by students has been in the medium of woodcut. Many of them used the technique to illustrate books made in their typography classes. A representative sample of about 1,000 of these prints is to be deposited in the College Archives. Space considerations always forced us to teach woodcut in a separate studio, but the new Brown Fine Arts Center will fully integrate the medium within the graphic art studio.

Photography, as well, was invigorated by the new Hillyer, which provided a studio and darkrooms for students whose enrollments had always exceeded capacity. The current renovations further improve on the studio facilities so radically revamped in buildings of the early 1970s.

Upon succeeding Baskin in the teaching of typography in the early 1970s, I began to receive many requests from faculty to design and print materials for various College events. I usually did this in the student printing office, assisted by students. In 1975 President Thomas C. Mendenhall (**24.1**) appointed me Printer to the College, and both faculty and administration began to call upon my students and me to design and print

such materials. I was expected to do all the designing and printing, often with student help, for the major ceremonial events of the College, among them presidential inaugurations, Spectrum programs, retirement symposia, a major development campaign, endowed lectures, and so forth. On their own, students designed and printed posters for innumerable lectures. In the past decade our extracurricular printing activities have diminished. Our collected materials from the last thirty years are soon to be deposited in the College Archives.

While the history of architecture has been taught in the art department since the early 20th century, in 1929 architecture as both history and practice was introduced by Karl Putnam, an instructor in the art department and a local architect who taught at Smith until 1952. In 1958 Peter Garland, a Harvard-trained architect, began to teach studio architecture courses. Along with history of architecture courses taught by renowned scholars Henry-Russell Hitchcock (**3.2**, **9.1**, **23.1**), William MacDonald, John Pinto (**27.1**) and Helen Searing (**9.3**), studio architecture has been a key block in our department major with an emphasis in architecture, or "Plan C." Many art majors, particularly those in Plan C, have gone on to study architecture at other institutions.

Painting, which in old Hillyer was taught in one small room with a large storage room and in an assortment of off-site spaces, found itself united in two spaces in the new Hillyer. Unfortunately, it was still inadequate. Uncomfortable but undaunted, Smith painters have worked assiduously under faculty guidance from Champney to

the present day, producing outstanding work. Sculpture, too, prospered in the new environment, with enrollments far greater than could be accommodated. In 1976 we were able to hire a second sculptor, Lee Burns, whose mechanical wizardry and dedication to improvement of the studio led him to invent and construct many new tools that would enhance dramatically the students' ability to carry out sculptural tasks. I also created several monumental works in the spacious new studio, including, in 1996, the larger-than-life-size *Johnson Memorial Horse* at the Smith College Riding Stables.

The new Brown Fine Arts Center builds on many lessons learned over the years. Exceptional facilities and equipment are essential to the life of Smith art students, permitting them both to observe and participate in the artmaking process. In printmaking, photography and sculpture, in particular, students must be given specialized technology to achieve work that would be otherwise unattainable. Drawing and painting can benefit as well. And the computer and its electronic world, which we have only begun to explore, offer hitherto unimagined opportunities to create new forms as well as act as handmaiden to realizing more conventional material, often with dazzling speed. Perspicacious presidents, from Seelye to Mendenhall to Ruth Simmons, seem always to have understood when it was time to move forward, providing an ever-better home for the Smith College Museum of Art and a finely equipped house for the teaching of art.

Dwight W. Tryon and Painting at Smith

Susan Heideman, Professor of Art

"*Paint with mud!*"

Dwight W. Tryon

In 1886, a mere fifteen years after Smith's founding, President Seelye offered the artist Dwight W. Tryon (14.2) a situation today's artists would kill for: full charge of the teaching of painting and drawing at Smith, with only his occasional presence on campus required. The day-to-day yeoman's labor of imparting actual skills would be left to "teaching assistants." In the meantime, as he always had done, Tryon would divide his year between New York City and the eastern Massachusetts fishing village of Dartmouth that he loved; only now, every third week of the academic year, he punctuated these sojourns with one or two days in Northampton. Here, usually on a Friday, he would critique the work of all of his sixty to seventy students in marathon sessions that went on for hours.

Students welcomed him with the enthusiasm and excitement reserved for a long-absent father. They were said to hang on his every word, and to marvel at his insight and acuity. As one of them reported, "He so imbued us with his own great enthusiasm that we were a-tiptoe with effort and desire for better things…." This appetite for "better things" kept them a-tiptoe in the studios well beyond the required six hours a week.

Alfred Vance Churchill (21.1), who joined Tryon in the art department in 1906, later explained in an issue of the *Smith Alumnae Quarterly* that Tryon was interested in the art department along "broad lines." He expressed his admiration for Tryon's enthusiastic interactions with his students and colleagues, as well as for his new ideas.

However, Churchill went on to explain matter-of-factly, the artist's enthusiasm happened to fall short of any interest in "administrative detail," and he [Tryon] "never attended department meetings." As new faculty recruits signed on to join what was originally a department of one, they seem to have agreed with Seelye and Churchill that the College's success in continuing to engage this celebrated artist was triumph enough. After all, we imagine them thinking, other colleagues better suited to such things might attend to the trifles of organizational planning, but to have an actual, market-validated artist in their midst was something special. In short, all parties seemed to feel they had the best of the deal. Certainly Tryon, always voluble about his love of teaching, felt that way. And content as he may have been with this arrangement (he taught at Smith for thirty-seven years), it was by no means the only reason people considered Tryon a lucky man. His biographer Henry White, by way of Linda Merrill (class of 1981), was to describe him as the sort of man who, if he fell down a sewer, would be sure to find a gold watch at the bottom.

And gold watches, during the last two decades of the 19th century, were among the many luxury goods commonly found in upper-class America. Although Tryon, born in Hartford in 1849, lived through the difficult Civil War years and the depression of 1873, by the time he left for Paris in 1876 prosperity was transforming his native land. His very means of financing this trip were an indication of the country's change of fortune: Tryon auctioned off ten years' worth of paintings and augmented that with a generous gift of

money from a prosperous Hartford silk manufacturer who had become his patron. Tryon and his wife left for Paris, where the artist enrolled in the French Academy, and they continued living in Paris and England for five years.

While the Tryons were in Europe, the acceleration in manufacturing and industrialization back home was prompting increased migration from farm to city, and in the city new preoccupations were on the rise. Americans were more self-conscious of their national identity, but they were also driven to find out how others lived. Some of the most important cultural institutions in urban America were founded at this time, often with help from the captains of industry: the great public libraries, symphony orchestras, museums, and horticultural societies; and grand edifices were built to house them. Smith College represented a radical variant: a degree-granting institution of higher learning dedicated to educating young women to be cultivated and knowledgeable members of a secular urban culture. This was social lubrication at its most sophisticated!

The imperative to teach music and art was inherent in Smith's mission almost from the start. Training students in their theory and practice in preparation for the Baccalaureate degree made Smith unique among American colleges and universities. When Tryon left for Paris, art history as a discipline barely existed, and the country had no more than ten art schools altogether. While it is unlikely that Seelye or Tryon envisioned transforming their students into professional artists, both nobly intended "to refine and elevate" them; young Smith women would

then—presumably—pass on their refinement and elevation to their husbands and children.

During the five years between his return from Paris and his appointment to Smith, Tryon became a celebrated painter, exhibiting in important venues and winning significant competitions. He attracted a powerful and influential patron, Charles Freer, the Detroit industrialist, and even briefly considered moving to Detroit. Freer had been collecting Whistler etchings for some time, but his acquisition and subsequent commissioning of Tryon's work were his first forays into painting. Primarily a landscape painter, Tryon was aesthetically conservative. In Paris he had turned away from Cézanne and the impressionists, preferring the work of the Barbizon School. Similarly, once back in the States, his artist heroes were George Inness and Thomas Dewing, rather than the slightly younger group of American impressionists who were his contemporaries.

When he returned, he established a studio in New York City. As a young painter Tryon had decided that he would never depend exclusively on painting sales for his survival, so he be-

gan accepting students, mostly women, who sought him out in New York. He would accept about ten students per winter (the season he spent in the city) and teach them as a group. It was this experience, along with his reputation as a painter and his sensible demeanor, that made him an ideal candidate for Smith in the eyes of his champions, Massachusetts governor William Washburn, then a trustee of Smith, and, subsequently, Seelye.

So how and what did Tryon teach thirty-seven years of Smith students? We can piece together a picture from his own occasional observations and those of Smith students. Tryon advocated students doing "what they pleased," as long as they dedicated themselves to the "fundamental truths of nature" and to his own notions about the "principles of aesthetics," rather circumscribed. He saw drawing from nature as fundamental and maintained that he could teach anyone to do so within a matter of months. (Of course, Smith never called upon him for this since others executed that workaday task.) He fiercely promoted discipline in drawing, using Ingres as his example. (In this, he followed his own training

14.1 Dwight William Tryon. American, 1849–1925. *Springtime*, 1895. Oil on panel, 16 × 24 1/8 in. (40.6 × 61.3 cm). Smith College Museum of Art. Bequest of Dwight William Tryon, 1925. Photograph by Stephen Petegorsky.

in the Paris atelier of Jacquesson de la Chevreuse.) Good drawing meant mastery of proportions, mass, gesture, and values. Students would engage in drawing from casts for the first half of the winter, then work from the model and create intermittent still-life studies. All this was generously seasoned with frequent museum and gallery visits, and Tryon urged students, as well, to consult books and periodicals.

Tryon was said to communicate his ideas about art with scientific clarity and the force of a dynamic personality. "Get a good drawing, a good drawing," he exhorted his students. "Then defile it if you must…. Work for drawing, then turn about and work for color…." Thus the discipline of Ingres was mediated with a dose of liberalness, something he had found lacking in the French Academy. But students too impatient for color probably bailed out early!

Whether or not Tryon actually believed his female students could become professional artists, he talked to them as if he did. "[T]he main thing must be whether you have so strong a love and desire for it [the painting] that you are willing to sacrifice everything else for it," he said. "If you have it in you to paint a great picture, nothing in the world can keep you from painting." In contrast to his rigor about drawing, in painting he taught his students to value invention over technique. He encouraged individual methods of expression with great enthusiasm, encouraging students to use thick paint, to scrape and repaint, and to start with "violent" ground colors that might later be offset with subtleties. "Paint with mud!" he challenged them, a proclamation no doubt counterbalanced by his equally forceful sentiment, "The test of any painting is its neutrals." Ultimately, he offered them the freedom to "do anything but violate the fundamental truths of nature"—Tryon Truths, that is.

Tryon was an idealist. He truly seemed to believe that "every one should be an artist, and when this day comes there will be better work done by all and more happiness in the world." By all accounts he himself led a happy existence to the end. And while in the later years of his Smith association he appeared so infrequently on campus that many in the department thought him a myth, Churchill later said of Tryon's tenure that "no member of the faculty was so little known, but none gave more freely or made a more lasting mark." He resigned from Smith in 1923 and died in 1925.

If Tryon's spirit didn't necessarily live on, painting at Smith did, carried on by a line of successors. George Cohen (1942–78) was the only artist who taught nearly as long as his predecessor. Until 1976 only two instructors, so far as our records indicate, were women—Clara Welles Lathrop, who was at Smith in 1906–07, and Beulah Strong, who taught from 1907 to 1923 (**21.3**). It is safe to assume that none of Tryon's successors could pull off his leisured teaching arrangement! Attitudes, too, gradually "liberalized," as Tryon might say. At some point during the first half of the 20th century, the pedagogical passion for working from plaster casts waned, and these artifacts were discarded. And while the practice

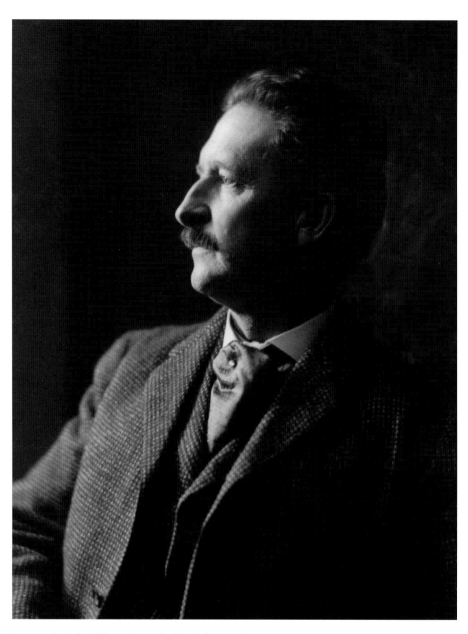

▌ **14.2** Dwight William Tryon. Smith College Archives.

of working from direct observation continues to this day as a mainstay for the beginning student, other conceptual strategies have made their way into the curriculum. These include those newfangled forms of abstraction that Tryon found so abominable when he first encountered them in the 1913 Armory Show in New York. He would be quite mystified, no doubt, by the current painting faculty's interest in how photography, video, digital technology, popular culture, and an array of other cultural developments affect the ways we think about the medium Tryon taught with such relative purity.

We now expect painting students to be literate in all visual idioms, regardless of their own predilections in painting. Whereas Tryon abjured the "present" that constituted the latter

part of his life, we hope that we are embracing ours, and helping our students ride it directly into the future. We believe that the ability to "read" their contemporary visual culture is a necessity for our students—though painting with mud is always an option.

———

Note

I am indebted to Linda Merrill's fine research in her monograph on Tryon, *An Ideal Country: Paintings by Dwight Tryon in The Freer Gallery of Art* (Washington, D.C.: Freer Gallery of Art, Smithsonian Institution, 1990). Henry White, a contemporary of Tryon's and a sometime student of his, wrote a biography, *The Life and Art of Dwight William Tryon* (Boston: Houghton Mifflin, 1930), which was also an invaluable source of information. The quotes in my essay are taken from these two sources.

Printmaking at Smith College

Gary Niswonger, Professor of Art
Dwight Pogue, Professor of Art

Gary Niswonger recollects:

When I arrived at Smith in the fall of 1972, I found an old lithography press, a collection of stones, used etching plates, two old etching presses and dried cans of printing ink scattered about the temporary print shop in Stoddard Hall. The new Hillyer loomed across Elm Street, where a vast empty room was to be the new print shop. This was the kind of room in which drawing might be taught or tea served; it did not look like a print studio. Into this room we moved the old etching presses and a new Brand lithography press ordered by my colleagues for the new facility. The ancient litho press it replaced had been used by the sculptor Randolph W. Johnston during the time he was at Smith, from 1940 to 1950 (**18.2**).

In President Seelye's report of 1882, etching was one of the courses of study a student of the School of Art might pursue, assuming she "has attained sufficient power to justify her in taking up the special studies, which she may choose. Such special studies are painting in oil or water color, sculpture, architecture, decoration and etching…." (Appendix to Presidents Report, June 20, 1882). Unfortunately, the records of the Art School have been lost, so it is impossible to discover any specifics about printmaking at Smith during that time. It is tantalizing to imagine the images students might have made during those early years.

The *Smith Alumnae Quarterly* of November 1944 (vol. 36) features an article on Johnston, who mentions that he taught the first Smith printmaking course in a summer session and that it was so successful that the course was added to the curriculum. This course was Graphic Arts, "printmaking as a means for creative expression with emphasis on woodcut, litho and etching." A second-level Graphic Arts course was described as "creative expression through means of printmaking with emphasis on mixed media and color printing…." Although it would be pleasant to imagine this course as a precursor to one recently slated for 2003–04, the 1940s mixed media were surely limited to woodcut or lithography. This configuration continued until 1951, when Johnston was slated to teach wood engraving and lithography. He had departed Smith in 1950, however, on a one-year leave of absence, and took a sabbatical the following academic year (he officially departed in 1953).

According to an article in the *Boston Herald* of February 25, 1951, George Swinton (1950–53) was instructing students in lithography. Photos show Swinton with his students at the very press I found in Stoddard Hall years later (**15.1**). Other photos in the same article indicate a very rude inking table on the top of a wood-burning Glenwood stove and students graining stones in a tiny plywood box.

Although Leonard Baskin (1953–73) was on the department masthead in 1953, he only began teaching, both sculpture and graphic arts, in 1955–56. The catalogue lists Graphic Arts, but, as became customary, there is no further description of content. Based on reading of the Smith College *Bulletin,* Baskin is presumed to have concentrated on woodcut in most of his printmaking offerings from 1955 to 1972. Woodcut, taught later by Elliot Offner, has remained an essential medium in the graphic arts at Smith. Artist Barry Moser has written to me,

> When I first came to the Valley in 1967 I met two men who were teaching printmaking at Smith College: Leonard Baskin and Ed Hill. When I met Baskin in his Fort Hill sculpture studio, I was hoping to study with him. He was, shall I say, less than enthusiastic. After he mumbled and grumbled for a while, he finally agreed, saying that I could come by his printmaking studio at Smith the following week, if I wanted to, and we would set up a plan of some sort. When I arrived for our appointment, he was in the studio, which was at that time in the basement of Seelye Hall. When I went in, he was trying to unscrew the cap of a can of liquid etching ground but couldn't get it off. Without so much as a greeting, he handed the can to me and said, "You look like a big, strong lad, see if you can get this damned thing off." From this one encounter I know that he was certainly making etchings there in the old Seelye studio, but I can only surmise that he was also teaching etching to his students. It stands to reason that he was. The same thing can be said for Ed Hill at about the same time. I have several Ed Hill etchings in my print collection, all of which were done while he was at Smith. Again, this merely suggests that he actually was teaching etching.

With occasional interruptions, as in 1962, when Mervin Jules (1945–71) taught the course, Baskin was in the print studio teaching graphic arts until he left. When the new Hillyer opened, intaglio was added to the curriculum.

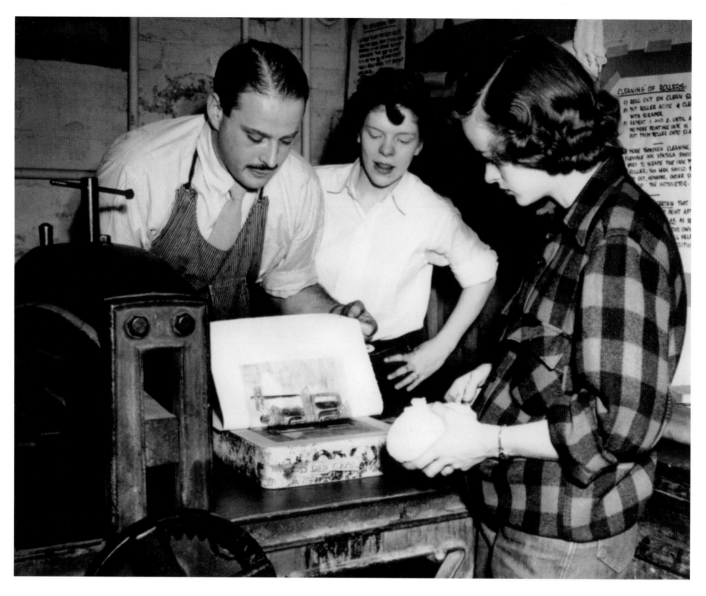

15.1 George Swinton pulling a print on the Fuchs & Lang lithography press in the basement of the original Hillyer, 1951, with students Jean Craig Howe (class of 1951) and Donna Davis Ballenger (class of 1951). The press was replaced in 1972, but students are still using the stone! Smith College Archives.

David Stokes (1969–77) introduced serigraphy (sceenprinting) in 1971, and, at the new Hillyer, a course in that medium was added to lithography and intaglio in the graphic arts curriculum.

The new studio needed many adjustments, but its spaciousness and light was the envy of many printmakers, who seem always to be relegated to basements. Melissa Pulis (class of 1997), recalls the graphics studio as "a familiar, comfortable place in the depths of Hillyer. Hillyer was my 'other' home. I spent a lot of time all over the building." Comfort was not always guaranteed during our first winter at Hillyer. One day, snow and ice came crashing down two stories and through the skylight above the etching press, narrowly missing students at work. A photo of the studio that first winter shows buckets on the floor that were set up to catch water dripping through the window seals (**15.2**). Although we did not realize it then, the failed skylights, as well as other design problems

at Hillyer, would eventually warrant a major revision of the building—bringing us to the occasion of our current celebration.

In its first thirty years as a studio offering, printmaking was taught by sculptors who, while focusing largely on woodcut, appear to have offered a range of experience in printmaking. However, it is difficult to assess the level of proficiency encouraged, since the course descriptions seem to indicate that students did a little of this and a little of that, just a smattering of the different media. This changed in 1976, when the department began to offer an alternating schedule of two semesters of intaglio and two semesters of lithography taught by me. Later, Dwight Pogue continued this one-medium for two-semester pattern. In this course of study we introduced intensive technical skills that were more in keeping with the growing interest nationwide in printmaking as a profession and with the establishment of printmaking

workshops around the country. Anna Purvis (class of 1983) recalls:

> The lithography and typography studios were where my Smith education really happened, my junior and senior years. It's where I learned to work more than the minimum, as I tended not to push myself very hard at school.
>
> There was something exhilarating about spending a large spate of time either setting type or rolling up a stone; I never felt like I was missing out on anything social elsewhere. In fact, with a couple of friends, the happy process of wrestling with the vagaries of acid, asphaltum and limestone or miniscule commas and decorative capital letters and a good radio show, Saturday nights were some of my happiest [times] at Smith.

Printmaking sensitizes the undergraduate art student to the range of possibilities inherent in blacks, whites and grays and the various textures that can be achieved through their skillful deployment. This is printmaking's special domain. In color printing, one can see images come into being in layers, and the artist must consider each of her actions, both its individual effect and the cumulative effect of all steps, in the process of making her piece. Both printing in color and printing in black and white require technical proficiency, but such is the case in any art form. Understanding the grays, blacks and whites of printmaking are its particular challenge and its reward. The hope, too, is that the knowledge of black and grays gained in printmaking will be applicable to other two-dimensional media.

While she admits having forgotten many of the details of printmaking, Susan Couch Lowell (class of 1979) wrote recently:

> I do remember the intellectual exercises of breaking down images into layers of partial images, attempting to bring out depth through a two-dimensional additive process, and coordinating color choices that reflect that depth. [She also remembers] learning to find the balance between the precise and the fluid. I liked fluid images, but had to employ fairly precise techniques to achieve them, like timing acid, like sanding (graining) perfectly flat that litho stone, like managing the pressure of the press. There's some play, of course, but the precision encouraged rigor, and the outcome inspired the next print."

Dwight Pogue recollects:

I arrived at Smith College in 1979 with a printmaking background that was more varied than traditional. I studied with Harry Krug, a master of impasto screenprinting, in which intricately cut tracing-paper stencils are used; after that I learned the latest European printmaking methods of flatbed offset printing while teaching two years at Bradford College of Art in England as a Fulbright recipient.

My first year at Smith College I taught screenprinting and drawing, and, with Gary Niswonger's support, introduced a new course in photo-printmaking. Based on our plans to reconfigure our area for photo-printmaking processes, the graphics studio was renovated during the summer of 1981, supported by a bequest from Jerene C. Appleby Harnish (class of 1916). In 1982 we purchased a German Dufa IVA offset press (**15.3**). To my knowledge, Smith was the first college in America to offer courses featuring this new technology. Today, these unique European proofing presses are highly sought-after by artists and printmakers throughout the United States. Pamela Talese (class of 1986), who was an art student at the time,

15.2 Under the skylight of the 1972 Hillyer, Gary Niswonger demonstrates hand wiping an intaglio, based on the size of the plates; it is probably a copper burin engraving. The temporary nature of the printmaking studio and the nascent problem of leaks are evident. Photograph by Gordon Daniels. Smith College Archives.

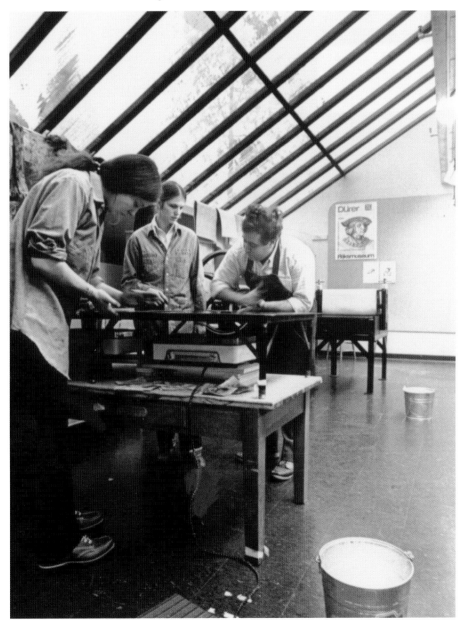

writes, "What is astounding about the Dufa is not only its speed, accuracy and consistency but its ability to reproduce art work with richness, depth and vibrancy."

Fred Wessel, who was Harnish Visiting Artist in printmaking in fall 1984, was instrumental in helping me organize the first Annual Smith College Print Workshop. This program, which will celebrate its twentieth anniversary in 2004, brings to campus prominent artists and master printers who collaborate to produce a limited-edition print. One impression from the edition goes to the permanent collection of the Smith College Museum of Art and several are made available for sale to support future workshops.*

The 1986 workshop with artist Gregory Amenoff and printer Maurice Sánchez featured a revolutionary method of making monotypes on the flatbed offset press. As many as nine or ten equally strong impressions can be attained from one drawn or painted plate, where normally printers can only pull one or two. Students love this way of making prints because it is so direct. Soon I introduced new courses

in Offset Monoprinting and Offset Printmaking. Although screenprinting was very popular, the toxic fumes generated when cleaning screens became a problem, so we eventually eliminated it from the curriculum.

The Smith College Print Workshops expose students to the creative processes of well-known artists as well as the complex give-and-take between artist and printmaker. Sometimes, too, students assist in the making of the print, as was the case with Karen Cuchal (class of 1986), who helped with the Janet Fish/John Hutcheson Workshop in October 1985 (**15.4**). She writes, "Hillyer 17 [the print studio] was a welcoming, stimulating room during the week of October 21–25. The pressure was on Fish and Hutcheson and often on the studio faculty, but all were willing to take time out to answer questions and take advantage of student assistance. Smith students are looking forward to opportunities for cooperating in future major artists' workshops."

In 1994, I added a two-week computer component to my printmaking courses, which I have expanded to include the use of the flatbed offset press to print original lithographs of images manipulated by computers. In order to make it easier for artists to hand-print digital images using oil-based inks on direct-printing presses, I soon joined Jim and Michael Hogan of Precision Ballgraining Corporation to research and develop a high-quality light-sensitive coating for deep-etch ball-grained lithography plates. The new plates, called Posi-Grain (introduced in 1998), make it possible for the artist to add drawing (using traditional drawing tools) to already exposed and developed digital images.

Mark Zunino joined us in 1996 as a full time technical assistant in the areas of printmaking, typography and photography. Mark is an accomplished artist and printmaker and is becoming well-versed in the new digital technology of prints. He has been invaluable in working with me to research and develop Posi-Grain plates, which colleges and universities are increasingly using to print digital images.

In 1998 I began using the computer to make large inkjet prints of my floral images. That August I printed them out on a new Design Winder at Alfred University, New York. Eventually I

15.3 Students printing a color lithograph on the Dufa IVA, 1985. Left to right: Heather Hoover (class of 1987), Ann France (class of 1985) and Pamela Talese (class of 1986).

acquired an Epson 9000 and a Cougar Contex large-format scanner for Smith students and faculty to scan and print larger images, both as finished inkjet prints (sometimes called "giclée" prints) and as positive color separations for lithographs printed on the offset press.

Printmaking continues to be the intellectual, artistic and technical pursuit that it was from the time prints were first made at Smith. Susan Couch Lowell sums it up this way:

> As for me now, well, I work for Intel Corporation, designing semiconductors using computer graphics. And wouldn't you know, the process of creating computer chips is a layer by layer intellectual exercise, as well. The three-dimensional aspect of the computer chip is not a direct issue in my work, but it does have great bearing on what designs we're able to create, and how much effort it will take. It's challenging and rewarding, and there is a final image to produce, so there's a sense of finality that is a key component of achievement, much like in printmaking.

Dwight Pogue and Gary Niswonger are excited about the new Brown Fine Arts Center and are looking forward to many years of continued development in the latest incarnation of the Smith printmaking studio: the Harnish Graphics Studio.

* Smith College Print Workshops have been as follows: James Rosenquist/Maurice Sánchez (1984–85); Janet Fish/John Hutcheson (1985–86); Gregory Amenoff/Maurice Sánchez (1986–87); Jane Goldman/Dwight Pogue (1987–88); Louisa Chase/Peter Pettengill (1988–89); Susan Shatter/Maurice Sánchez (1989–90); Yvonne Jacquette/Patricia Branstead (1990–91); Robert Cumming/Maurice Sánchez (1991–92); Mary Frank/Maurice Sánchez (1992–93); Jaune Quick-To-See Smith/Maurice Sánchez (1993–94); Joan Snyder/Maurice Sánchez (1994–95); Sandy Skoglund/Maurice Sánchez (1995–96); Lesley Dill/Peter Pettengill (1996–97); Steven Sorman/Steven Sorman with Dwight Pogue and Mark Zunino (1997–98); April Gornik/Julia D'Amario (1998–99); Georgia Marsh/Maurice Sánchez (1999–2000); Walton Ford/Maurice Sánchez (2000–01).

15.4 Janet Fish (class of 1960) and Dwight Pogue during the 1985 annual Smith College Print Workshop.

History of the Architecture Studios at Smith College

Richard S. Joslin, Former Lecturer in Art
Gretchen Schneider, Lecturer in Art

In 1877, President L. Clark Seelye proposed that Smith's art department should "…furnish practical and theoretical instruction in the principles of art and design, drawing, painting and sculpture *including elements of architectural styles and decoration…."* But more than forty years would pass before the College first offered an architecture studio, and that was in landscape architecture, a studio taught by Kate Reis Koch (a graduate of Vassar and an M.L. DES., Cornell University), who joined the botany department in 1919. A strong interest in the field was well-established by that time. In the 1890s Frederick Law Olmsted had designed Smith's campus as an ornamental and instructional arboretum, and the Botanical Garden was an early treasure. Botany was an early, strong department, offering courses in horticulture and ornamental planting.

Women at that time, it was thought, might find professional opportunities in landscape architecture, especially garden design. A quarter of a century after Seelye had envisioned a course in architectural design at Smith, however, fewer than one percent of practicing architects in the United States were women, and they were not admitted to most graduate schools. In response, a group of women graduates from various colleges joined Harvard instructors in Cambridge in 1915 to form a graduate school of architecture for women, called the Cambridge School of Domestic Architecture and Landscape Architecture, offering professional courses in architecture and landscape architecture.

Smith's President William Allan Neilson was an early supporter of women in the design disciplines—and of the Cambridge School. During his tenure, new studio courses in architecture and landscape architecture were added to Smith's curriculum, and the College and the Cambridge School became increasingly intertwined.

When Smith's art collection moved to Tryon Hall in 1926, Hillyer's vacant third floor was converted to studios, and, the next year, Koch's landscape course moved there. Northampton architect Karl S. Putnam (B.A., University of Pennsylvania and B.S. Arch., Columbia University) joined the art department in 1929 to create the first architecture studio. Described as "a consideration of…historical styles and…the evolution of modern form," his course finally addressed Seelye's goal to include architecture in Smith's curriculum. In 1931, Koch transferred from the botany department to the art department, and, by the early '30s, Koch and Putnam, both associate professors, added advanced courses to the studio curriculum.

As has been true of all subsequent Smith architecture studio faculty, Putnam was professionally active. For the College, he designed the Boat House (1911), the Crew House (1920), the Field House (1939) and the first addition to Neilson Library (1938).

In 1933, under Neilson's guidance, Smith adopted the Cambridge School as an allied graduate institution. Consequently, the Cambridge School could grant master's degrees in architecture and landscape architecture. Though the school remained in Cambridge, the two faculties frequently visited both Smith and the Cambridge School, and

Smith alumnae played a strong role in both: in one year, nineteen of the forty enrolled Cambridge School students were from Smith College.

In 1934, the College instituted an interdepartmental major, Architecture and Landscape Architecture. The Smith art faculty in this area continued to grow. In 1935, the department hired Dorothy May Anderson (graduate of Washington University and M.L. Arch., Cambridge School) as an assistant professor to teach landscape architecture one semester and to act as resident campus landscape architect the next.

By the late 1930s, the Depression began taking its toll on the Cambridge School. Though the Second World War increased demand for women in the design professions, Smith's reduced budgets led it to close the School. Coincidentally, the United States' entry into the war greatly reduced enrollments at Harvard's graduate school, and in 1942 Harvard opened its doors to women. When the Cambridge School closed its doors, many of its students transferred directly to Harvard.

The postwar years also marked a shrinking of studio architecture at Smith. In 1943 Anderson left for a government post, and her position was not renewed. In 1952 Koch and Putnam retired, and their two positions were reduced to one. The interdepartmental major Architecture and Landscape Architecture was dropped. When landscape architect Martin R. Jones came in 1952, he would teach a combined one-year course, Introduction to Architecture and Landscape Architecture, and two advanced courses, one in each discipline. In 1957, architect John F. Lee succeeded Jones.

16.1 In the Hillyer architecture studio, Emily Weinberg (class of 1994) tries yet another solution to a planning problem. Photograph by Jim Gipe. Smith College Archives.

The next year, Peter Garland (A.B., M. Arch., Harvard University) arrived, and for twenty-five years taught the studios and maintained an active practice. As Elliot Offner wrote in the *Smith Alumnae Quarterly* (vol. LXXV, no. 2, Winter 1984, p. 69), Garland "launched scores of Smith students into the professional study of architecture."

In Garland's last years he was assisted, and later replaced, by architects Etel Kramer and Andrus Burr. At Garland's death in 1983, the architecture studio position was reduced again. At the same time, in response to increased opportunities and student demand—and to the prodding of Smith architectural historian Helen Searing (**9.3**)—the department initiated a third "plan" of

the art major, Plan C: Architecture and Urbanism. Architectural practice requires a professional degree, and the Smith studios do not constitute a professional program. Whether as design professionals, developers, lawmakers or simply engaged citizens, the Plan C major was intended to help all Smith graduates actively shape their built environment.

In 1984, Richard Joslin (A.B., M.Arch., Harvard University) was opening his own practice in Cambridge after serving as Chief Architect for the city of Boston, as Boston's Director of Urban Design and Downtown Planning and, finally, as an associate partner at Skidmore, Owings & Merrill. Searing proposed that he teach the new

combined introductory and advanced Smith course for one year. Twelve—maybe fifteen—students were expected. Twenty-seven students showed up.

A student, Susan Norr (class of 1985), solved the underlying problem. For her the studio was a revelation that changed her career goals. In her honor, her father, David Norr, provided funds to allow the teaching position to become full-time, the two studios to be taught separately, and an assistant to be provided for the introductory course.

Richard Joslin remained at Smith for sixteen years. For fifteen years, Kevin Wilson assisted with expert instruction in drafting, rendering and model building. Also for fifteen years, landscape architect Shavaun Towers (class of 1971) volunteered, acting as a visiting critic to guide the studio's landscape projects.

During each school year, the skylit architecture studio gradually filled with yellow trace-paper drawings, black-line prints, models, and finally computer printouts. Design juries included art history and art studio faculty members, as well as active practitioners and academics from other institutions. The classes regularly attracted students from other of the Five College campuses. A regular, memorable event during Joslin's tenure was the annual exhibition he organized, in which all Hillyer studio students jointly showed their work. For this show his first-year students pinned up their many house designs, and second-year students displayed the plywood furniture they had designed in the studio and then fabricated in the woodshop.

In 2000–02 the architecture studios were temporarily relocated to charming but cramped quarters in Tilly Hall,

16.2 At night in a darkened studio, Vanessa Tiegs (class of 1989) works on her house design. Photograph by C. Kuhns. Smith College Archives.

which students quickly transformed into an energized jumble of drawings, diagrams and models. Gretchen Schneider (class of 1992 and M. Arch., Harvard University), the first alumna to teach the Smith studios, took charge of the studio at Tilly and of its relocation to the Brown Fine Arts Center.

There are currently new interdisciplinary efforts, including joint projects with Smith's Picker Engineering Program and the new interdepartmental Landscape Studies (a result of the indefatigable efforts of alumnae Paula Deitz, class of 1959, Susan Komroff Cohen, class of 1962, and Ann Leone, class of 1971). Similarly, recent Five College collaborative efforts have produced new intercollegiate lectures, workshops and classroom discussions.

In America's graduate design schools today, women's enrollment is coming to parity with that of men. Although still only thirteen percent of registered architects are women, the gender gap is steadily narrowing. Smith is one of the few liberal arts colleges nationwide—colleges not in the shadow of a graduate architecture program—to offer a substantive architecture major. With new facilities and a strong history; with Seelye's vision and the commitment of Neilson, Searing, and Norr; and, finally, with the efforts of those who have taught the courses and the students who have taken them, the Smith architecture studios today face tremendous opportunities.

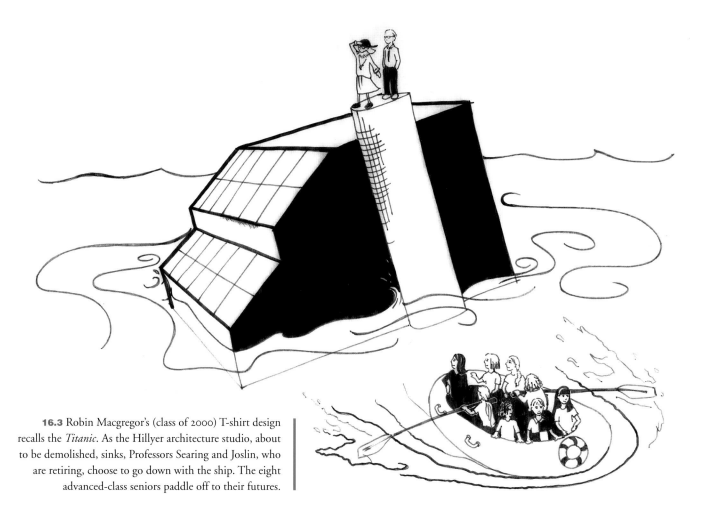

16.3 Robin Macgregor's (class of 2000) T-shirt design recalls the *Titanic*. As the Hillyer architecture studio, about to be demolished, sinks, Professors Searing and Joslin, who are retiring, choose to go down with the ship. The eight advanced-class seniors paddle off to their futures.

The Arts of the Book at Smith College

Martin Antonetti, Curator of Rare Books

Formerly the preoccupation of only a handful of bibliophiles, interest in the arts of the book, including fine printing, letterforms, hand bookbinding and illustration, was spreading throughout the country in the 1930s and 1940s, largely the result of such popular ventures as the Limited Editions Club, the Folio Society and the Heritage Press, which promoted traditional (i.e., non-industrial) standards of design and production and made "fine" and "collectible" books available to a wider public. This movement was based on the aesthetic principles articulated by John Ruskin and then recapitulated in the 1890s by William Morris and later by his American followers, Frederic Goudy, Elbert Hubbard and John Henry Nash, who operated presses of their own based on Kelmscott. At the same time these principles were being introduced into the academy by teachers who understood the need to rescue the graphic environment from the depredations of commercial designers: Rosalind Keep at the Eucalyptus Press at Mills College (1930), Ray Nash at the Graphic Arts Workshop at Dartmouth College (1937), Victor Hammer at the Wells College Press (1941) and Hannah French at the Book Arts Laboratory at Wellesley College (1944).

In this spirit President William Allan Neilson invited Helmut Lehmann-Haupt, already a noted bibliographer and curator of rare books at Columbia University, to Smith as visiting lecturer in the spring of 1939 to teach a new course, "The History of the Making of Books and the History of the Book as a Work of Art." Courses like this were not uncommon in American library schools at the time—indeed Lehmann-Haupt would go on to teach something similar at Columbia's famous School of Library Service in the 1940s—but they were normally not included in the undergraduate curriculum. The importance of Lehmann-Haupt's project— and what must have been wonderfully memorable for his students—was that he proposed to teach the course using the fine collection of rare books that was then housed in the library's Browsing Room, setting a precedent for pedagogy with original materials that continues to this day. Lehmann-Haupt offered the course again in 1940 and then in 1941 launched his Book Arts Seminar, which was described as "lectures, discussions and students' reports on the history, technique and art of bookmaking." After this, Lehmann-Haupt's duties at Columbia prevented his return to Smith, but his pioneering foray into the history of the book arts sparked an interest that was to grow, and in some periods to thrive, at the College for over six decades.

Lehmann-Haupt's success must have had a catalytic effect on the art department, for soon after his departure the College hosted a major international conference on typography. Organized by Clarence Kennedy in April 1942, the conference featured such authorities as Philip Hofer, who had founded the Department of Printing and Graphic Arts at Harvard's new Houghton Library that year, and Beatrice Warde, the scholar of printing history who braved a dangerous passage from war-torn London to attend. Kennedy, himself a serious typophile, also curated a large public exhibition of rare books which

Courses like "The History of the Making of Books and the History of the Book as a Work of Art" were not uncommon in American library schools at the time, but they were normally not included in the undergraduate curriculum. The importance of the course at Smith is that it was taught using the College's fine collection of rare books, setting a precedent for pedagogy with original materials that continues to this day.

was held in conjunction with the conference from his and the Smith library's collection, augmented by loans from designers Carl Rollins, William Addison Dwiggins, Rudolf Ruzicka, and Daniel Berkeley Updike.

The fortuitous return to Northampton of librarian Eunice Wead (class of 1902) in 1945 provided the art department with another means of keeping the typographic momentum going. Wead had recently retired from the University of Michigan, having enjoyed a distinguished career as curator of rare books and assistant custodian of the Clements Library (1917–26) and then professor in the library school (1926–45), where she specialized in teaching the history of the book and rare book librarianship. Her course, The History, Technique and Art of Book Production, which was taught from 1945 to 1947, treated the making and illumination of medieval manuscripts, block printing, the history of typography from the 15th century to modern fine printing, and styles of bookbinding.

Clarence Kennedy, who had founded the Cantina Press in his home in the late 1930s and had already been designing and printing programs and invitations for the College for years, counted typography and other arts of the book among his major interests (**17.1**). From 1948–54 he continued Eunice Wead's course, but with a greater emphasis on book illustration and book design and on the practice of letterpress printing. Called variously The Development of Typography from Fifteenth Century to the Present and The Art of the Book, Kennedy's course made extensive use not only of materials from the library's rare book collection, but also of a

Vandercook proof press and a bank of metal type that he had installed in the basement of Hillyer Hall.

Leonard Baskin, who brought American fine printing to new levels of excellence with his own Gehenna Press (founded in 1942), arrived at Smith in 1953 and initiated a new era in the teaching of graphic arts. Baskin placed emphasis on mastery of relief and intaglio processes and introduced students to the latest developments in modernist and contemporary fine printing. In 1956 he established a student printing office under the Apiary Press imprint which over the next ten years published forty titles in very limited editions designed, illustrated and printed by undergraduates from both Smith and Amherst. A perusal of the collection of Apiary Press editions in the library's Mortimer Rare Book Room reveals that without exception these student-produced works were remarkable for their high level of technical skill, intellectual sophistication, and creative energy. In addition to this, throughout his tenure at Smith, which lasted until 1974, Baskin continued to teach courses and occasionally tutorials in the history and practice of typography and the graphic arts.

Building upon Baskin's legacy in the graphic arts, Elliot Offner developed a series of courses in the 1970s which capitalized on his intense interest in letterforms. He opened the series with his Introduction to Printing in the fall of 1971, a course structured largely on the model of Ray Nash's Book Arts Workshop at Dartmouth, with the important difference that students would be required to design and print texts of their own creation, thus melding

literary and technical processes into a single creative action. Calligraphy and Letterforms, which followed in 1973, also linked the two processes, this time within the medium of the pen and brush.

Offner was greatly aided in his project of teaching a more systematic approach to book arts at Smith by the arrival of a new curator of rare books in Neilson Library. Indeed, Offner himself had played a crucial role in bringing Ruth Mortimer (class of 1953) back to the College. A graduate of Columbia University's School of Library Service, protégé first of William A. Jackson and then of Philip Hofer at Harvard's Houghton Library from 1957, Mortimer had made an international reputation for herself as compiler of two bibliographical monuments: *French 16th-Century Books* (1964) and *Italian 16th-Century Books* (1974), both based on the Houghton's collection of illustrated books. In 1975 Mortimer succeeded Dorothy King as curator of rare books at Smith, determined to carry on the tradition of teaching with original materials. Her legendary course, Composition of Books, was taught each year from 1976 until her death in 1994. Composition of Books was conceived only secondarily as a historical survey of printing; it really functioned as an in-depth exploration of the relationship between word and image. In this respect it was the perfect complement to Offner's series of studio courses in the book arts. Mortimer was also an industrious collection builder for the library, acquiring books by purchase and donation from the 16th century to contemporary artists' books to aid in the teaching of these

courses. Mortimer's activist and hands-on approach to rare book curatorship and pedagogy has been carried on by her two successors, Michèle Cloonan (1995–96) and myself (1997 to the present), who have taught our own versions of the course for the art department.

Over the years the art department has been fortunate enough to take advantage of the large and active colony of book artists resident in western Massachusetts to fill temporary vacancies and augment the curriculum: at various times courses have been offered by such well-known printers, binders and illustrators as Barbara Blumenthal

(class of 1975), Art Larson, Claudia Cohen, Susan Medlicott (class of 1984), Alan Robinson, Michael Russem and Barry Moser. This local community of book artists has for decades acted as collaborators with faculty and provided an important artistic resource to students. In 2001 the Harold P. McGrath Collection, honoring the influential Northampton pressman, was established in the Mortimer Rare Book Room to document the long efflorescence of book arts activity in the area and to serve as yet another facet of the department's book arts program.

17.1 Clarence Kennedy and students at work at the Cantina Press in his home in the late 1940s. Rosamond Rogers (class of 1950), on the left, examines Kennedy's copy of the Piazzetta Tasso (Venice, 1745). Smith College Archives.

A Brief History of the Teaching of Sculpture at Smith College, with Emphasis on the Contributions of Randolph Wardell Johnston

A. Lee Burns, Associate Professor of Art

While Smith College offered studio art classes from the start, it was not until the 1940–41 academic year that a course for sculpture appeared in the curricular catalog. The first to teach it was Randolph Wardell Johnston, who remained at the College for a decade (**18.2**). During this time the sculpture course was increased to two semesters, and in 1943 Johnston added bronze casting to working in stone, wood, and clay. This same year the class meeting time was increased to six hours per week, still the standard for Smith studio courses.

The sculpture curriculum remained essentially the same until Leonard Baskin arrived in 1953–54, when the course descriptions show that bronze casting was dropped and the emphasis returned to carving in wood and stone. Baskin left in 1960, and Elliot Offner arrived. At that point the sculpture course was described as offering instruction in methods of direct carving and plaster techniques. In 1970–71, the two sculpture courses acquired their current titles, Sculpture I and Sculpture II; the next year, with the opening of the new Hillyer facility, the technique of welding was added. During 1977–78, with Offner away for a year, the sculpture faculty was augmented to two: Pamela Endacott, who remained through 1978–79, and myself. With the shifting of welding from Sculpture I to Sculpture II in 1977–78 and the reintroduction of bronze casting in 1981–82, the sculpture curriculum at Smith became what it is today.

The early sculpture course that Randolph Johnston taught at Smith included techniques of modeling clay from life, the carving of wood, and eventually the firing of terra-cottas. Probably because of the difficulty of carving stone and its greater time requirements, Johnston substituted ordinary livestock salt lick blocks for stone, noting that they responded to the tools similarly, and that, with sanding, their surfaces could take on a look very like that of fine-grained marble. An anonymously authored article entitled "Sculpture Faces New Future at Smith," in the *Smith Alumnae Quarterly* of November 1944, describes Johnston's attitudes toward teaching and his art:

> Confessing that his point of view previously had been in favor of coeducation as the more liberal and modern idea, he says that a comparison of his experience in teaching in both kinds of institutions now makes it clear that girls working alone, at Smith, do better work and are more serious students. Indeed, when visited in the workrooms in the basement of Hillyer, where the elementary sculpture class was in progress, it seemed that amazing results were being achieved in modeling heads and figures from life. Mr. Johnston teaches the girls to work directly in the various materials—stone, wood, bronze. When they work in clay, it is done in such a manner that it can be fired directly into terra cotta. The studio is equipped for casting bronze, with a forge for making tools.

> The sculptor is well-known for his work in bronze. In his South Deerfield home…he has his own studio, which is well equipped for sculpture, with furnaces, casting pits, and machinery, where up to half a ton in bronze can be melted. At Smith up to 100 pounds of bronze can be melted.[1]

The Smith archives contain a series of photographs from 1949 documenting the bronze casting process that was carried out in the basement of Hillyer Hall by Johnston and his class. Several of these photos appeared in an article in the *Springfield Sunday Republican* of October 9, 1949 (**18.1**). By current standards (**18.3**), the conditions for casting bronze in 1949 appear quite unsafe. The participants are not wearing goggles or, indeed, any face protection or flameproof head coverings. Their pant cuffs are turned up, which could catch metal splashes, and they are shod in cloth tennis shoes and ordinary short-top loafers. Even though the participants are wearing leather gloves, their shirtsleeves are either rolled up or are tucked into the glove cuffs. While Johnston appears to have on leather leggings, the other participants are dressed in ordinary clothing, and a gallery of ordinarily clothed observers is, in addition, located fairly close by. While techniques may have changed little in the intervening years, students casting bronze at Smith today wear head-to-foot aluminized body suits to protect themselves from injury.

Notations in pencil on the backs of the archive photos identify eight students in the 1949 casting session, whom I contacted for their impressions of Johnston; five responded. Jeanne Marie Perdue Jones (class of 1950), writes that he "was a kind, gentle, quiet man who kind of glowed with warmth and interest in art, sculpture and our work. I don't remember him ever being critical but he was somewhat exacting and expected the best from us. Looking back on my classes at Smith, most of which I loved…, I realize that he did in

a subtle way influence me in my teaching of sculpture…." Priscilla Hurd Donaldson (class of 1949) reports that she still has her bronze sculpture from Johnston's class, an "imperfect" casting due to technical difficulties; yet she notes that her teacher found it "agreeably abstract" in its final condition. She recalls that "Mr. Johnston was an excellent teacher, who encouraged each student, talented or not, to select her own subject material. He was also a firm taskmaster, requiring us to work to the limit of our abilities." Marcia Gwirtzman Wasserman (class of 1950) remembers tossing coins into the molten metal, and that Johnston "had a Zen-like calm about him. He was non-judgmental of our work, preferring that we learn from our own experience and that of our classmates." Janice Hall Thompson (class of 1950) says that "he always wore blue jean jackets and pants. A wonderful person and teacher," while Ghislaine Gindorff Jackson (class of 1949) feels fortunate to have also been taught in grade school (Bement, in Deerfield) by Johnston, and remembers him as "large, hairy, very kind and gentle."

From the comments of these five students and from the series of photos in the archives, the casting process as Johnston taught it can be reconstructed. The furnace for melting the metal was against one wall of the room shown. It appears to have been coke- (or possibly coal-) fired, with the combustion gases released through the building flue. The molds were probably de-waxed and then fired in the same room. The mold being poured in the photo shows an electrical resistance wire that would have been used to heat the mold to remove the wax and quite probably also to reheat the mold to remove the water and wax residue before casting. Johnston seems to have invented this electrical resistance technique, and he actually described it in an article he wrote in 1947 for the *Bulletin of Smith College Museum of Art.*[2] The technique is mentioned in practically every article about Johnston, as well, so I suspect he was very proud of it. I know of no use of it these days, however; most investment casting is done traditionally, with the wax melting and mold firing occurring in a heated oven or kiln rather than on the casting room floor. According to Johnston's article, at a certain stage in each different application of this resistance heating the mold is encased in copious amounts of pow-

18.1 Bronze casting at Smith, 1949. Left to right: Dorothy Street Jones (class of 1950, with white headband), Randolph Johnston (partially obscured, with hat), Jeanne Marie Perdue Jones (class of 1950, with headscarf), Marcia Gwirtzman Wasserman (class of 1950, plaid shirt). Smith College Archives.

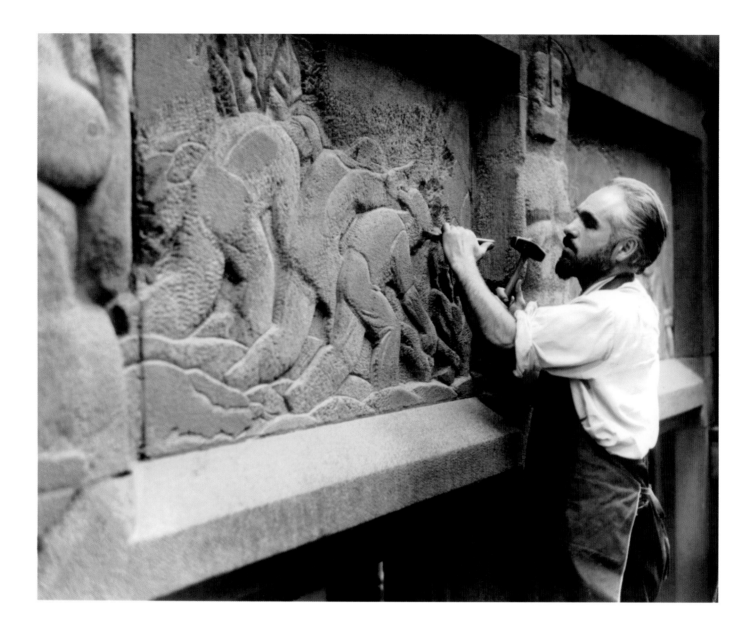

dered asbestos—yet Johnston lived to be eighty-seven. After the firing process was complete, the castings were finished in the classroom across the hall.

Randolph Johnston left for a one-year sabbatical in 1950–51 and eventually stayed in the Bahamas, never to return to Smith College. He died in 1991.[3]

Just two Smith faculty members created sculptures that are on permanent exhibition outdoors on campus, all three of them bronzes: Leonard Baskin (*The Owl*, 1962, at the entrance of Wright Hall); and Elliot Offner (*Great Blue Heron*, 1987, in the Botanic Garden pond; and *Johnson Memorial Horse*, 1998, at the entrance to the riding stables on West Street).[4] However, the current renovation of the art facilities has brought to light another faculty work: reliefs created by Johnston for Graham Hall, in an ensemble that is being considered for reinstallation

somewhere at the new Brown Fine Arts Center. Completed in 1946, the reliefs remained in situ until they were removed to storage in 1970, when Graham Hall and the other buildings of the art complex were razed in preparation for the new construction of the early 1970s. Carved directly from the sandstone masonry, three 32 1/2 × 47 1/2 in. polychromed panels depict scenes of the tobacco industry in the Connecticut Valley, with figures planting, chopping and drying the crop. There are, in addition, two caryatid-like nude figures (approximately 40 1/2 × 24 in.), one male and the other female, which were carved on the vertical stone elements separating the panels. The total ensemble, including various other stone elements bordering the panels, would measure 55 1/2 × 210 in. if reassembled.

The article in the November 1944 *Smith Alumnae Quarterly* describes Johnston at work:

18.2 Randolph Johnston at work on his brownstone relief carvings of Connecticut Valley tobacco farmers. The reliefs were placed on the south facade of Graham Hall.

On the three brownstone panels of the second story level of Graham Hall, facing College Hall, [Johnston] is working with hammer and steel chisels, depicting the planting, the cutting, and the hanging of tobacco.

Limited in working time by the scheduling of lectures in Graham, and to some degree by light and weather, none of the panels is yet completed. The middle one, showing the cutting of tobacco, is furthest along, and the one on the right, depicting the hanging of the tobacco, is just roughed in.

Mr. Johnston's interest in tobacco started about 10 years ago. During the course of the decade he has been building up his knowledge. He has worked in the fields during each process, has sketched and studied

the workers. He made a scale model and mapped out the studies in a frame. Then he made a plaster model, which he carved, as mental exploration of the problem. Now he works directly on the building itself. He is thinking of doing the panels in polychrome, or color, in harmony with the rest of the building, leaving the vertical figures in the natural brownstone.

The importance Johnston placed on this project can be inferred from a broadside in the College Archives promoting a public lecture he was to give to the Lions Club of Springfield, Massachusetts, in January of 1945. One of two photographs on this sheet shows him at work carving the center panel.

Apparently Johnston heard about the razing of the buildings, because on September 17, 1970, he wrote a concerned letter, addressed simply to the president of Smith, regarding the fate of the work.

1) The carved reliefs document the traditional (and now disappearing) industry of the Connecticut Valley farmers—the growing of cigar wrapper tobacco, the profits from which industry, as I understood, form the foundation of the original Smith endowment.

2) The carvings were done in my own time and at my own expense, and took several years' work. The psychic or mental prepara-

tion alone was, according to some people, impressive; I worked with the local farmers for a long time in all the typical operations, in order to feel the physical rhythms of the work and the emotional motivation of the farmers toward it.

Fearing that the College might destroy the work, Johnston admonishes,

3) The destruction of a work of art by a cultural institution is morally equivalent to book-burning, but in its effect infinitely worse: since book-burning practically never succeeds in complete destruction of the author's message—which destruction of a specific work of art does. In this case the effect is to destroy several years of my life.

President Thomas C. Mendenhall replied on September 30, 1970, that the sculptures had been carefully removed, and were safely stored awaiting the completion of the new Fine Arts Center. He further noted, "The architect has already been asked to consider how they might be displayed to best advantage in [the Fine Arts Center]."

More than three decades have passed, during which Johnston's Graham Hall reliefs have lapsed into obscurity. Their conservation and installation on campus will pay tribute, at last, to the man who founded the sculpture program at Smith College.

Notes

1 Anon., "Sculpture Faces New Future at Smith," *Smith Alumnae Quarterly* 36 (November 1944).

2 Randolph W. Johnston. "Resistance Firing of Terra Cottas and Bronze Molds," *Smith College Museum of Art Bulletin*, 1947.

3 He gives a narrative of these later years in his book *Artist on His Island: A Study in Self-Reliance*, 2nd ed. (Marsh Harbour, Abaco, Bahamas: Little Harbour Press, 1975), which was written with the assistance of Denny Johnston, who also collaborated on Randolph Johnston's *Survive, Man! Or Perish: Sculptural Metaphors to Command Allegiance to Life, Resistance to Race Suicide* (Marsh Harbour, Abaco, Bahamas: Little Harbour Press, 1980). See also Emily M. Dahlgren, *Randolph Wardell Johnston: Feel Intensely, Imagine Vividly, Control Precisely* (Washington, D.C.: Magazine Street Press, 1993).

4 On permanent display indoors are Baskin's portrait of the composer Alvin Etler, in Sage Hall, and Offner's Jacobson Learning Center high-relief plaque in Seelye Hall. In addition, Offner designed and had struck four commemorative medals for Smith: The Smith Medal, given annually to distinguished Smith College women, rather like an honorary degree; The Charis Medal, given to faculty who have completed twenty-five years of service; The Sophia Smith Medal; and The Presidential Medal, given only to Smith presidents.

18.3 Bronze casting at Smith, 2002. Left to right: Elly Barksdale (class of 2004), A. Lee Burns (partially obscured), and Rebecca Nonn (class of 2002). Photograph courtesy Lauren Appel (class of 2002).

Photography at Smith

Chester Michalik, Professor of Art

Within the studio arts curriculum, photography has been offered since 1941–42, at a time when photography in most colleges and universities was ignored, dismissed, consigned to the science departments or relegated to extracurricular activities. That year, a course appeared in the Smith course catalogue: Art 327: "Techniques of presenting the subject matter of the visual arts; the preparation of books on Art for publication, and the arranging of exhibits; photography, stereography process of reproduction, typography. Lectures on all the techniques and laboratory instruction in one selected by the student. Mr. Kennedy." No one understood the importance and expressive potential of photography better than Clarence Kennedy (1892–1972), who began his career at Smith in 1916 as an instructor in the history of art, teaching courses on Greece and the Italian Renaissance, but who also became the College's first teacher of practical photography (**6.1**, **17.1**).

Clarence Kennedy had already lectured about photography earlier, in 1933, in Springfield, Massachusetts. An announcement in the *Springfield Union* newspaper reads:

NEW Extension Course
Prof. Kennedy to Begin Lectures on Photography This Evening. The university Extension course in photography begins tonight at 7:30 in Central High School. Prof. Clarence Kennedy of the department of art at Smith College will be in charge. Prof. Kennedy is well known for his photographic studies. In 1931–32 he was research fellow of the College

Art Association, and in 1930–31 he was the recipient of a Guggenheim fellowship.

Prof. Kennedy will give instruction in equipment and materials used in photography. The major part of the course, however, will be devoted to a study of art in photography....

It wasn't until 1952–53 that the designation of hands-on art courses was changed in the Smith catalog from "technical courses" to "studio courses," and in that year Kennedy offered a course entitled The Art of Photography. The last time he taught it was in 1960; he died in 1972. In a memorial tribute to Kennedy, who was well known for his innovations in the medium, Ulrich Middeldorf from the Roberto Longhi Foundation in Florence, Italy, wrote in the *Art Journal* (1973):

Clarence Kennedy's contribution to the theory and practice of photography, his collaboration with the Eastman Kodak Company and Edwin Land's later Polaroid Corporation, his stereo-photography for aerial mapping transcend our field and will have to be appreciated by someone more competent in the science and technique of optics. But his teaching of photography to students of the history of art, his work as a photographer of sculpture concerns us closely. Actually for a student of sculpture his photography was a revelation. Today, when clever photography—often too clever for its own good—is the order of the day, when the market is flooded by illustrated books, which often kill all thought by a deluge of badly controlled images, it is hard to realize what impact Clarence Kennedy's photographs made on us who had never dreamt of anything like them.

The Smith College Museum of Art began to collect photography as a fine art long before most other museums and just one year after the Museum of Modern Art in New York made its own first acquisitions in the medium. In 1933 Jere Abbott (**22.1**), then the director of the Smith College Museum of Art, purchased seven photographs, two by Luke Swank, one by Walker Evans, two by George Platt Lynes, and two by László Moholy-Nagy (**19.1**). The museum has acquired photographs ever since and has become, on this score, the envy of many museums across the country and an extraordinary teaching resource for both the Smith art department and the College as a whole.

After Kennedy's final photography course in 1960, studio photography courses were dropped from the course catalog until 1968–69. That year a new one appeared, Art 282: "Photographic Vision and Design. An introduction to the camera as an artistic means based on a series of studio problems in light, motion, optical control, visual selectivity and photographic composition. Mr. Batchelder." David Batchelder had been hired to revive photography in the studio curriculum. By 1971 there were two full-time photography instructors, Batchelder and Ed Hill, in the art department, giving photography a stature equal to that of the other studio arts. Other photographers—Barbara Shamblin, Peter Johnson, and Al Souza, among others—helped at various times to maintain the medium throughout the 1970s. I arrived in 1978.

A bequest from Jerene Appleby Harnish (class of 1916) in 1980 allowed the addition of much-needed darkrooms for the photography courses,

images. A number of Smith graduates have gone directly into photography graduate programs at Yale University, Rhode Island School of Design, the University of New Mexico, the School of the Art Institute of Chicago, and elsewhere. Some have also made careers in related fields, in publishing and as curators. Meanwhile, photography has transcended its former limitations, crossing boundaries both material and conceptual. New darkrooms have been constructed in the Brown Fine Arts Center and new space and lighting will allow for work in studio photography. The new facilities will assure that the photography program will continue to be a broad-based, vital and exciting medium of expression and communication for Smith students for the future. The photography area will be named to honor Marilyn Fifield (class of 1946), who generously contributed to the building fund.

19.1 Luke Swank. American, 1890–1944. *Heads of Grain*. Gelatin silver print, 17 3/4 × 13 3/4 in. (45 × 34.9 cm). Smith College Museum of Art. Purchased, 1933. Photograph by David Stansbury.

and in 1982, the Harnish Visiting Artist Program was established, bringing photographer-teachers to Smith for one or two years on a full-time basis. The Harnish Visiting Artist Program has given Smith students the opportunity to learn from photographers with a variety of expertise and points of view and to make connections with photographers from around the country. These have included Carl Chiarenza, Chris Enos, Jane Tuckerman, Robert Cumming, and Delilah Montoya, among others. Visiting artists have introduced the students to a wide range of photographic methods, from early non-silver to new digital processes.

Following Clarence Kennedy's lead, the photography program at Smith College helps students both to appreciate historical methods and to look to the future for new ways to create

The Digital Age in the Department of Art

Gary Niswonger, Professor of Art
Dana Leibsohn, Associate Professor of Art

The creation of visual images and their interpretation have always depended upon technology. For art historians, magnifying glasses, slide projectors and photocopies represent familiar, portable tools of the trade. Artists have long depended upon innovations, from the plumb line and camera obscura to pencils and oil or watercolor in tubes. In the last decade computers and digital images have entered studios, museums and classrooms as if by storm and, in so doing, have spawned new rituals for the study and production of art.

Computers and art at Smith have had a peripatetic history: finding space, finding equipment, finding a true home. The story begins in 1977. When computer science was not yet a department, Bert Mendelssohn, the mathematician who brought computer science to Smith (he taught at the College from 1957 to 1988), provided Gary Niswonger with a printout of random numbers that helped guide the artist in producing a series of relief etchings. This random set of numbers provided him with the first taste of the computer's possibilities for working with visual images. Soon afterwards, Niswonger participated in two Visual Language Workshops offered by MIT, where, in the early 1980s, artists and scientists were working together on mainframes, developing software and making art of all sorts. Dazzling but very remote. Or so it seemed.

Today it is possible for every student to operate computers in every dormitory room on campus; the classroom, too, has become computer-friendly. The first step the art department took

was in the studio curriculum, which, beginning in 1988, presented the first art course at Smith based solely on the computer, Design with Computers. This became a regular offering. The first class of eight design students met in a closet in the basement of Neilson Library, and they worked on four IBM ATs using software created for the video industry. By 1992, the class came out of the closet—quite literally—and into Stoddard Hall. Along with this relocation, which permitted a slight increase in the number of work stations, a switch was made from PC to Macintosh computers. And this changed everything, making all manner of new work possible. But still, one could not make art with computers in Hillyer, where the rest of the studio department was located, since the building was not yet set up for digital technology.

The renovation of Seelye Hall in 1992, along with support from the Gladys Brooks Foundation, provided the first digital imaging lab at Smith, outfitted for fifteen students. The computer-art project continued to improve when instructional support was added to the mix through Educational Technology Services. Finally, in 1997, through the assistance of the Andrew W. Mellon Foundation, the art department was, at last, able to build a computer lab in Hillyer, its first true home. The convenience and growth of this Hillyer facility, which had both PC and Mac workstations, brought many new users from across the department.

Presently, digital components are a part of a wide range of studio courses, including photography, printmaking, architecture and drawing. In 2001, Barbara Lattanzi, a multimedia artist

whose work draws upon computers, video and film, became the Harnish Visiting Artist. Her efforts have added Advanced Digital Design and Multimedia to the roster of studio courses.

Yet Smith's commitment to computers in studio art did not follow a straight or easy path. Initially, many artists trained in traditional techniques viewed with suspicion the lack of kinesthetic experience inherent in the hands-off nature of the computer workstation. When photography was invented in the 19th century, there was a similar debate about the relationship between this new technology and painting. As happened then, a new technology has raised complicated issues about creativity, replication and the making of art. In the late 1980s and early 1990s, the computer was seen largely as a tool to extend the native skills of the artist, as she created essentially traditional art products. Now we understand that the computer's technical innovations are, themselves, visualizing resources with the power to lead us toward new forms of expression—not purely visual, but potentially involving all the senses.

Smith's art history faculty and students have been no less active on the computing front, bringing digital imagery into their classrooms, research, and writing. Digital imaging makes it possible to see more art, more often. Digital imagery in no way replaces the attraction or efficacy of experiencing original works of art; rather, museum and digital encounters nourish each other, creating new means to see and compare originals and reproductions. Round-the-clock access to full-color images is enhancing the possibilities

20.1 Scanning images for the Smith College digital database.

20.2 Studying for class with digital images from the Smith collection.

Computer technologies do not simply make extant art more available; digital images are themselves changing the definition of what constitutes "art" and how both historians and artists should interpret acts of creation.

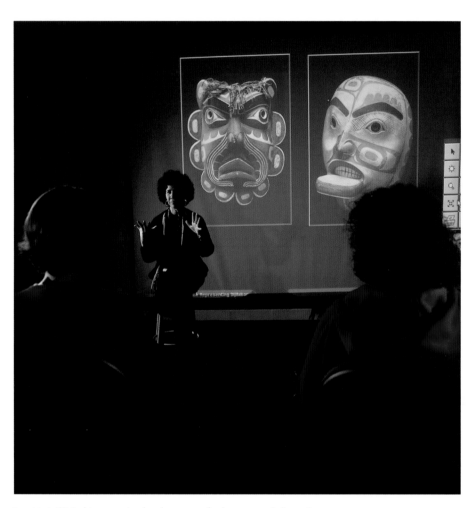

20.3 Digital imagery in the classroom, for lectures and discussion.

number of students has come to depend upon digital resources. By the end of 2002, eight different art history courses will have put Smith's digital database to work, drawing upon 10,000 digital images. Not only has museum studies enlisted *Insight,* so too have introductory courses, and upper division classes such as Pre-Columbian arts and Great Cities: Pompeii, as well as a seminar on arts in the age of Alexander the Great and his successors. This seems to be just the beginning. Other art history classes, and other departments, such as geology, religion and classics, have plans to use digital images as well.

Currently, lectures are now conducted with digital images instead of slides, students study for exams and write papers based on digital images, and they give oral presentations in class via digital projection. Much of the excitement surrounding this work comes from our students, who take quickly to digital images and have been instrumental in developing projects with the Smith College database. No less significant have been a series of successful external grants and on-going technical support from Smith's Educational Technology program. All of these pieces have been critical to stretching Smith's art history program.

Yet access is not everything. We have learned that computer technologies do not simply make extant art more available, but that digital images are themselves changing the definition of what constitutes "art" and how both historians and artists should interpret acts of creation. Here lies the future of computers: both in the fascination they generate and the challenges they set.

for research. With a password, a Smith student or faculty member can view all of the images, not only in a particular course, but also in the Smith College Museum of Art, every time she sits at her computer.

In 1997, the art history faculty began experimenting with digital technologies. Through grant money from the Mellon and Davis Foundations, and with support of future-looking deans of the faculty, Smith became an

"early adopter" of a digital database called *Insight.* So early, in fact, that Smith was the first academic user of this digital database anywhere in the United States. Now, she is joined by institutions such as Stanford, Cornell, and Yale. What this means: an exciting network is developing, in which images and collections can be shared across institutions.

Since the initial art historical experiments with *Insight,* an ever growing

Founding a Museum: Laurenus Clark Seelye, Dwight William Tryon and Alfred Vance Churchill, 1870–1932

Michael Goodison, Archivist and Editor
Museum of Art

Smith College traces its origins to the mind, vision and heart of Sophia Smith of Hatfield, Massachusetts. Unmarried, childless, and in possession of a considerable family fortune, guided by her conscience and her pastor, John M. Greene, she decided near the end of her life to leave her wealth to found a college for the higher education of women. She signed the final version of her carefully worded last will and testament, prepared by her friend and business advisor George W. Hubbard, on March 8, 1870. She died in Hatfield three months later on June 12.

With certain conditions, the will directed that the College was to be located in the town of Northampton, specified the members of the founding board of trustees (including Hubbard and Greene), and outlined the course of instruction that the new college was to offer. In principle, the teaching, making, study and collecting of art at Smith College were "given" from the moment of its foundation. Article 3 of the will stipulated that "higher culture…be given in said College…in the Useful and the Fine Arts, in…Moral and Aesthetic Philosophy."

In the five years following Sophia Smith's death the trustees purchased land for the College at the edge of downtown Northampton, elected the first president, Laurenus Clark Seelye, and erected two buildings—the president's house and College Hall, the first academic building. Its dedication, along with Seelye's inauguration, took place on July 14, 1875, and, in the fall, the first group of students assembled there for the opening of Smith College.

Space had already been reserved in College Hall for the purpose of displaying reproductive engravings of paintings and plaster casts of sculpture (**21.2**). Seelye referred to it in his inaugural address: "Not less, however, should the College see to it that artistic tastes are not starved and dwarfed from want of proper culture. It should have its gallery of art, where the student may be made directly familiar with the famous masterpieces….Our art gallery, we trust, will ere long be amply provided with all the material requisite for such a work." In 1877 funding was secured to acquire photographs, engravings and paintings for the gallery, and James Wells Champney, whom Seelye described in his 1923 history of the College as "an artist of repute," was engaged to give art instruction "and a course of lectures upon sculpture and painting." Seelye also began making contact with artists in New York and Boston to acquire original works of art for the gallery (and was often able to negotiate a concession in price). In 1879, with the advice of Champney, he made his first acquisitions of original paintings. Canceled checks preserved in the College Archives document purchases from R. Swain Gifford, William Sartain, Louis Comfort Tiffany, Winslow Homer, Thomas Eakins, and other American artists, including Champney himself (**28.2**).[1]

Construction proceeded briskly on the young campus, with a new building completed nearly every year. By 1881 fundraising for a building dedicated to the study of art had amassed $8,000, attracting the notice of Winthrop Hillyer, a retired Northampton businessman who seems to have expressed no

> *Not less, however, should the College see to it that artistic tastes are not starved and dwarfed from want of proper culture. It should have its gallery of art, where the student may be made directly familiar with the famous masterpieces…. Our art gallery, we trust, will ere long be amply provided with all the material requisite for such a work.*

Laurenus Clark Seelye, in his inaugural address

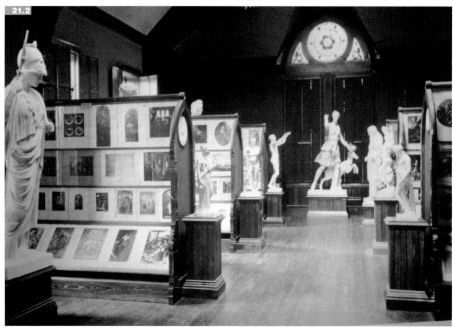

21.1 Alfred Vance Churchill, c. 1905. Photograph by Katherine McClellan. Smith College Archives.

21.2 College Hall Gallery, c. 1877.

previous interest in either art or Smith. Hillyer offered the College $25,000 for an art building, provided the money already raised go toward purchasing more works of art for the gallery. Seelye and the trustees readily agreed, and the new building, named after Hillyer, opened in 1882. The galleries provided ample space for the display of the casts, engravings, and the growing group of paintings by contemporary American artists (21.3, 4).

Hillyer did not live to attend the June 26, 1883, dedication of Hillyer Art Gallery during the College's fifth commencement (he had died in April). Having never married, he was survived by his brother, Drayton, and sister, Sarah Hillyer Mather. They discovered in their brother's papers an unsigned memorandum expressing his wish to leave Smith College $50,000 to endow a fund for the maintenance of the gallery. While the document was not legally binding, the siblings respected their brother's wishes and presented the trustees with this gift, which forms the basis for an endowed fund that continues to benefit the museum today. By 1887 the official circular of the College could boast that "Hillyer Art Gallery… is provided with studios and exhibition rooms, and contains the best collection of casts in the United States."[2]

In 1886 Seelye persuaded Dwight William Tryon (14.2), an artist with a growing reputation as a painter of serene, poetic landscapes, to join the faculty of the art school. (His teaching career is discussed elsewhere in this volume.) Tryon began to advise Seelye on his purchases, and his genteel aesthetic sensibilities are reflected in many of the acquisitions that came to the gallery

during his nearly forty-year association with the College. Contemporary artists whose work entered the collection in those years included Thomas Wilmer Dewing, Ralph Albert Blakelock, Abbott Handerson Thayer, James McNeill Whistler, Albert Pinkham Ryder, and Tryon himself (*The First Leaves*, which had won the prestigious Webb Prize, awarded at the eleventh exhibition by the Society of American Artists for the best landscape painting by an American under age forty, was bought in 1889, the year it was painted).

In 1905, with Tryon long established as the head of the art department, Seelye and the trustees considered creating a new faculty position for instruction specifically in the history and interpretation of art. Colleagues of Alfred Vance Churchill, then director of the art department at Teachers College at Columbia University in New York, urged Seelye to consider him for such a position (**21.1**). Churchill, a Mid-

westerner born in 1864, had studied art in Europe (he married a German). Understanding he could not support himself or a family through his painting, he briefly took a position as head of the art department at Iowa College (now Grinnell College), then arrived at Columbia in 1897. Along with his wife and young son, he spent the 1904–05 academic year on sabbatical in Paris, where a letter from Seelye dated February 11, 1905, reached him. Seelye wrote, "We desire a resident teacher who will give special attention to the history and interpretation of art,—not merely for those who are engaged in practical work but for the benefit of all who wish to have an intelligent appreciation of the art treasures which the world contains."

Negotiations between Seelye and Churchill continued by mail during that spring. On April 29 Seelye confirmed the appointment: "The Trustees of Smith College at their spring meet-

21.3 Interior of Hillyer Art Gallery, c. 1920, with Beulah Strong, Dwight William Tryon (seated) and Alfred Vance Churchill. Smith College Archives.

ing yesterday established a professorship of the History and Interpretation of Art, and appointed you its first incumbent....We desire to have the instruction given, as you suggest, first, in the History of Art, second, in criticism of Art, and third, in application of Art Principles, and we will endeavor to co-operate with you so as to carry out the ideals of art instruction." On July 16, 1905, Churchill wrote to a friend that he planned to accept the Smith offer, noting that "Dwight Tryon (one of our very best painters) is close by." (In another letter, Churchill wrote that Seelye assured him "that I will have lots of time to paint at Smith.") Churchill, who wished to remain in Paris an additional year, asked Seelye for a

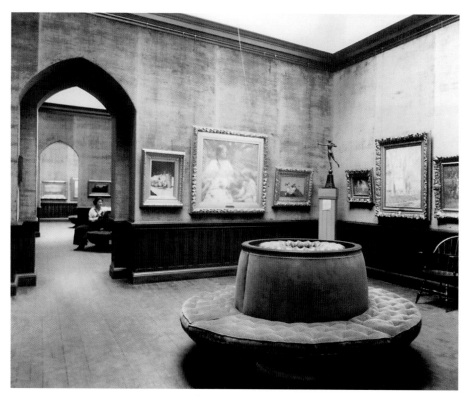

21.4 Interior of Hillyer Art Gallery, c. 1915. In the gallery can be seen *Children in the Forest* by Frank W. Benson (purchased 1905, sold 1942); to its left and right are still lifes by Julian Alden Weir (purchased around 1900, sold 1946); in the corner is the bronze sculpture *Diana of the Tower* by Augustus Saint-Gaudens (purchased 1915, still in the collection); on the wall to the right is the Childe Hassam *Church at Old Lyme* (purchased 1905, sold 1946). Smith College Archives.

postponement of the appointment to fall 1906, to which Seelye agreed. The 1905–06 annual circular of the College (predecessor to the modern course catalogue) lists Churchill as "Professor of the History and Interpretation of Art (absent for the year)."

In fall 1906 Churchill arrived at the art department, joining Tryon and Clara Welles Lathrop (class of 1886), who was in charge of daily studio instruction (she died less than a year later). Churchill taught only juniors and seniors in two courses: Art 10, Art Interpretation ("The work of art as an organism; the principles of order which underlie all beauty"); and Art 11, History of Art ("The masterpieces of architecture, sculpture, and painting, considered as a record of the thought and feeling of the race from the earliest times to the present day"). Tryon and Churchill (as well as Lathrop) were sympathetic in many regards. Both had traditional academic training in Europe; they sought to create in their paintings and drawings subtle, refined objects of beauty and taste; they tended to look back in their art rather than forward; and they were deeply suspicious of modern technology, fearing the direc-

tion they believed it would take society.

One imagines Seelye, who was by now looking toward retirement (which he took in 1910), giving increasing responsibility to Churchill and Tryon for the development of Smith's art collection. The paintings purchased for the gallery during the early years of their collaboration reflect their refined tastes: *A French Flower Girl* by Lathrop, acquired after her June 1907 death; *St. Cecilia, Spring Time* and *The Music Room* by Edward August Bell; *Budding Oak* by Willard Leroy Metcalf; *Mrs. Lewis Jarvis* by Whistler; and *Miss Tribbie* by George DeForest Brush. Their acquisitions even reflect their shared love of springtime: "What a marvel it all is; a real resurrection," Tryon would write to Churchill many years later. Churchill responded, "But the infinite and inexplicable part is to see life renewing itself."

While these acquisitions are all by American artists, Churchill also began to move the collection away from its native focus. In 1911 a group of students presented the gallery with an impression of the Rembrandt etching *The Three Crosses* (**28.4**). Three years later Churchill purchased a cast of Auguste

Rodin's *Children with Lizard* (**28.5**), and three years after that, in 1917, the Detroit industrialist Charles Lang Freer, Tryon's friend and patron, gave the gallery a group of Asian objects. In 1919–20 Churchill was appointed director of the gallery, which was now unofficially referred to as an art museum, and in 1920 the first volume of the *Bulletin of Smith College Hillyer Art Gallery* was published.[3] In it Churchill outlined the early history of the gallery, which, he wrote, "is essentially a college museum." While the collection's strength was still American painting, it now included prints, textiles and bronze and wood sculptures from America, Europe and Asia. Then, as now, gifts were significant to the development of the gallery.

The trustees, realizing the growing importance of the art collection to the College, asked Churchill in 1920 to develop a collecting plan. He responded by submitting "Our Concentration Plan," which emphasized the importance to an American museum of acquiring Western art from antiquity through the Renaissance to the present day. Realizing, however, that this was too vast an ambition for a small museum, he suggested concentrating instead on the development of "modern" art, meaning for him from about the time of the French Revolution to today. "At that period," he wrote, "ancient beliefs, traditions and practices were ruptured and new ones started in every realm of thought including art. The break with the past has never been more complete."[4] He proposed a list of artists whose work should be included in such a collection: Goya, Constable, David, Ingres, Gros, Géricault, Delacroix, Daumier, Corot, Millet, Courbet, Manet, Renoir, Monet or Pissarro, Gauguin, Van Gogh and Cézanne. In the twelve remaining years of his directorship he was able to add the work of many of these artists to the museum.

Nearing age seventy-four, Dwight Tryon retired from the faculty in 1923. In the next year, perhaps following the example of his late patron Freer, who had funded the construction of the Freer Gallery in Washington, D.C., Tryon decided to give to Smith a building in his own name, whose sole purpose would be the display, care and study of the art collection. He made the offer informally to Churchill, who then presented it to President William

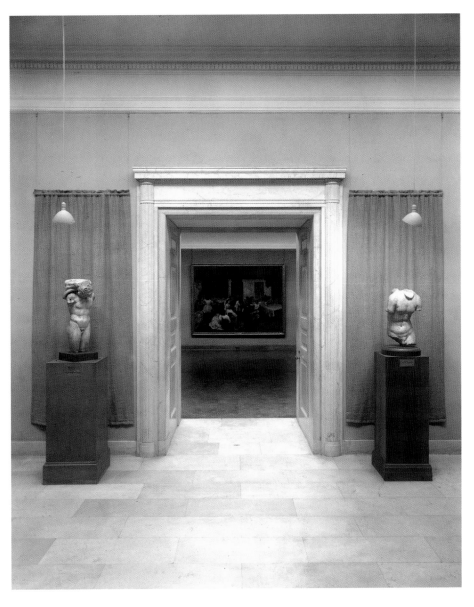

21.5 Tryon Art Gallery. Entrance hallway and view to main gallery. Left of door: *Smiling Faun*, Graeco-Roman, 1st century C.E., purchased 1919; right of door: *Winged Torso*, Roman, 1st century C.E., purchased 1922; view through doorway: Gustave Courbet, French, 1819–1877, *The Preparation of the Dead Girl* (then called *Preparation of the Bride*), c. 1850–55, purchased, Drayton Hillyer Fund, 1929. Photograph by Allison Spence.

Notes

1 While the Thomas Eakins painting *In Grandmother's Time* bears the museum's first accession number (1879:1), it was paid for in May 1879. Earlier purchases were made in February.

2 Indeed, a catalogue of the casts published in 1898 lists nearly 400 examples.

3 The first six issues (1920–25) were called *Bulletin of Smith College Hillyer Art Gallery.* With issue no. 7 (1926) it was renamed *Bulletin of Smith College Museum of Art.* The *Bulletin* continued under that name, with some later years grouped together, until issue no. 41 (1961), after which it ceased publication.

4 "Our Concentration Plan," *Bulletin of Smith College Museum of Art*, no. 13 (May 1932), 11. Churchill reproduces in this issue of the *Bulletin* a number of works he acquired for the collection following his plan. Many have subsequently had attribution changes; a few are no longer in the collection.

Allan Neilson. In a letter dated November 4, 1924, Churchill told Tryon of his meeting: "I had the pleasure just a few minutes ago to tell the President…in a private interview. I tell you he swallowed hard! You knew we were beginning to need a new building very badly." By that time Tryon's health had begun to decline, but he followed planning for the building carefully. Frederick Ackerman was engaged as architect, and plans were finalized in the spring of 1925. Near the time of the late June groundbreaking Churchill wrote to Tryon, "We were all grieved to hear of your ill health. I shall hold to the hope that your strength will return, that we shall see you in Northampton again." That was not to be. Tryon died on July 1 in South Dartmouth.

The Tryon Gallery, now officially the home of the Smith College Museum of Art, the trustees having voted to so name the art collections, opened in 1926 (**2.3, 21.5**). In the *Bulletin* (now the *Bulletin of Smith College Museum of Art*) Churchill wrote of the new building, "And as it was a dream to Tryon, so for Smith College it was increasingly a necessity….The College art collections are not large, but they are choice, and they are growing." Churchill would devote six more years to that growth and to Smith before reluctantly retiring in 1932, rightly proud of all that he had accomplished.

Following seventeen years of active retirement, Alfred Vance Churchill died at home on December 29, 1949. (Although he made Northampton home for forty-three years, he chose to be buried in his birthplace, in Oberlin, Ohio.) While Churchill thus lived almost precisely through the first half of the 20th century, he was, like Dwight Tryon, grounded intellectually and aesthetically in the 19th. It would be his successor who would lead the museum decisively into the modern era.

Building (and Unbuilding) the Collections: Jere Abbott, Frederick Hartt and Edgar Schenck, 1932–1949

Linda Muehlig, Curator of Painting and Sculpture
Associate Director for Curatorial Affairs
Museum of Art

When Jere Abbott (**22.1**) assumed the directorship of the Smith College Museum of Art at age thirty-two, it was only his second museum position. Three years previously, in 1929, Alfred Barr, Jr., and Abbott had assumed posts as the first director and associate director, respectively, of the newly fledged Museum of Modern Art in New York. Paul J. Sachs, their mentor at Harvard, had given their names to MoMA founders Lillie P. Bliss, Mrs. Cornelius J. Sullivan and Mrs. John D. Rockefeller, Jr., who had approached Sachs concerning plans for a museum of modern art. Sachs would again act on Abbott's behalf by recommending him to Smith College President William Allan Neilson as Alfred Vance Churchill's successor. In turn, Sachs urged Abbott to consider the job, writing, "I believe that there is a very great opportunity at Smith College….The museum has been well started and has substantial funds for its development…. The teaching opportunities I think are exceedingly attractive. In short, the purpose of this letter is to say just this to you:—unless you are wedded to New York I think you ought to consider very seriously the whole question of Smith College if you are asked to take the job."[1]

Abbott took Sachs's advice and became the second director of the Smith College Museum of Art in 1932, a position he would hold until 1946. Born in Dexter, Maine, the heir to his family's woolen mill business, Abbott graduated from Bowdoin in 1920. He went on to train as a chemist and physicist at Harvard, but then made a complete about-face, abandoning science to study art in Paris. He returned to the United States to continue his art studies at Princeton, where he met and began a friendship with the young Barr. In 1926 both men left for Harvard to study with Edward Forbes, director of the Fogg Art Museum, and Sachs, whose "Museum Work and Museum Problems" course served as basic training and springboard for an entire generation of American museum professionals. The year that Abbott and Barr took the course, their classmates included Kirk Askew, who would head the New York branch of Durlacher Brothers; Henry-Russell Hitchcock, who became a distinguished architectural historian and the fifth director of the Smith College Museum of Art; and James Rorimer, who went on to direct the Metropolitan Museum of Art in New York.[2]

Soon after Abbott arrived in Northampton to assume the directorship of the Smith College Museum, his first purchases of 19th-century French art reaffirmed Alfred Vance Churchill's collecting policy to build a collection of modern art from the French Revolution onward. Abbott's fourth acquisition, *La Table* (**22.2**), a great synthetic cubist work by Pablo Picasso, demonstrated his collecting acumen as well as his knowledge of contemporary art. Although this painting has long been considered a masterwork by the artist, its acquisition in 1932, if not controversial, was not universally embraced. The following year, Abbott purchased Edgar Degas's monumental early, unfinished history painting *The Daughter of Jephthah* (**28.8**) and bought one of the collection's gems: *Woman with a Monkey* (**28.9**), an oil study by Georges Seurat for his 1884–86 masterpiece, *A Sunday on the Island of La Grande Jatte*. In 1934 Abbott organized an exhibition of portraits and landscapes by Camille Corot and purchased Corot's *La Blonde Gasconne* (**22.3**), a canvas prized by the artist, which has been described as one of Corot's "most celebrated and popular representations of women."[3]

Abbott would go on to make other important additions to the museum's French 19th- and early-20th-century holdings, assembling a group that comprises the core masterworks from this area in the museum's collection. Among the portraits he acquired are Degas's superb painting of his younger brother, René De Gas, as a schoolboy posing with his books and inkwell; Gustave Courbet's "society portrait" of Monsieur Nodler at the beach at Trouville; and Edouard Manet's fresh and loosely painted portrait of seventeen-year-old Marguerite de Conflans. Claude Monet's *Seine at Bougival* (**28.12**), an early impressionist work from 1869, was a highly important purchase for the collection, which would eventually include two other works by the master. Post-impressionist works bought by Abbott include *The Suitor,* an exquisite "intimist" painting by Edouard Vuillard; Henri Rousseau's charming *Bords de l'Oise;* and a late landscape by Pierre Bonnard.

Abbott's purchases of American paintings were not as numerous as his European acquisitions, but they included John Frederick Peto's *Discarded Treasures,* a trompe-l'oeil still life of books painted in 1904, which Abbott appreciated as a formal composition and interpreted as a stylistic forerunner of modernism. Abbott was also respon-

sible for acquiring one of the museum's
most famous 20th-century American
paintings: Charles Sheeler's *Rolling
Power* (**22.4**), a "portrait" of the drive
wheels, bogie wheel and engine parts
of a Hudson-type New York Central
locomotive designed by Henry Drey-
fuss. *Rolling Power* remains to this day
one of the works most often sought out
by museum visitors and is frequently
requested for loan by other institutions.

Abbott had originally hoped to
study drawings at Harvard with Sachs,
and at Smith he made a number of
drawings acquisitions, the most im-
portant of which is a rare silverpoint
attributed to Dieric Bouts (**22.5**), one
of the finest early Netherlandish por-
trait sheets in this country. Abbott's
catholic taste and ability to recognize
high quality throughout a wide range
of artistic expression led to purchases
of a section of a mosaic floor from the
ancient city of Antioch, a Romanesque
relief of Saint Peter, a carved axe made
by an unknown artist of the Luba

people, and a silvered surrealist mobile
by Alexander Calder. He began col-
lecting photographs in 1933, at a time
when few considered the medium
worthy of museums. He was also the
guiding influence in the College's com-
mission to the great Mexican muralist
Rufino Tamayo to create a 43-foot-long
fresco, *Nature and the Artist: The Work
of Art and the Observer,* for the walls of
Hillyer Art Library (**26.2**).

Abbott's importance to the develop-
ment of the Smith College Museum's
European collection cannot be over-
stated, but as one of the Sachs-trained
museum directors and curators known
as the Harvard modernists he also
belonged to a wider circle of influence
in the arts. Less heralded than some of
his more famous peers—Barr; Everett
"Chick" Austin, the protean young
director of the Wadsworth Atheneum;
composer Virgil Thomson; and Lincoln
Kirstein, the future founder of the
New York City Ballet—Abbott was
nonetheless among the young tyros

*The more one talks
about pictures in a
museum, the more one
comes to think that it
is a rather pernicious
habit. I am sure that
many times you have
stood patiently waiting,
while somebody finished
an explanation about
a picture and all the
time, very modestly and
quietly, without inter-
rupting in any way, the
picture stood there; it
really had something
definite to say....*

**Jere Abbott, November 21, 1934, from a
lecture at the Smith College Chapel**[4]

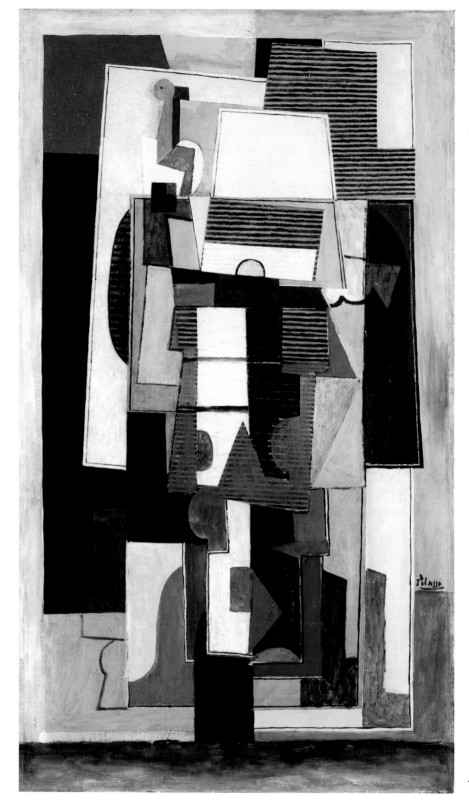

Hartt (**22.6**), who had just been discharged from the U.S. Army Air Corps before coming to Smith as the acting director of the art museum and lecturer in the art department.

Hartt had received his bachelor's degree at Columbia University in 1935 and master's degree from New York University in 1937 before enlisting in 1942. As an officer with the Monuments, Fine Arts and Archives Program, Hartt served in the Allied Military Government in Tuscany, where he accompanied advance forces to locate and return works of art looted by the Nazis and also supervised the restoration of war-damaged monuments. In Austria in 1945–46 he assisted in the return of over 6,000 stolen works, many of which had been hidden in salt mines. He was awarded the Bronze Star for Meritorious Service and was made a Knight of the Crown of Italy and an Honorary Citizen of Florence.[7]

During Hartt's brief one-year term as acting director, the Smith College Museum hosted the exhibitions *War's Toll of Italian Art, Paintings Looted from Holland,* and *Art of 18th Century England,* as well as masterpieces from the Rijksmuseum and Italian baroque paintings. His purchases included drawings by Domenico Campagnola and Ludovico Cigoli and French baroque paintings by Jean Jouvenet and Hyacinthe Rigaud. He also added to the museum's 20th-century American holdings with Marsden Hartley's late still life *Sea Window, Tinker Mackerel.* However, Hartt's most lasting—and unfortunate—impact on the museum was made through a deaccessioning campaign that removed many American paintings from the collection.

who helped to change the culture of visual and performing arts between the two world wars. Champions of both traditional and modern art, advancing film, photography and design as worthy of exhibition and collecting, they were also strong advocates of museums as a means of educating the middle class.[5] Known as "the Friends" or "the family," for a time they enjoyed great freedom. According to Virgil Thomson, after the 1929 Crash "they [the establishment] let their curators take over for a minute.

For five to ten years the intellectuals were allowed to run things."[6]

Jere Abbott's tenure as director of the Smith College Museum ended in 1946, when he returned to Maine to take over his family's woolen business. He would never again hold a permanent position in an art museum, although he was an advisor to and patron of Colby College and later in life joined the Smith College Museum's Visiting Committee. Abbott's successor was the Renaissance scholar Frederick

22.3 Jean-Baptiste Camille Corot. French, 1796–1875. *The Fair Maid of Gascony (La Blonde Gasconne),* c. 1850. Oil on canvas, 15 3/4 × 11 7/8 in. (40 × 30.2 cm). Smith College Museum of Art. Purchased, Drayton Hillyer Fund, 1934. Photograph by David Stansbury.

22.4 Charles Sheeler. American, 1883–1965. *Rolling Power,* 1939. Oil on canvas, 15 × 30 in. (38.1 × 76.2 cm). Smith College Museum of Art. Purchased, Drayton Hillyer Fund, 1940. Photograph by David Stansbury.

Soon after his appointment, Hartt submitted a plan for raising money for expanding the museum's storage and exhibition space by selling works in the collection, primarily American paintings thought not to be of first quality or that were deemed "duplicates." The final list, approved by the College, included some eighty works, most of which were sold through a sales gallery at Gimbels department store in New York. Many of the paintings were purchases made by President Seelye in the early days of the College. Most have never been located, but several found museum homes, including Abbott Handerson Thayer's *Winged Figure,* in the collection of the Art Institute of Chicago, and Thomas Dewing's *Lute Player,* owned by the National Gallery of Art. In the end, the Gimbels

22.3

22.4

22.5 Attributed to Dieric Bouts. Flemish, by 1457–1475. *Portrait of a Young Man*, late 1460s–70s. Silverpoint on ivory prepared paper, 5 7/16 × 4 1/4 in. (13.9 × 10.7 cm). Smith College Museum of Art. Purchased, Drayton Hillyer Fund, 1939. Photograph by David Stansbury.

sale garnered only about $10,000. A number of the works did not sell at the retail price and were discounted; some were sold through galleries and to individuals.[8] Only after 1949, under director Henry-Russell Hitchcock and curator and assistant director Mary Bartlett Cowdrey, who was an American specialist, would Hartt's breach to the museum's American collection begin to be repaired.

After leaving Smith in 1947, Hartt went on to establish his reputation as a distinguished scholar, particularly of the work of Michelangelo, and as the author of thirteen books, including his monumental textbook, *History of Italian Renaissance Art.* He was succeeded as acting director by Edgar Schenck, who had headed the Honolulu Academy of the Fine Arts for ten years before coming, as he said, from "an outpost of New England to New England"[9] in the summer of 1947. A graduate of Princeton, where he received a bachelor's degree in 1931 and an MFA in 1934, Schenck was appointed director of the museum in July 1948. He made several significant purchases of paintings for the collection, including William Hogarth's jovial portrait of the Reverend John Hoadly (which had been shown in the exhibition *Art of 18th Century England* the previous year), Henry Fuseli's Shakespearean subject *Lady Constance, Arthur and Salisbury,* and Ben Shahn's *Sound in the Mulberry Tree.*

Arguably, Schenck's most important achievement during his two years at Smith was the 1948 *Pompeiana* exhibition, a collaborative project with Phyllis W. Lehmann and other members of the Smith College art department. The exhibition, which featured the never-before-lent Boscoreale silver treasures from the Louvre, commemorated the discovery of Pompeii and explored its influence on the arts (**22.7**). Edgar Schenck left Northampton in 1949 to succeed Andrew Ritchie as director of the Albright Art Gallery in Buffalo. He went on to become director of the Brooklyn Museum of Art from 1955 until his death abroad in 1959.

Notes

1 Letter from Paul J. Sachs to Jere Abbott, December 31, 1931, Harvard University Art Museums Archives.

2 Other prominent museum professionals mentored by Sachs include John Walker, director of the National Gallery of Art, Washington, D.C.; Agnes Mongan (Smith AM 1929), the Fogg Art Museum's distinguished curator and connoisseur of drawings; her sister, Elizabeth Mongan (Smith LHD 1985), curator of prints at the National Gallery and later at the Smith College Museum of Art; Otto Wittman, director of the Toledo Museum of Art, and others.

3 Michael Pantazzi, in *Corot,* exh. cat. (New York: Metropolitan Museum of Art, 1996), p. 175.

4 Lecture transcript, Smith College Archives (Jere Abbott file, box 6554.1).

5 Steven Watson, "Julien Levy: Exhibitionist and Harvard Modernist," in Ingrid Schaffner and Lisa Jacobs, eds., *Julien Levy: Portrait of an Art Gallery* (Cambridge, Massachusetts: MIT Press, 1998), pp. 83–95.

6 Quoted in Watson, p. 85.

7 Press release, November 11, 1946, Smith College Archives (Frederick Hartt file, box 841).

8 Linda Muehlig, Introduction, *Masterworks of American Painting and Sculpture from the Smith College Museum of Art* (Northampton: Smith College Museum of Art, in association with Hudson Hills Press, 1999), pp. 10–11.

9 Edgar Schenck, quoted in a Smith College press release, September 1, 1947, Smith College Archives (Edgar Schenck file, box 1006).

22.6 "Smith College Couple Leaves for Florence—Prof. Frederick Hartt, acting head of Smith College Art Museum, and Mrs. Hartt board motorship Sobjeski of Gydnia American Line in New York…" Photograph published by the *Boston (Mass.) Traveler*, stamped July 2, 1947. Smith College Archives.

22.7 "Five silver pieces over 1,800 years old…examined on the liner De Grasse on her arrival yesterday by Mrs. Phyllis W. Lehmann, Assistant Professor of Art at Smith, and Edgar C. Schenck, director of the college museum, as the collection is turned over to them by Cap. Joseph Cailloce." Photograph published in the *New York Times*, November 6, 1948, article "Pompeii Treasure Here for Exhibit."

Filling the Gaps: Henry-Russell Hitchcock and Robert Owen Parks, 1949–1961

Helen I. Hall, Assistant to the Director, Smith College Museum of Art, 1960–61

An architectural historian of international renown, Henry-Russell Hitchcock (**3.2**, **9.1**, **23.1**) brought to his stewardship of the Smith College Museum of Art (1949–1955) a broad knowledge of the museum world as well as the many connections he had forged during his tenure in the 1930s as assistant to A. Everett ("Chick") Austin, the innovative director of the Wadsworth Atheneum in Hartford.[1] Hitchcock, who had arrived at Smith in 1948 as a professor in the art department, had for many years followed the work of contemporary artists on both sides of the Atlantic, a longstanding interest that would serve to enhance the collections of the museum.

Hitchcock was an astute administrator. To set the museum on a more professional footing and to add expertise in the field of American art, he appointed Mary Bartlett Cowdrey (**23.2**) to the new position of assistant curator soon after he became acting director in 1949. Cowdrey had worked as registrar at the Brooklyn Museum and as curator of prints at the New-York Historical Society; her handling of the day-to-day operations of the museum became invaluable to Hitchcock, who continued to teach half-time.[2] In addition, Hitchcock was responsible for establishing the museum's Visiting Committee. The committee, consisting of alumnae, collectors, and museum professionals, was conceived in response to a request made by the Counselors of Smith College, who in October 1951 approached Hitchcock and Bernice McIlhenny Wintersteen (class of 1925) about forming a group to advise on museum

policy and on the development of the collections. The newly formed Visiting Committee met for the first time in April 1952.

As a scholar, Hitchcock saw the need to make information about the collections more readily available to an audience beyond the Smith campus. He revived the *Smith College Museum of Art Bulletin*, which was published biennially. He also planned to issue a series of "picture-books" of the museum's French, American and English holdings. The only one to be published, however, was *Forty French Pictures* in 1953, consisting of two introductory essays by Hitchcock and George Heard Hamilton, full-page illustrations and brief catalogue essays. In the same year forty-five paintings and drawings from the museum's collection were exhibited at the Knoedler Gallery in New York. Two exhibitions, *Smith College Collects I* and *II*, consisting of recent purchases and gifts of works by contemporary British, Italian, French, Israeli, Canadian and American painters and sculptors, were circulated nationally by the American Federation of Arts from 1953 to 1955. Under Hitchcock, the museum's lending policy was generous and brought to the institution both national and international attention, especially with the loan of Courbet's *The Preparation of the Dead Girl* (**28.6**) to the Venice Biennale, then to museums in France and Britain, in 1954 and 1955.

As he added to the collections, Hitchcock followed the lead of Alfred Vance Churchill and Jere Abbott in focusing on the origins of modern painting; but while Churchill and Abbott drew their examples almost

exclusively from French and American art of the 19th and early 20th centuries, Hitchcock expanded the field to include works from a wider range of countries extending back through the 18th century.

Hitchcock's first important English purchase was in 1950: *A Cavern, Evening*, 1774, by Joseph Wright of Derby, which he followed with acquisitions of mezzotints after Wright of Derby's paintings. (In 1955 Thomas McCormick of the art department organized the first American exhibition of the artist.) Notable gifts included twenty-six English watercolors from the children of Florence Corliss Lamont (class of 1893) and a large group of Ruskin drawings donated by Charles E. Goodspeed, who was inspired by the exhibition *Ruskin's Seven Lamps of Architecture*, held at the museum in 1949.

On his annual summer forays to Europe, Hitchcock was able to purchase contemporary paintings, sculpture and prints, sometimes directly from the artists. Through Hitchcock's efforts the museum came to possess a small group of distinguished works by British painters and sculptors of the 1940s and 1950s, among them Ben Nicholson and Henry Moore, which is probably unparalleled in the United States. Contemporary Italian art was likewise added to the collection, which came to include a 1954 still life by Giorgio Morandi and Marino Marini's *Head of Igor Stravinsky*, purchased with funds given by Bernice Wintersteen.

Although major French works were becoming harder to find and increasingly expensive, Hitchcock was able nonetheless to fill some gaps, acquiring Hubert Robert's neoclassical *Pyramids*

of about 1760, a small Vernet, examples of romantic art including the atypical Ingres *Death of Leonardo da Vinci* and *Arab Battle* by Chassériau, and Barbizon paintings. Gauguin's *The Market Gardens of Vaugirard*, 1879, and the almost contemporary *Outskirts of Pontoise* by Pissarro strengthened the holdings of impressionist landscapes, while *Mechanical Element I* by Léger complemented other cubist paintings in the collection. Hitchcock acquired drawings by David, Daumier, Greuze, Guys and Redon at a time when paintings by these artists were scarce or unaffordable.

The twenty-fifth anniversary of the Tryon Gallery in 1951 brought a number of gifts, including Benjamin West's *Conversion of St. Paul* from Adeline F. Wing (class of 1898) and Caroline R. Wing (class of 1896) and Florine Stettheimer's *Portrait of Henry McBride* from her sister Ettie. American holdings were further enhanced by the purchase of a portrait by Thomas McIlworth, examples of the Hudson Valley School, the anonymous *View of Northampton from the Dome of the Hospital* (later identified as by Thomas C. Farrer) and Edwin Romanzo Elmer's *Mourning Picture* (**28.24**). With such acquisitions, Hitchcock, assisted by Cowdrey, began to offset the losses to American art that the museum had suffered under the deaccessioning policy of Frederick Hartt.

Hitchcock turned to prints to provide affordable examples of works by artists not already represented in the collection. Among his earliest purchases, and reflecting his interest in architecture, were several volumes of Piranesi etchings, including the *Carceri* series from the collection of the Prince of Liechtenstein. Five Canaletto etchings came from the same source. For advice on print acquisitions, Hitchcock turned to a subcommittee of the Visiting Committee—W. G. Russell Allen, a Boston print collector, and Philip Hofer and Agnes Mongan of the Fogg Art Museum—and two galleries were made available for the study of prints. A major addition to the fledgling photograph collection came as a gift from the Philadelphia Commercial Museum: 479 photogravures from Eadweard Muybridge's *Animal Locomotion*.

As the collections expanded, lack of space in the small museum became an increasing problem. The galleries containing the permanent collection were constantly being changed to accommodate temporary exhibitions that were generated by the museum staff or that were circulated from the American Federation of Arts, the Museum of Modern Art or the Smithsonian Institution, often as a supplement to courses being taught in the art department. In 1950–51 the College built an enclosed bridge, designed by Karl. S. Putnam, professor in the art department, linking the Hillyer building with

Our building, any gallery in it, any group of objects of a given school or period, any single major or minor treasure, is obliged to excite something like surprise, admiration and wonder….what is of first and last importance for the College is that this fine tool, among its most conspicuous ornaments, must be put to use to stir up the fire.

Robert Owen Parks, 1956

23.2 Mary Bartlett Cowdrey.
Smith College Archives.

23.3 The early European room at the
time of the celebration of the twenty-fifth
anniversary of the Tryon Gallery, 1951.

the rear of the museum and replacing an underground tunnel. While presenting a more welcoming approach on the campus side of the museum, this new space also served as a gallery for modern sculpture.

Hitchcock returned to teaching full-time in the fall of 1955. In his final annual report he noted that the museum had received more gifts in that year alone than in any other to date. This pace of generosity was to continue unabated during the directorship of Hitchcock's successor, Robert Owen Parks (**23.4**).

Parks, who came to Smith College in 1955 from the John Herron Art Museum in Indianapolis, made it his mission from the outset to foster the museum's didactic purposes. "Our building," he wrote in 1956, "any gallery in it, any group of objects of a given school or period, any single major or minor treasure, is obliged to excite something like surprise, admiration and wonder….what is of first and last importance for the College is that this fine tool, among its most conspicuous ornaments, must be put to use to stir up the fire."[3]

Under Parks, who had a background in 17th- and 18th-century art, the collections became much more encyclopedic. His purchases of objects from a wide range of countries, periods and media reflect a fine eye and an understanding of what would be most valuable in teaching. He questioned the wisdom of too closely following a concentration policy that had been established a quarter of a century earlier, when tastes, purchase power and supply had been different. He wrote, "It seems to me that we will be wiser to be

opportunists, buying whatever we can find that we want. It seems to me that the quality of the works of art available should be the main determining factor in making acquisitions."[4]

The purchases Parks made in the first two years he was director clearly demonstrate his eclectic tastes. They include Kirchner's *Dodo and Her Brother* (**23.5, 28.16**), Bellotto's *View of a Palace Courtyard*, Ralph Earl's *Master in Chancery*, a portrait by Girodet, Redon's *Les Yeux Clos*, a sixth-century Greek kylix, drawings by Agostino Carracci and Salvator Rosa, thirty-seven engravings by Abraham Bosse (an exhibition on this artist was held at the museum in 1956), and a 15th-century English alabaster of the Crucifixion.

The postwar break-up of European collections meant that there was a wealth of drawings on the market, and Parks was able to take advantage of this, both in New York and abroad (like Hitchcock, he traveled to Europe each summer). His purchases included Rosso Fiorentino's red and black chalk drawing of the *Martyrdom of Saints Marcellinus and Mark*, an ink landscape sketch by Fra Bartolommeo, a

mountain landscape in ink by Pieter Brueghel, a chalk study of a *Head of a Woman*, by Federico Barocci, and G. B. Tiepolo's ink drawing of *Rinaldo and Armida*. He also found, in 1959, a graphite study for *The Death Leap of Marcus Curtius*, a painting by Pannini that had been given to the museum in 1951.

Alumnae and other friends of the museum continued to be extraordinarily generous, giving both objects and funds for their purchase. Three donors in particular stand out: Eleanor Lamont Cunningham (class of 1932) and Adeline (class of 1898) and Caroline (class of 1896) Wing. Mrs. Cunningham had donated funds to the museum annually since 1949. Hitchcock had used them to pay for visiting lecturers, for books relating to objects in the collection and to buy a large Ben Nicholson painting and a portrait by Thomas McIlworth. The Cunningham funds enabled Parks to publish the *Bulletin* annually, buy paintings by Abraham Mignon, Sebastien Bourdon and Rousseau, a Schwitters collage and prints and drawings. In addition to donating the Benjamin West altarpiece

23.4 Robert Owen Parks and two students standing in front of the painting by Ralph Earl, *A Master in Chancery Entering the House of Lords*. Smith College Archives.

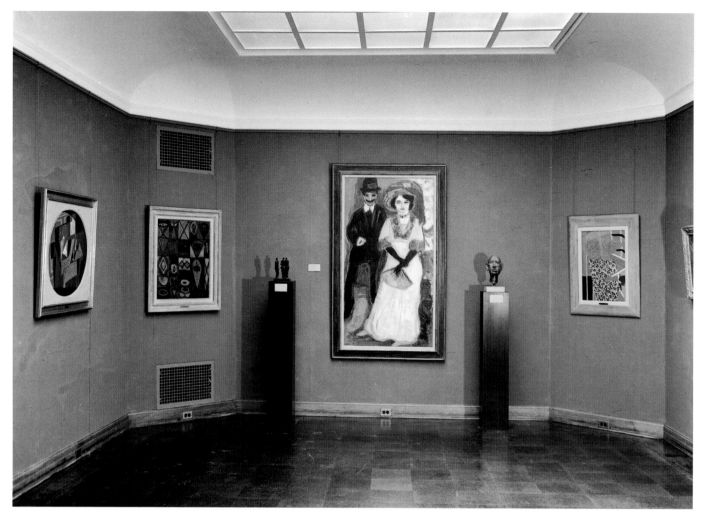

and Lily Martin Spencer's *Reading the Legend* during Hitchcock's directorship, the Wing sisters provided funds that Parks used to purchase several 17th-century Dutch paintings, including Terbrugghen's *Old Man Writing by Candlelight* as well as Monet's *Cathedral at Rouen*.

Margaret Goldthwait Taylor (class of 1921) was another generous alumna. Not only did she and her brother give the portrait of Henrietta Vane by Gilbert Stuart, but she also created a slide show of highlights in the collection, which she enthusiastically presented to Smith clubs throughout the United States, thereby generating a wider alumnae interest in the museum.

When Parks arrived at Smith, Mary Bartlett Cowdrey's position was eliminated. Remarkably, with a reduced staff he was able to prepare an annual *Bulletin*, teach in the art department, and maintain a full exhibition schedule. He reorganized the galleries so that the earliest art was displayed in the downstairs rooms, and he used the corridor there as a space to hang prints and drawings. Exhibitions were devised in consideration of the sometimes highly special-

ized interests of students in art courses: *Neolithic to Ming, Michelangelo's "Figura Serpentinata,"* a major Piranesi show with a symposium, and a 20th-century American sculpture exhibition organized jointly with Mount Holyoke College. Several masterpieces, including paintings by El Greco, Veronese, Poussin, a sculpture by Giovanni da Bologna and a 12th-century French enamel reliquary, were borrowed from larger museums for study in senior seminars.

Parks's last major exhibition at Smith, which opened in January 1961, six months before the Hancock Shaker Village, was *The Work of Shaker Hands* (**23.6**), accompanied by *Shaker Inspirational Drawings*. Parks was instrumental in organizing a week-long study of the Shakers on campus, involving the departments of art, English, government, history, music, religion and theater, with a symposium and concert at which the glee clubs and orchestras of Smith and Amherst Colleges performed.

Between the time Parks resigned in April 1961 and Charles Chetham's arrival in 1962, the museum was admin-

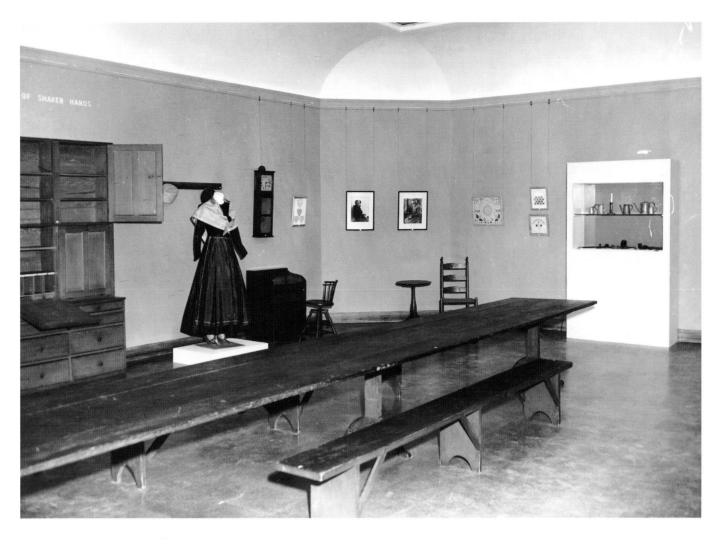

istered first by Hamish Miles, a visiting lecturer in the art department from the University of Glasgow, then by Patricia Milne-Henderson, who had come to Smith from Cambridge University to do graduate work. Even in this short interregnum, the programs at the museum were varied and instructive. A Daumier exhibition was followed by one of drawings by George Romney, the subject of Milne-Henderson's thesis. She also put together an exhibition of Greek and Roman coins drawn from the museum, the classics department and members of the faculty.

Hitchcock and Parks were each honored later at the museum with special exhibitions, Hitchcock in 1968 at the time of his retirement from the art department, and Parks, posthumously, in 1999.

I would like to thank Sue Welsh Reed for her help and Michael Goodison for his patience in guiding me through the archives at the Smith College Museum of Art. The directors' annual reports and the minutes of the Visiting Committee were a valuable source of information.

Notes

1 For Hitchcock's activities at the Wadsworth Museum see Eugene R. Gaddis, *Magician of the Modern: Chick Austin and the Transformation of the Arts in America* (New York: Alfred A Knopf, 2000).

2 In 1951 Cowdrey became assistant director of the museum and was acting director in the fall semester of 1954, when Hitchcock took a leave of absence. Three exhibitions stand out among the many she organized at the museum: the first-ever of still-life paintings by John Peto in 1950; *Winslow Homer, Illustrator*, built around the newly purchased Homer oil *Shipbuilding at Gloucester* in 1951; and *Edwin Romanzo Elmer* in 1952. With her knowledge of the art world, she brought potential acquisitions to Hitchcock's attention; she also undertook the task of providing more suitable frames for many of the paintings and drawings in the collection. She left the museum when Hitchcock's successor, Robert O. Parks, arrived in 1955.

3 Robert O. Parks, "Smith College Collects Plus," *Smith Alumnae Quarterly* XLVII, 2 (Winter 1956).

4 Appendix to the agenda of the January meeting of the Visiting Committee, March 20, 1957.

23.6 View of the exhibition *The Work of Shaker Hands*, January 1961.

Energy, Expansion and Diversity: Charles Chetham, 1962–1988

Christine Swenson, Curatorial Consultant

Charles Chetham, director of the Smith College Museum of Art and professor in the art department from 1962 to 1988, brought to his stewardship great imagination and energy, meeting all challenges during a period of sustained growth in collections, staff, and facilities. When Chetham arrived in Northampton, the museum was still in Tryon Hall. He began with a staff of three including himself. By the time he left he had established many new positions—among them Associate Director/Curator of Painting, Assistant Curator of Painting, Assistant Curator of Prints and Drawings, Archivist and Preparator—and increased the staff to sixteen. The collection had grown from 6,000 to 18,000 objects. The facilities had expanded fourfold in a new art complex, which he was instrumental in developing, and he had created a lasting treasure of loyal and dedicated donors and supporters as well as trained three generations of museum professionals.

Chetham's era coincides with the tenures of three College presidents: Thomas Corwin Mendenhall, Jill Ker Conway, and Mary Maples Dunn (24.1). After assuming the position of director in 1962, Chetham worked closely with these presidents and the faculty of the College to nurture a museum dedicated to providing resources for students, educators and the general public, improving relations between "town" and "gown." In his first annual report to the College (1963), he set the tone for his aims and goals:

The Smith Museum is a museum in miniature, but none the less a museum in its own right. This is a result of its long and distinguished history and is attested to by the attention paid its exhibitions, publications, and collections…. The Museum can make a solid contribution to the cultural and intellectual life of this community and to the education of the Smith girl.

With his well-known energy and enthusiasm, Chetham immediately set about seeing to it that the Smith College Museum of Art would continue to be recognized as a world-class art institution.

Chetham, a graduate of Harvard University and, before coming to Smith, the assistant director at the University of Michigan Museum of Art, was sincerely dedicated to teaching—not just teaching from slides in a classroom, but using original works to instill a real understanding of art. This hands-on approach to art and to the workings of a museum became key to his directorship, under which the museum became ever more essential to the learning experience at Smith.

Chetham quickly began to hire young professionals, who not only contributed their academic knowledge and experience to the museum, but also gained professional training there. The first of these was David Brooke, who worked at Smith from 1963 to 1965. He went on to become director of the Currier Gallery of Art in Manchester, New Hampshire, and then the Sterling and Francine Clark Art Institute in Williamstown, Massachusetts. Michael Wentworth, widely known and respected for his scholarly publications on the British painter and printmaker James Jacques Tissot, worked at Smith from 1968 to 1970.

Chetham also took an interest in a younger, less experienced generation. In 1964 he taught his first museum seminar for Smith College students. The objective was to provide students with a direct experience of art museums and the consequent responsibilities and creative potential. Each semester the students organized an exhibition, from researching the works to installing them, and made at least one trip to New York City to visit galleries and museums. Chetham also established a work-study program for Smith students. Undergraduates could work with various staff members and learn the ins and outs of museums, from curatorial documentation and archival record-keeping to shop work and installation. Many of Chetham's students went on to professional careers in the arts, becoming dealers in commercial art as well as curators, administrators and directors of museums.

It is impossible to discuss the development of professional standards and increased efforts in education at SCMA without mentioning Elizabeth Mongan (24.2), the museum's first curator of prints and drawings. Mongan had worked with Lessing J. Rosenwald, managing his collection of works of art on paper in Allentown, Pennsylvania, just outside Philadelphia. When the Rosenwald collection became part of the National Gallery of Art, Mongan was appointed curator of prints at the NGA before joining the staff of SCMA. Her experience, knowledge, expertise and eye for quality helped shape and organize a superb collection of works of art on paper at Smith.

Marilyn Symmes, who later went on to become curator of prints and drawings at the Cooper-Hewitt, National Design Museum, Smithsonian Institution in New York, with stints in between at the Detroit Institute of Arts and the Toledo Museum of Art, was Mongan's assistant in the Cunningham Print Study Room when the new building opened in 1973. Together Mongan and Symmes set high standards for the collection of graphic arts.

Chetham established an internship program at SCMA that took advantage of a newly established National Endowment for the Arts program funding museum internships. Through educational and professional collaboration with the federal government, the SCMA acquired a changing staff of interns who, in turn, gained professional experience through an association with the museum.

Chetham built particularly strong connections with the University of Michigan and the Williams College graduate programs in art history and museum training, as well as with the art museums at those institutions. Charles Sawyer, director of the University of Michigan Museum of Art when

Chetham was assistant director for one year, was the son of a Smith graduate. Nesta Rubidge Spink (Mrs. Walter Spink, class of 1948) was one of the curators at that museum. The Spinks had known Chetham and his family in Cambridge, Massachusetts, and renewed their acquaintance with him in Ann Arbor. Marjorie Harth (class of 1965), one of Chetham's first seminar students at Smith, became the director of museum studies at the University of Michigan and associate director of the museum there. Sawyer, Spink and Harth encouraged several Michigan graduate students to pursue museum careers, beginning with internships at Smith. In Williamstown, David Brooke had become director of the Clark Art Institute by the time the NEA internship program was established at SCMA, and through his long association and friendship with Chetham, guided a number of valuable interns from the Williams College graduate program to SCMA.

Many former Smith interns have gone on to establish careers in the arts, including Elizabeth Evans, now a freelance curator; Marilyn Symmes; and two valuable members of the current

24.1 Charles Chetham, Thomas Corwin Mendenhall and Jill Ker Conway, mid-1970s. Photograph by Stan Ries.

24.2 Elizabeth Mongan, c. 1977. Photograph by Gabriel Amadeus Cooney.

24.3 Betsy Burns Jones, c. 1977. Photograph by Gabriel Amadeus Cooney.

SCMA staff, Linda Muehlig, associate director for curatorial affairs, and Michael Goodison, archivist/editor. Patricia Junker went on from her internship to several prominent museums and is now curator of American art at the Amon Carter Museum in Fort Worth. Nancy Sojka, now curator of graphic arts at the Detroit Institute of Arts, began her career at SCMA then went to the Philadelphia Museum of Art. The NEA funded internships almost every year from 1972 to 1995 when Congress reduced its support; SCMA can now seek NEA funding for only one project annually, and has reluctantly ended the NEA internship program. Dan Strong, the twenty-third and last NEA intern (1995–96), is now associate director of the Faulconer Gallery at Grinnell College.

Chetham's enthusiasm also attracted many benefactors to the museum, who were inspired to make its long-term goals achievable. Among them were Priscilla Cunningham (class of 1958), Selma Erving (class of 1927), the Dalrymple and Doyle families and the Smith Club of Michigan. Cunningham, born and bred in the museum world (her father was Charles C. Cunningham, who had a long and distinguished museum career, and her mother was Eleanor Lamont Cunningham, class of 1932) supported SCMA with gifts, good deeds and hard work (**24.6, 28.15**). Erving gave her collection of late-19th and early-20th-century prints, drawings and books to the museum, making SCMA one of the finest resources for this material, not only in New England but in the nation (**24.7, 28.22**).

Chetham fostered strong ties to the New York art world, building on the already strong association with the Museum of Modern Art forged during the era of Jere Abbott. Chetham persuaded Betsy Jones (class of 1947) (**24.3**) to leave her position as curator of painting and sculpture at MoMA in 1974 to become SCMA's associate director and curator of painting. A solid scholar, Jones also brought a good jolt of appreciation for 20th-century art as well as a sense of humor. Chetham also depended on many distinguished professionals in New York and New England to serve as members of the Visiting Committee, including prominent alumnae, former SCMA associates, museum professionals and others.* Their advice and support as curators, art historians, authors, and collectors were important to the museum's development and its strength within the community both locally and internationally.

During this period the museum continued to develop a collection marked by excellence. Most particularly, Chetham was instrumental in establishing a superb photography collection, building on the influence of Abbott and following the example of MoMA. During the 1960s and 1970s, many museums and libraries discovered, tucked away in storage, important photographs originally acquired as reference materials. Chetham, who had a special appreciation for the artistic value of photographs, not only found them in existing Smith archives, but took a very active approach to expanding the collection with photography purchases and, when offered, gifts. He also commissioned photographs for the permanent collection. In 1985, for example, he arranged to have Robert Mapplethorpe photograph Mary

24.4 Robert Mapplethorpe. American, 1946–1989. *Mary Maples Dunn*, 1985. Gelatin silver print, 20 × 16 in. (50.8 × 40.6 cm). Purchased with funds from the Museum Members, Smith College Museum of Art. Photograph by David Stansbury. © Robert Mapplethorpe Foundation.

Maples Dunn (**24.4**). Mapplethorpe's image is a rich and subtle portrait of the then-new president of the College.

Chetham found treasures in what some might think unlikely sources. George Dimock, Jr., son of Professor George Dimock of Smith's classics department, came across a trove of mid- to late-19th-century photographs at the Lenox Library in Lenox, Massachusetts, where he worked. He contacted Chetham, who went to Lenox to see the collection and to discuss the issues with Dimock; Smith then purchased the collection (**28.23**). Among the gifts of photographs to the museum was Charles Sheeler's *Drive Wheels*, given by Dorothy Miller (Mrs. Holger Cahill, class of 1925). Sheeler's painting of the same subject, titled *Rolling Power* (**22.4**), is also in the museum's collection and was based on the photograph.

In addition to firmly establishing the photography collection, Chetham developed the collection as a whole in a similarly remarkable fashion, with an emphasis on the aesthetic and material quality of objects as well as a consideration of their relation to the museum's ideals and goals. Again, Chetham cultivated gifts and donations, as well as purchase funds. The collection of modern paintings developed in depth. An untitled painting by Joan Mitchell was acquired with funds given by Nancy O'Boyle (Mrs. John O'Boyle, class of 1952). Frank Stella gave his painting *Damascus Gate* in 1969, one of the first major acquisitions in Chetham's tenure. Two untitled Mark Rothko paintings were the gift of the Mark Rothko Foundation in 1986. Chetham founded the College's first sculpture garden in 1963 (**28.19**). In 1965 the museum acquired Auguste Rodin's *Walking Man* (**24.5**), which was installed in the courtyard between the museum and the art history and studio building when the complex was completed. Sol LeWitt's *Cube Structure, 1976–77*, was purchased in 1977, the same year as Richard Stankiewicz's untitled circular steel piece of 1975. Claes Oldenburg's *Soft Fan*, made in 1965, was purchased for the SCMA collection in 1979.

Bequests provided essential support for the growth of the collection during these years. The Seaver bequest, the Sigmund and Maxine Kunstadter bequest, and the Seasongood bequest are a few of the generous resources established in this era, providing for the purchase of works as well as the funding of museum publications.

Intent on expanding the public's awareness of the significance of SCMA's collections, Chethem initiated a major effort in publishing them. He encouraged the staff to write, and numerous catalogues were issued, some of which were general guides and others focused on specific topics or artists. When Tryon and Hillyer were closed in the early 1970s for the rebuilding of the arts complex, major paintings from the collection went on tour, and *19th and 20th Century Paintings from the Collection of the Smith College Museum of Art*, a catalogue edited by Mira Matherny Fabian, Michael Wentworth and Charles Chetham was published to document the exhibition. This catalogue and exhibition served as a precedent for recent traveling shows of the collection organized while the Brown Fine Arts Center has been under construction. While the 1970 publication featured just paintings, there were also other types of guides to the museum produced during Chetham's tenure, including *A Guide to the Collections: Smith College Museum of Art*, published in 1986, and two volumes of the Selma

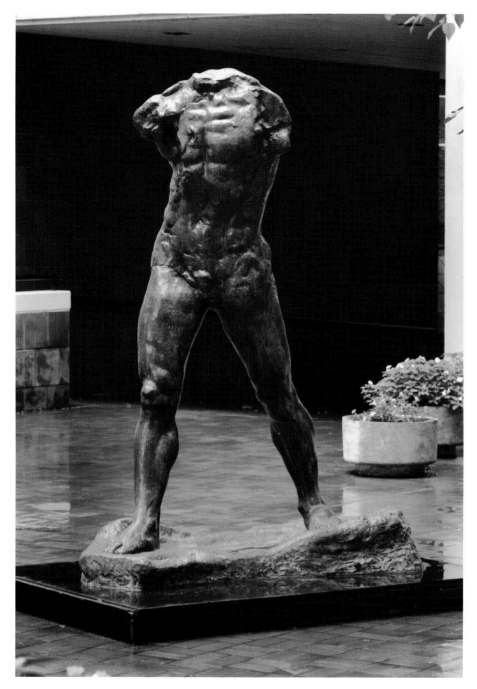

24.5 Auguste Rodin. French, 1840–1917. *The Walking Man*, modeled 1877–78, this cast 1965. Bronze, 7 1/2 × 2 1/2 × 5 1/4 ft. (228.6 × 76.2 × 160 cm). Smith College Museum of Art. Purchased, 1965. Photograph by E. Irving Blomstrann.

lections. Through the development of a professional staff, rigorous standards, and the training of students and young professionals, Chetham motivated the Smith College Museum of Art to become a truly world-class arts facility.

* Among these were Jere Abbott and David Brooke, Jean Brown, Charles E. Buckley, Mrs. Malcolm G. Chace, Jr. (Beatrice Oenslager, class of 1928), Mrs. Jerome Cohen (Joan Lebold, class of 1954), Mrs. Ralph F. Colin (Georgia Talmey, class of 1928), Charles C. Cunningham, Priscilla Cunningham (class of 1958), Mrs. Henry T. Curtiss (Mina Kirstein, class of 1918), Dorothy Dudley, John L. Eastman, Colin Eisler, Selma Erving (class of 1927), Ernest Gottlieb, Marjorie Harth (class of 1965), Philip Hofer, Barbara Petchesky Jakobson (class of 1954), Mr. and Mrs. Sigmund W. Kunstadter (Maxine Weil, class of 1924), Mrs. Maurice Lazarus (Nancy Stix, class of 1942), Douglas Lewis, A. Hyatt Mayor, Dorothy Cahill Miller (class of 1925), Agnes Mongan (AM 1929; LHD 1941), Elizabeth Mongan (LHD 1985) (after she had left the museum), Mrs. Raymond D. Nasher (Patsy Rabinowitz, class of 1949), Beaumont Newhall, Mrs. John W. O'Boyle (Nancy Millar, class of 1952), Mrs. Roger B. Oresman (Janice Carlson, class of 1955), Mrs. James E. Pollak (Mabel Brown, class of 1927), Sue Welsh Reed (class of 1958), James Thrall Soby, Mr. and Mrs. Morton I. Sosland (Estelle Glatt, class of 1946), Joanne Melniker Stern (class of 1944), Mrs. Charles Lincoln Taylor (Margaret Golthwait, class of 1921), Angela Westwater (class of 1964), Enid S. Winslow (Enid Silver, class of 1954), and Mrs. John Winstersteen (Bernice McIlhenny, class of 1925).

Erving gift. The first, *The Selma Erving Collection, Modern Illustrated Books*, appeared in 1977 with an essay by Ruth Mortimer, then-curator of rare books at Smith, and edited by John Lancaster, curator of special collections at Amherst College. The second Erving volume, subtitled *Nineteenth and Twentieth Century Prints*, was issued in 1985. When Chetham retired, the third and final volume documenting Selma Erving's collection of drawings was in progress. Other provocative and illuminating publications, catalogues as well as independent projects, were more specific in focus and demonstrate a dedication to art-historical scholarship on the part of both faculty and museum staff. Projects ranged from

classical art to American painting, as well as European printmaking and the book arts.

During these energetic and dynamic years, the installation of the permanent collection was constantly changing. When visitors entered the museum they might see a replica of Shakespeare and Company, the bookstore on the Left Bank in Paris, or a startling new arrangement of the partitions and works placed in unexpected juxtapositions. The museum was an environment for thinking and learning as well as a space to see wonderful works of art—and always a place for new experiences. The collection grew to rival that of other major academic institutions as well as many public and private col-

24.6 Paul Cézanne. French, 1839–1906. *Village Cottages (Maisonettes)*, 1880–85. Brush with transparent and opaque watercolor (gouache) over graphite on beige wove paper, 12 7/8 × 19 11/16 in. (32.7 × 49.9 cm). Smith College Museum of Art. Bequest of Charles C. Cunningham in memory of Eleanor Lamont Cunningham (class of 1932) through the kindness of Priscilla Cunningham (class of 1958), 1980. Photograph by Stephen Petegorsky.

24.7 Henri de Toulouse-Lautrec. French, 1864–1901. *Miss Loie Fuller*, 1892. Lithograph on wove paper, 15 × 11 1/8 in. (38.1 × 28.2 cm). Smith College Museum of Art. Gift of Selma Erving (class of 1927), 1978. Photograph by Stephen Petegorsky.

Shaping the Museum for the 21st Century: From Edward J. Nygren and Charles Parkhurst to the Present

Suzannah Fabing, Director and Chief Curator
Museum of Art

After more than a quarter-century under Charles Chetham's leadership, the Smith College Museum of Art entered a period of rapid change. Edward J. Nygren (**25.1**), who had been curator of collections at the Corcoran Gallery of Art in Washington, D.C., became director and chief curator at Smith in fall 1988. He departed two-and-a-half years later to become curator of art collections at the Huntington Museum in San Marino, California. Charles Parkhurst came out of retirement to serve as interim director from March 1991 through July 1992, when I took office. In addition to undergoing this rapid turnover at the helm, the museum was buffeted during these years by major building repairs and the effects of the recession of the early 1990s.

Although he is best known for his scholarship on American and British art of the 18th and early 19th centuries, Nygren should be remembered here at Smith for refocusing attention on contemporary art, particularly painting and sculpture, coming full circle to President Seelye's notions about the function of the collection. With the staff, Nygren reinstalled the galleries in a roughly chronological sequence, placing the earliest art—that of Egypt, Greece and Rome—on the uppermost floor and the most recent on the lowest level. The museum's greatest strengths, its 19th- and early-20th-century holdings, became the first works a visitor saw upon entering, and large-scale contemporary works benefited from the dramatic, high-ceilinged space of Dalrymple Gallery.

Nygren traveled extensively in 1988–89 in conjunction with the College's fundraising campaign. Along the way the new director visited many distinguished alumnae collections, from which he formulated an exhibition entitled *Smith Collects Contemporary*. Students in his 1990 museum seminar prepared catalogue entries for the exhibition, which opened in May 1991 and included seventy notable paintings and sculptures from the previous four decades.

Along with associate curator of painting and sculpture Linda Muehlig, Nygren sought to make contemporary art more vivid by devising more exhibitions of recent work and by inviting living artists to campus to conceive site-specific installations, talk about their work and interact with students. Nancy Spero created such an installation in 1990, followed by Janna Longacre and Joseph Upham (1990–91) and Vernon Fisher (1990–91). An exhibition of Betye and Alison Saar brought this dynamic mother and daughter pair to campus in spring 1991. Patrick Dougherty and Grace Knowlton were shown the following academic year. A trio of artists of diverse ethnic backgrounds was invited to respond to the 500th anniversary of Columbus's discovery of America in 1992–93: Chicana Carmen Lomas Garza, African-American Pat Ward Williams, and Native American Jaune Quick-to-See Smith.

Nygren set a goal of attaining accreditation from the American Association of Museums, a designation that attests to an institution's professional excellence in all areas of its operations. In preparation for the accreditation review, the staff, Visiting Committee, and ultimately the College's Board of Trustees formalized a mission statement and policies on acquisitions, deaccessioning, loans and ethics. Parkhurst carried forward the lengthy application process; the museum was accredited in 1991 and reaccredited in 1997.

Nygren also set the wheels in motion for adding a curator of education to the staff, arguing that this would strengthen the institution's ability to serve both the campus and the community. While area colleges regularly took advantage of its great resources, "the Museum remains…underutilized," he wrote. Like many museums in the country at this time, Smith's was eager to shed any hint of exclusionary elitism and to attract a broad general audience. Nygren saw that the museum's offerings for primary and secondary schools could be strengthened if this important responsibility were entrusted to a professional rather than to a succession of graduate interns. He also envisioned a curator of education as coordinating interdisciplinary programs that would engage the museum with a wide variety of academic departments within the College. Through his initiative the education position was partially endowed in the campaign, and Nancy Rich became the first incumbent in 1992. No change since then has had a more profound effect on the museum than this expansion of its educational mission.

To strengthen the museum's finances Nygren founded a special support group, named the Tryon Associates after Dwight Tryon. These valued patrons' annual dues constitute one of the museum's most important sources of unrestricted funds, which can be

used for developing exhibitions and programs or for whatever needs are most pressing. Through The Campaign for Smith, over $1.5 million was contributed to acquisition endowments, and the directorship itself was partially endowed by Robert and Ryda Hecht Levi (class of 1937).

1990 saw the museum disrupted by the removal of asbestos from the building (**28.26**). Thousands of works of art were relocated, and the galleries were closed from May to November. During this period an exhibition of eighty-two highlights from the collection was shown at the IBM Gallery in New York, with a reception for Smith alumnae that remains legendary. John Russell, reviewing the show in *The New York Times*, observed, "The Smith College Museum of Art…is known for having got just about everything right since it made its first purchase…."

Parkhurst arrived when Smith, like many other private colleges and universities, was experiencing significant financial difficulties and had ordered all departments to reduce staff and cut budgets. Having directed the Allen Memorial Art Museum at Oberlin and the Baltimore Museum of Art and served

as assistant director and chief curator at the National Gallery in Washington and co-director at the Williams College Museum of Art, Parkhurst negotiated the administrative riptides with humor and wisdom. "The year just past was almost devoured by the Reorganization process," he wrote in the 1991–92 *Annual Report*, describing the elaborate staff restructuring, budget cut of nearly ten percent, and curtailed open hours. Looking on the brighter side, he also announced a phenomenal flood of acquisitions, 456, or nearly one a day for the eighteen months in which Congress had restored tax incentives for such gifts. Yet this difficult year was made even more painful by the death in October of Constance D. Ellis, the beloved long-time head of the membership organization, Friends of the Museum.

As the museum's tenth director, I have struggled to measure up to my distinguished predecessors. I am fortunate to work with a magnificent collection amassed through the generosity of alumnae and the perspicacity of earlier directors, supportive administrators, and a wise and committed Visiting Committee. My talented, hard-work-

ing staff includes many with more than twenty years of service—David Dempsey, Michael Goodison, Louise Laplante, Linda Muehlig, and Ann Johnson—whose dedication and knowledge have been critical to our success. Smith's faculty is excited to teach with original works of art, a lamentably rare circumstance in higher education these days, and students here are eager and bright. I see our goal as being to align all these strengths to make SCMA a paradigm of what a teaching museum can be.

Central to that vision is making the museum a resource for undergraduate teaching across the curriculum. Faculty members have been encouraged to rethink their courses, treating the museum's collections as primary sources. Twenty-six such courses have been developed since 1994 in eleven fields ranging from chemistry to dance to American studies, as well as art. This program, undertaken with grants from the Andrew W. Mellon Foundation, has now been endowed. Curator of education Nancy Rich serves as liaison with faculty and students, encouraging the entire campus to make full use of the museum. The associate curator of education, assisted by a cadre of Smith student docents, focuses on programs for schools, families, and adults. In this area, too, enormous strides have been made in the past decade. The museum hosted over 4,000 schoolchildren per year before the current renovation and hopes to expand that number in the future. Weekend events for families and a wide range of programs for adults make the museum a resource for the surrounding communities as well as for the campus.

25.2 Carmen Lomas Garza, in tattersall-checked shirt, oversees Smith students who are stenciling floor panels for her site-specific installation, *Homenaje a Tenochtitlan*, fall 1992.

I have worked to strengthen the museum's relationship to the art department, its most natural partner on campus, and have been gratified by the department's warm response. Our Art Museum/Art Department committee, nicknamed ADAM, facilitates easy communication and undertakes collaborations such as this volume. In 1999 ADAM served as catalyst for a semester-long, campus-wide investigation of the nature of creativity. *Idea<>Form: Looking at the Creative Process* centered on an exhibition of work by studio art faculty members, to which faculty colleagues in other disciplines were invited to respond in the accompanying catalogue. Lectures, panels, performances and class sessions expanded this investigation of creativity to all corners of the liberal arts.

One of my pet projects has been a series of symposia exploring various career areas in the visual arts. The program planners are alumnae in the field, and alumnae feature heavily at the podium and in the audience. "Women Curators in the Arts" (1993), "Speaking of Architecture" (1998), and "The Visual Arts in the Digital Age" (2001) have been the topics thus far. Through the generosity of the Emily Hall Tremaine Foundation, this series has been endowed. We also continue to introduce students to museum careers through work-study positions, internships, presentations by alumnae in the field, and Interterm courses in museum studies. My version of the "museum course" is a three-week-long intensive credit-bearing seminar taught during Interterm, when ten students and I travel to Boston, New York, and other destinations to explore the inner work-

25.3 Sandy Skoglund performs a ceremonial walk across the floor of the sculptural tableau "Walking on Eggshells" at the opening of her retrospective at the Smith College Museum in March 1998. The piece, commissioned for the exhibition, incorporates a floor of 15,000 blown eggshells, cast paper bathroom fixtures and wall tiles, and bonded-bronze snake and rabbit sculptures. Photograph by Jim Gipe.

25.4 Smith student assistant Amy Oliver (class of 1998) admires a mask made by a young visitor as part of a family program on animals in art, November 1997.

25.5 Hundreds of guests wish the museum bon voyage as the building closes for renovation in April 2000. Staff capitalized on the empty galleries to plan a rousing "Sail Away" party, and volunteers from both campus and community created elaborate nautical decorations.

ings of the art world. The culminating exercises are mini-exhibitions put together by student teams that bring to light works from the collection that are seldom shown.

The publication of our holdings has been another priority of recent years. Two major catalogues—of our best American paintings and sculptures and our best drawings—were published by Hudson Hills Press. Written by present and former staff members under the editorship of Muehlig and former associate curator Ann Sievers respectively, each was nearly a decade in the making. A third volume, by John Davis and Jaroslaw Leshko, features fifty American and fifty European masterworks. Smith's entire collection, along with those of the other Five College museums and Historic Deerfield, has been catalogued in a joint database that is accessible on the Internet, and a campaign to add digital images is in progress. The museum's thrice-yearly *Newsletter* began publication in 1995, winning a regional publication award the following year.

For its size, the Smith College Museum has long had an extremely active and varied exhibition program. Viewers may particularly remember *Cigoli's "Dream of Jacob" and Drawing in Late Sixteenth-Century Florence* (1997), *Sandy Skoglund: Reality Under Siege* (1998), and *Equal Partners: Men and Women Principals in Contemporary Architectural Practice* (1998), organized by Sievers, Muehlig and Helen Searing, respectively. Contemporary art remains prominent, with neon and video artists exhibited along with those working in more traditional media. Occasional loan exhibitions have featured Asian,

African, and Native American topics, and in the enlarged museum we hope to present non-Western art regularly, along with the European and American art that has been our traditional focus. A dedicated gallery for works on paper now makes it possible to have on regular view selections from our holdings of approximately 15,000 prints, drawings, and photographs, and the remainder are readily available to anyone in the spacious Cunningham Study Center.

The collection continues to grow, thanks to the extraordinary munificence of alumnae and others, and now numbers nearly 25,000 objects. A major gift of ninety-two works from the 1970s and 1980s from William and Susan Spencer Small (class of 1948) merits special mention because of its extensiveness, but hundreds of other donors have added works of great quality and importance to our holdings. We have stretched our purchase funds—always inadequate—to buy objects important for teaching that we could not hope to obtain by gift and occasionally to sample an emerging talent, following in the footsteps of Seelye, Tryon, Jere Abbott and Robert Parks and with, we hope, some semblance of their acuity. Recently we have decided to build a modest but high-quality collection of Asian, Islamic, African, Oceanic, Native American, Pre-Columbian and

contemporary Latin American art, insofar as possible by gift, in order to support the increasingly global curriculum at Smith. In this effort we are being advised by curatorial consultants drawn from the faculties of colleges in the region.

With all this activity, by the mid-1990s the building had become a serious constraint. Smith classes vied for the single classroom in which original works of art could be handled, making scheduling a nightmare. Art storerooms were stuffed. Two or three staff members often shared an office. There were many more exhibitions we wanted to hold than the available galleries allowed. Visitor support spaces—the lobby, coatroom, and shop—were too small for our 45,000 annual visitors. Furthermore, the terracotta tiles on the building's exterior had started to deteriorate, and our aging climate control systems were not as energy-efficient as newer systems.

After an initial survey of the building's condition by Alderman & MacNeish, Smith asked Kliment & Halsband Architects to undertake a feasibility study for expansion on the site and estimate costs for various options. Buoyed by President Ruth Simmons, the trustees agreed to undertake the most expansive of the four options and, after a search, hired Polshek Part-

nership Architects in 1998 to design the major renovation and expansion celebrated elsewhere in this volume.

The museum closed in December 1999, and museum staff and collections moved out. The staff has turned this period of "exile" into an opportunity to share Smith's treasures more widely. Three exhibitions from the collection have traveled to nineteen cities across the U.S. and in Europe, where they have been seen by more than three quarters of a million people. These masterpieces have now returned to Northampton for our gala reopening. The staff also used the hiatus for self-reflection and planning: to reformulate the museum's mission, examine how it can better serve its many constituencies, and envision an exciting future in the new facility.

It has been hard to be without art around us for these past three-and-a-half years, but harder still to be without you, the visitors and friends of the museum who are our *raison d'être*. We look forward to welcoming you to our gloriously improved surroundings. We are eager to reacquaint you with old favorites from the collection and to introduce you to some magnificent new acquisitions made while the museum was closed. We hope you will bring your friends and family to look and learn with you. The dedicatory plaque on the 1925 Tryon Hall invoked "the solace and inspiration of art." May each of you, over time, find these same qualities in our handsome new spaces.

25.6 Erasmus Quellinus II. Flemish, 1607–1678. *Adoration of the Shepherds*, 1669. Oil on canvas, 69 1/4 × 85 3/4 in. (175.9 × 217.8 cm). Smith College Museum of Art. Purchased with museum acquisition funds, the Beatrice Oenslager Chace (class of 1928) Fund, the Fund in honor of Charles Chetham, the Hillyer/Mather/Tryon Fund, the Janet Wright Ketcham (class of 1953) Fund, the Diane Allen Nixon (class of 1957) Fund, the Katharine S. Pearce (class of 1915) Fund, the Madeleine H. Russell (class of 1937) Fund, with restricted acquisition funds, and with funds realized from the sale of works given by Caroline R. Wing (class of 1896), Adeline F. Wing (class of 1898), and Mr. and Mrs. Allan D. Emil, 2002. Photograph courtesy of Senger Bamberg Kunsthandel, Bamberg, Germany. This major recent acquisition will be unveiled when the museum reopens in April 2003.

Hillyer Art Library: Its History and Development

Barbara Polowy, Art Librarian

The proposal to create a branch art library at Smith College can be traced to January 23, 1918, when Alfred Vance Churchill wrote to Josephine A. Clark, the Smith College librarian, to request in the art department's name "that the art books of the Library be placed in the Hillyer Gallery," site at that time of both the art department and the College's art collection. He went on to say that "the value of the books would be greatly enhanced" by their proximity to "photographs and other illustrative material," including the casts and framed pictures housed in the gallery. Miss Clark responded the next day, acknowledging the logic of the request and noting that "there is not the slightest objection to transferring all the publications relating to art that you may desire." Professor Churchill thereupon suggested that the books be housed in the gallery's Photograph Corridor, which could be made accessible to students for "evening work" without compromising the security of works displayed in the Gallery of Paintings. He even proposed a kind of circulation system under which "a member of the Art staff can issue and return books to students...," though "purchase, repairing, cataloguing, etc. would of course be under the direction of the college librarian."

Thus the essential operations and philosophy of service that characterize today's Hillyer Art Library were in place from the start: a schedule designed to accommodate student study needs ("evening work" in 1918, almost 100 hours a week today), careful stewardship of the collections, and close relationships with both the College library and image collections.

It is not clear whether the art library's first home was indeed the Photograph Corridor. It is known that for several of its earliest years the library occupied a space in Graham Hall originally intended to be a drawing studio. The June 1928 *Bulletin of Smith College Museum of Art* would report that the shelf space there "was inadequate and the room itself did not produce a studious atmosphere." When the new Tryon Gallery opened in 1926, providing improved galleries to display museum collections and exhibitions, the art library took over some of the space that had become available in the Hillyer Art Gallery, moving into remodeled ground-floor facilities there in the fall of 1927. Funds for remodeling and expanding the building had been bequeathed by Mrs. Drayton Hillyer in 1924, and the new Drayton Hillyer Art Library was named to honor the Hillyer family's many contributions to the College. The *Bulletin* found it to be a "beautiful and convenient" site that provided seating for seventy readers and doubled the shelf space available for collection growth. Reading tables and low bookcases were grouped in five alcoves. One alcove apiece was dedicated to each of the four major subject areas (Italian art, modern art, classical art, and design) then covered by the department, with related works from the museum's collection displayed above the bookshelves. The fifth alcove housed the card catalog and was decorated with Northern European art (**26.1**). Its open expanse of wall space made the library an ideal setting for Rufino Tamayo's monumental fresco *Nature and the Artist: The Work of Art and the Observer*, commissioned in 1942 to honor Elizabeth Cutter Morrow (class of 1896) (**26.2**).

The art library remained a department of the museum until 1946, when administrative oversight was transferred to the Department of Art. Additions to the library collections—books, periodicals, and portfolios as well as "illustrative material" (lantern slides, photographs, and postcards)—were listed in the accessions and loans reports published in the gallery's (and later the museum's) annual bulletins along with works of art acquired or borrowed for exhibition. These reports trace the early development of both the art library and the image collections. They show a library with a collection development policy closely tied to both the art department curriculum and the strengths of the museum. They also show consistently strong support for building art library collections both through purchases and donations. The first of these reports, published in 1920, lists a gift of eleven books from the estate of the great art collector Charles L. Freer and the purchase of one book, the Fogg Museum catalogue *Collection of Mediaeval and Renaissance Paintings* (the latter remains available in the library collection). Ten years later, the library purchased 152 books and received seventy-five books bequeathed by professor of art Dwight W. Tryon. Today the library adds an average of 3,000 purchases and gifts a year.

The museum bulletins also trace the staffing of the art library. As promised by Churchill, the art department staffed the facility from its inception. A quick succession of appointees served

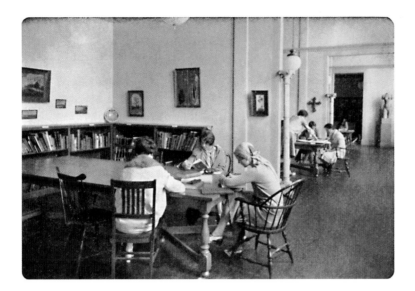

26.1 An alcove of the art library. From the *Bulletin of Smith College Museum of Art*, no. 9, 1928.

as curators of books and photographs from 1920 to 1927: Hazel M. Leach (1920–21), Anna Polowetzski (1922), Gladys I. Page (1923), and Elizabeth S. Allison (1924–26). The first professional in the art library was Carolyn M. Burpee, who served as librarian from 1927 to 1933. Charlotte Baum was curator of lantern slides and photographs from 1928 until Burpee's departure in 1933 and then, as curator of books and photographs, directed the art library from 1934 to 1959.

Phyllis A. Reinhardt was appointed art librarian in 1959 (**26.3**). In April of that year she wrote a detailed and candid "Survey and Program of the Art Library, Smith College." The collection of 12,000 volumes and 36,000 photographs and facsimiles was still housed in Hillyer Art Gallery, which Reinhardt described as "one large L-shaped room with bookshelves…, one small room for periodical study and storage, a long room with balcony used for the photograph collection, and a departmental office used also for work space." Although the library now served more than 900 students, faculty, and museum staff, seating had been reduced to spaces for fifty readers. The only staff other than the librarian was one assistant and a group of student workers.

Reinhardt laid out a five-year plan for improving library collections and services. It called for more efficient use of existing space, expanding the staff, tightening circulation procedures, and increasing the acquisitions budget. Reinhardt noted a rapid escalation in both the cost and number of art books. Relief was in sight, however: later that year Mr. and Mrs. Edwin H. Land

established an endowment, named in honor of Clarence and Ruth Wedgwood Kennedy, to purchase art books and photographs. The income from this donation immediately doubled the library's acquisitions budget and rate of acquisition—thereby making the growing inadequacy of the art library facilities yet more apparent.

Reinhardt's report also recommended establishing an Art Library Committee to include representatives from the art department, the museum, and the college library. The committee would "establish general policies, advise on the development of the collections, review budget recommendations, approve major staff appointments, and assist with the development of donor potential and future space." Thanks to Reinhardt's energetic leadership, all her recommendations were implemented over the next few years. Although administration of the art library was transferred from the art department to Neilson Library in 1968, the Art Library Committee continues to advise the art librarian on the library's operations and services, and art faculty continue to play a major role in collection development.

In a letter to Reinhardt dated October 4, 1962, Smith President Thomas Mendenhall suggested that discussions then taking place would have "considerable bearing on the future requirements of the Library." He was referring to the "Lieberfeld report," a planning study commissioned to assess the space needs of the art department and the museum and how these could be addressed by moving some department or museum facilities into Stoddard Hall. In 1966 the trustees chose a more ambi-

The creation of a branch library for art dates to a request of Alfred Vance Churchill, who asked in the art department's name "that the art books of the Library be placed in the Hillyer Gallery," where "the value of the books would be greatly enhanced" by their proximity to "photographs and other illustrative material," including the casts and framed pictures housed in the gallery.

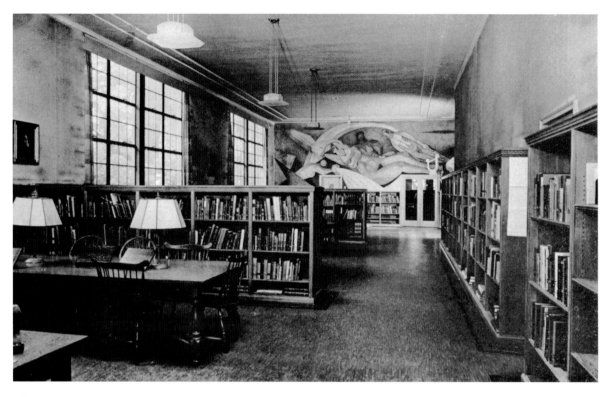

tious alternative: addressing the space needs by commissioning a new fine arts facility. Anticipating the demolition of Hillyer Art Gallery in preparation for the new construction, the art library moved to temporary quarters in Stoddard Hall in the late summer of 1969. Planning for the move, establishing the services in the temporary facilities, and implementing the details of the new art library were all done by assistant art librarian Anne Mausolff, who after Reinhardt's death in October 1969 served first as acting art librarian, then as art librarian.

The art library moved into the new Fine Arts Center during the summer of 1972 (**26.4**). Prominently positioned in the northwest corner of the first and second floors of Hillyer Hall, the new library site was convenient to the art department classrooms, studios, and faculty offices, all of which were housed in the building, and to museum staff across the sculpture courtyard in Tryon Hall. At approximately 15,000 square feet, it provided ample space for the collections (which grew from 29,500 volumes on move-in day to almost 86,000 by 2000) and seating for 150 readers at large tables, in easy chairs, and at individual carrels. It represented what was then the state of the art in library technology, with "media carrels" equipped for slide-tape and audiotape programs, a new service desk with special wells for date-due cards, secure shelving to house a closed

course-reserve collection, and spacious offices and a workroom for the staff, which now included four full-time and six part-time employees. The bright blue-and-vermilion color scheme, also characteristic of its time, was a marked change from the muted sage-green and golden-orange of the old Hillyer Art Gallery reading room.

Anne Mausolff resigned from Smith in June 1973 and her position was filled by Karen J. Harvey later that year. The open plan and generous size of the library proved quite adaptable to changing art library needs for the next thirty years. Harvey's annual reports and those of her successors Amanda Bowen (1992–96) and myself (1996–present) reflect trends and changes at Smith and in academic art librarianship generally. In an effort to stem thievery from the collection, Hillyer in December 1973 became the first Smith library to implement a security program, first providing staff to check bags and monitor after-hours access to the art department's studio facilities and later placing security gates at the library's exit. Overdue fines were first levied in January 1974. The microform collection, now numbering 37,000 items, was established in 1977–78 with the purchase of the *Marburger Index.* The first online public library catalog was introduced in 1988 and the first online bibliographic database for the visual arts, *Art Index* on CD-ROM, in 1992.

By the early 1990s the art library was subject to the same building-envelope and ventilation-system problems affecting the rest of the building: air exhausted from the studios permeated the library, and window and roof leaks caused several minor floods. Nearing its shelving capacity, the library was also running out of room for collection growth. When an extensive renovation and expansion of the Fine Arts Center was approved in 1999, the Hillyer Art Library staff worked closely with Polshek Partnership Architects, the project's designers, to renovate and reconfigure library facilities to incorporate contemporary information technology and reflect contemporary ideas about library services. The new plan greatly increases staff visibility, provides power and data connectivity to every seat, includes an area for group library instruction, uses compact shelving to maximize on-site storage capacity, and, above all, provides a pleasant, even inspiring, environment in which to study and work.

After two years in makeshift quarters in Bell Hall at the Clarke School for the Deaf, the art library staff looks forward to occupying its new quarters, where it expects to offer a 21st-century take on Phyllis Reinhardt's 1959 vision of Hillyer Art Library as "a busy center for many students keeping a variety of books in constantly active use."

26.3 Art Librarian Phyllis Reinhardt assists student Kristin Stromquist (class of 1968) in Hillyer Art Library, 1966.

26.4 Section of the art library from the stairwell, 1973. Photograph by Gordon Daniels.

The History of the Image Collections

Elisa Lanzi, Director of Image Collections

Together with original works in the Smith College Museum of Art, the image collections at Smith College have played a critical role in fostering visual literacy in this liberal arts community. From their beginnings in the Photograph Corridor of the museum to their evolution into today's campus-wide digital image network, the image collections have been essential to teaching and learning at Smith. Already in 1927, they were mentioned in a mission statement by the museum and art department: "The Museum is a permanent exhibition of original works of art of many periods and countries, supplemented by reproductions" (*Bulletin*, June 1927).

From the start, then, the image collections have shared a history with the art department and museum as well as the Hillyer Art Library. Despite this fact, the unique characteristics of images (they are neither original works of art nor books) have set them apart in terms of use and management. The image collections are of a mixed nature, comprising, for example, photographic reproductions, slides, and some special primary materials (such as the postcard collection and a facsimile lending library). Their cataloging and classificatory systems have posed special challenges, as they were often devised independently of Library of Congress or other national standards. They must accommodate the demands of the classroom as well as serve a wide range of users, students and faculty both in the visual arts and in other disciplines.

Smith's image collections—in particular the photograph collection—have garnered a considerable reputation for comprehensiveness and general excellence. Moreover, the degree of their accessibility is quite unique. As image collections curator Sherry Poirrier has noted, "[The] collection is unique in an undergraduate setting. Other similar collections, such as those at Yale University and the Harvard Fogg Art Museum are generally available only to graduate students and faculty. The provision of such a resource here at Smith College contributes to the excellent reputation of the undergraduate fine arts curriculum" (*News from the Libraries,* Spring 1988*)*. Not only are the scope and size of the collections impressive, but they have been cataloged from the early 1920s and housed in facilities that have been carefully designed with users in mind.

In 1877, President L. Clark Seelye noted that "an Art Gallery has been furnished with casts of noted statues and several hundred autotype copies [photographic prints that use carbon pigment to form the image] illustrating the different schools of painting" to support the teaching and learning of the subject (L. Clark Seelye, *The Early History of Smith College 1871–1910* [Boston: Houghton Mifflin Co., 1923], p. 42.). When the Hillyer Art Gallery opened in 1883, it included the display of casts of classical works from major historical periods. In addition to the casts, the Gallery's Photograph Corridor held continuous exhibitions of study images, including, as one contemporary noted, "facsimile reproductions of drawings by Rembrandt."

"The collections of our Gallery, when it was begun about fifteen years ago, had not a single slide, and of photographs, only about one hundred Braun carbons, which, though fine in themselves, were framed and hence of little use for study," wrote Elizabeth M. Whitmore, professor of art, in the March 30, 1921, *Bulletin*. This was the first article devoted exclusively to the "Collection of Illustrative Material." Fortunately, she added, the collection's "growth [slides and photographs], rapid from the first, received a second impetus from the addition in 1916 of advanced courses on specific periods in the history of art." She mentioned, in particular, the usefulness of lantern slides in such a setting: "[F]or large groups, if the instructor is to make his point clear to the entire class at once, the lantern is indispensable."

In 1920, Alfred Vance Churchill, who was director of the museum at the time, wrote, "We have a collection of casts and a library of photographs and lantern slides of significant extent and certainly of superior quality" (*Bulletin*, May 1920). By 1921, the Collection of Illustrative Materials contained about 9,500 slides and more than 5,000 photographs. Between 1920 and 1922, Hazel M. Leach, the first curator of books and photographs, undertook the first documentation of the illustrative materials by instituting a cataloging system. The first item recorded in the photograph accession book—a progressive inventory of the photographs in the collection—was a "Bust of Roman Emperor," by Mino da Fiesole (Museum of Fine Arts, Boston; it's not clear from the records whether this item was purchased directly from the museum or from a photographer). The first lantern slide recorded was an image of "Pompeii, Domus Vettiorum, Sala Dipinta" produced from a photograph made

27.1 Professors Jaroslaw Leshko, Helen Searing and John Pinto in the slide room. Smith College Archives.

One eye sees, the other feels.

Paul Klee

by Allison Spence. These "illustrative materials" were cataloged and classified using a Yale University–based system in which each object was given an alphanumeric decimal notation. In 1922, Curator of Books and Photographs Anna Polowetzski began keeping a subject catalog for slides and photographs. Headings were based on the Library of Congress model, but with adjustments made to accommodate the cataloging of pictures as opposed to books. Examples of early subject headings include "Archangels in Art," and "Art, Bible, Old Testament, Worship of the Golden Calf, see Moses." In 1928, Charlotte Baum became the first staff member to specialize in images when she was named Curator of Lantern Slides and Photographs under librarian Carolyn M. Burpee. The job titles of this period reflect the emerging specializations of book librarians and image curators.

In 1931, Elizabeth H. Payne, assistant to museum director Churchill, described a collection of 25,000 slides and 30,000 photographs, "not only halftones, but vivid, yet accurate color-reproductions" (*Bulletin*, May 1932, p. 28). By the 1930s, the collections also included color photographs, photogravures, offset engravings, and clippings from art magazines. During this period, too, the postcard collection was developed, now a source of primary materials documenting the built environment. It is especially strong in images of American and European landscape architecture from that period. In addition to purchased items, illustrative materials were donated by well-known people and institutions in the field of art, including Mr. and Mrs. Clarence Kennedy, Paul J. Sachs, Duncan Phillips, Daniel Chester French, Oberlin College, the Frick Library, Arthur Kingsley Porter, and Julius Meier-Graefe.

Accession lists published in the *Bulletin* indicate the steady acquisition of photographs and lantern slides. In the 1940s, the photograph collection was the recipient of a group of postcards from the Cambridge School of Domestic Architecture and Landscape Architecture. Lantern slides, many produced from photographs taken by Clarence Kennedy, remain important historical

documents of Renaissance and Baroque sculpture as well as of pre-1945 views of American and European architecture that may have been damaged or altered during the war years.

By 1943, the burgeoning illustrative materials collections required more staff, as evidenced by the presence of no fewer than four "Assistant Curators of Photographs." In 1946, the art library, which still supervised the image collections, was transferred from the museum to the department of art. Patricia Harwood became the first Curator of Slides the following year, and Miriam Weest was added as the first in-house departmental photographer. In 1957 Harwood's successor as slide curator, Erna Huber, began a long reign of exclusive attention to slides (until she retired in 1975). Huber's devotion to the slide collection and the art department was legendary. Faculty fondly recall a rarified environment that no longer exists, in which Huber insisted on total silence.

Still at the museum in the early 1950s, however, was a collection of seventy-five works of original art and reproductions constituting an art loan

program that had been instituted in 1910–11. George Cohen, professor in the art department, began in 1953 to re-organize this "Student Loan Collection of Art," so that, as he put it, students might look at paintings, drawings and prints as "specific works of art to live with, understand, and enjoy" (College press release, November 8, 1953). Sylvia Plath, a Smith student at the time, took note: "Among the bargains offered Smith College students upon their return to Northampton is the chance to rent framed reproductions of master-pieces at the Hillyer Art Gallery" (College press release, October 2, [1952?]). Cohen retained a keen interest in the image collections over the years, and continued to advocate placing images into students' hands. Today, the Visual Resources Collection carries on in this spirit with a circulating collection of full-color facsimiles for student use.

In an article on "recommended practice" for photograph and slide collections, Phyllis Reinhardt, the art librarian, noted, "Full documentation of the work of art and exact identification of the source of the reproductions are given on the catalog card and in

full or abbreviated format on slide and photograph label" (*Special Libraries*, 50/3 [March 1959], p. 100). Ironically, in that same year, cataloging practices within the image collections began to diverge from each other when the photograph curators ceased maintaining handwritten accession books and started a card file. Using three-part carbons in a typewriter, they created labels, shelf list cards, and accession cards for each photograph. The slide collection retained the use of accession books and never converted to cards but went directly to the VRMS database program in 1990. In 1968, the Smith College Library took over the administration of the Hillyer Art Library and the photograph collection (then called the Visual Resources Collection), after it had for twenty-two years been part of the art department. The slide collection remained in the department. Plans for a new fine arts center, with expanded space for slide and visual resource collections, were underway. Around 1970, the use of the alphanumeric classification numbers for slides and photographs was abandoned in favor of a locally-derived filing order.

In 1972 the slide collection moved with the rest of the art department to the new Fine Arts Center with the museum, library and Visual Resources Collection. The slide room was on the third floor adjacent to the art history faculty offices and included, somewhat unusually for an institution of this size, individual faculty carrels for preparing lectures. The Visual Resources Collection was located on the second floor in the library and included a photo reserve study area with storage bins, large bulletin-board surfaces for display, and tables and chairs for student group study and discussion. A favorite haunt for the student body was the study room on the first floor, where many gathered to study approximately two thousand photographs a year for Art 100. In 1974 Alice Margosian became slide curator and Sherry Poirrier visual resources curator. A significant expansion of Asian art slides and photographs was undertaken that year as well, with the guidance of art history professor Marylin Rhie.

In the past dozen years, computerization, reorganization and growth have made for an intense period of activity for the image collections. In 1990, the administration of the Visual Resources Collection was transferred back from the art library to the art department; and the slide collection and Visual Resources Collection began using the first computerized database program, VRMS, for cataloging and labeling. The art department took the initiative to expand the Art 100 curriculum to "non-Western" art (African, Native American, Oceanic, and Pre-Columbian), and the image collections experienced significant growth in these areas. A project to convert 25,000 lantern slides to 35-mm 2×2-in. slides was implemented. As had been the practice for many years, the image collections continued to purchase slides and photographs from museums, historical societies, tourist bureaus and commercial image vendors. In 1992, Beverly Cronin came on board as slide curator.

A Mellon Foundation grant intended to train faculty for cross-disciplinary teaching opened the door in 1996 for digital imaging at Smith College. The grant specified the use of a computerized database, and Daniel Bridgman was hired to find such a database and

27.2 Students in the Art 100 study room. Smith College Archives.

27.3 Students studying a reproduction of *The Garden of Delights* by Hieronymus Bosch. Smith College Archives.

27.4 Faculty light table in slide room, 1998.

develop further support. Working with an ad hoc group from the art department that included department photographer Richard Fish, professors Dana Leibsohn and Gary Niswonger, and the newly appointed dean, Donald Baumer, a second Mellon grant was secured in 1997. Professors Caroline Houser and Barbara Kellum were instrumental in convincing the administration that this was an important new direction for the College to take. In the spring of 1998, Smith was one of the first colleges to implement the *Luna Insight* software for classroom presentation of digital images. *Insight* has many advantages over working with slides; students and faculty can work independently, outside of the classroom and collections. They can zoom in on the images at will and examine them from all sorts of angles.

The summer of 1998 marked the opening of the Visual Communications Resource Center, a lab for digital imaging. With advances in database technology and the challenge of managing digital images, the VRMS cataloging database was no longer adequate. The visual resources collection curator became involved in building a collaborative cataloging tool (called IRIS) with several other New England academic collections. In its use of standard fields and controlled terminology, the IRIS database took full advantage of such recent efforts as the Visual Resources Association Core Categories and the Getty Art and Architecture Thesaurus.

In July of 2000, an entity called the Image Collections was created by merging the resources of the slide collection and the Visual Resources Collection and by adding a digital imaging

component. I was named director of the unit, which is administered by the art department, although digital imaging is a collaborative project with staff from Educational Technology Services, notably Daniel Bridgman. A grant from the Davis Educational Foundation has provided support for digital content development, faculty training and a more efficient collections management system for images.

A snapshot taken today shows the image collections preparing to move to a state-of-the-art Imaging Center in the new Brown Fine Arts Center. The center will provide a physical environment and equipment that will support activities related to the use of images in teaching, learning and research. The staff is saying goodbye to the old oak cabinets as they transfer 280,000 slides to compact archival units. Department photographer Fish is now proficient with both camera and scanner as he produces slides and digital images for teaching. Curators Cronin and Poirrier catalog slides, photographs and digital images in the same database, while I strive to accommodate the diversity of image needs in both new and older media, including the licensing of commercial digital images.

Digital imaging has created the need for new types of collaborative posi-

tions, such as a digital image cataloger (Jolene de Verges) and a digital imaging assistant (Kevin Kanda). An "imaging committee," including current art department chair, John Davis, and the head of Educational Technology Services, Robert Davis (among others), serves in an advisory capacity. Five art faculty members (Leibsohn, Niswonger, Kellum, Houser, and Brigitte Buettner) are involved in developing the best methods to teach with digital images. The Teaching with Technology program is introducing digital teaching to other disciplines (e.g., Classics and Religion). As for our library and museum colleagues in the Fine Arts Center, technology and the new building present new opportunities for us to work together in our common goal, present from the start, of educating Smith students in the arts.

Special thanks to Daniel Bridgman, Beverly Cronin, Craig Felton, Richard Fish, and Sherry Poirrier for their help with this essay.

Note

Bulletin refers to the *Bulletin of Smith College Hillyer Art Gallery* (before 1926) or the *Bulletin of Smith College Museum of Art* (after 1926).

Timeline

1870, March 8
Sophia Smith signs her final will, outlining her wishes for the "Institution for the higher education of young women" that would bear her name and be located in Northampton, Massachusetts. Article 3 directs that instruction be given "in the Useful and Fine Arts."

1870, June 12
Death of Sophia Smith in Hatfield, Massachusetts

1871, April 12
First meeting of the Board of Trustees (established by Sophia Smith's will), held at Smith's Charities in Northampton. The charter is accepted and the organization of the Board completed.

1871, September 12
Second meeting of the Board of Trustees. By-laws are adopted, and a committee is appointed to select a president. Trustees vote to purchase the homestead of Judge Dewey as a site for the College.

1871, November 14
Trustees vote to purchase the homestead of Judge Lyman as additional land for the College. The site for the College now consists of about thirteen acres, from Elm Street to Mill River. The trustees believe this will be adequate to the needs of the College for many years.

1872, July 15
Laurenus Clark Seelye, a professor at Amherst College, is approached to take on the presidency. He declines.

1872, September
The trustees issue a prospectus, including the statement that, at Smith College, "More time will be devoted than in other colleges to aesthetical study, to the principles on which the fine arts are founded, to the art of drawing and the science of perspective, to the examination of the great models of painting and statuary."

1873, June 17
Negotiations with Professor Seelye come to fruition, and he is unanimously elected President of Smith College by the trustees. He later leaves for Europe to study educational institutions there.

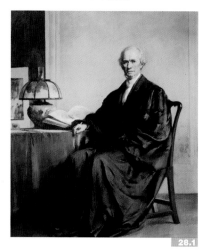

1875, July 14
College Hall, designed by the Boston firm of Peabody & Stearns, is dedicated as the first academic building of the College, including space for an art gallery on the second floor. Laurenus Clark Seelye is inaugurated as President. In his inaugural address he includes his vision for the arts at Smith:

In the fine arts, as in literature and science, the College should simply aim to give that broad and thorough acquaintance with mind which is in itself the best preparation for special work in any calling. If this be its aim, however, it cannot be true to its character and ignore art. Too many of the grandest creations of the human intellect are embodied in the fine arts to remain unnoticed by an institution which seeks the highest mental culture....

If our higher schools are to fulfill their mission, they must see to it that no unusual artistic gift be impoverished from lacking the nutriment of that broad and generous thinking on which alone it can grow to its greatest strength and beauty....Not less, however, should the College see to it that artistic tastes are not starved and dwarfed from want of proper culture. It should have its gallery of art, where the student may be made directly familiar with the famous masterpieces; it should have facilities for musical culture in good instructors and instruments. Lectures, models, and special exercises should keep alive and develop the aesthetic faculties equally with other mental talents....

Our art gallery, we trust, will ere long be amply provided with all the material requisite for such a work....

1875, September 9
Fourteen students assemble in College Hall's social room for the opening of Smith College's first academic year.

1877
A trustee offers $1,000 on condition that the Board appropriates an additional $4,000 to secure photographs, engravings, and paintings for the gallery. A second trustee gives another $1,000 for this purpose. Plaster casts of famous sculptures and a large collection of reproductive prints are purchased and displayed. Art department is established; James Wells Champney is employed to come to campus twice weekly during six weeks of the fall and winter terms to give art instruction.

1877, October
In the official circular, courses in art and music are announced:

The study of Art and Music has been made, as will be seen by reference to the curriculum, a part of the regular intellectual work of the College. It is not an extra, and its cost is included in the regular tuition.

An Art Gallery already has been furnished with casts of noted statues and several hundred autotype copies illustrating the different schools of painting. These are so arranged in alcoves as to present in epitome the characteristics of the best painters and the schools they represent.

Lectures on the history and principles of the Fine Arts, and the works of the most celebrated musicians and painters, will be given to all the students, and practical instruction will also be furnished in Drawing, Painting, and Music to those who have the requisite talent and taste for it.

1879
President Seelye, with the advice of Champney, begins making purchases of paintings from living American artists. Many prominent artists agree to make concessions on the prices of their work to help Seelye form a collection of American art. These early purchases include work by Thomas Eakins, Robert Swain Gifford, Louis Comfort Tiffany and Winslow Homer, among others.

1879, June 16
The first class, now ten students, graduates at Commencement ceremony.

1879, September
The entering class numbers ninety-two, with a total enrollment of 202 students.

1881
About $8,000 is raised through subscription to fund a separate building for art instruction. Winthrop Hillyer, a retired Northampton businessman, offers the college $25,000 for such a building if the original funds raised be used to secure additions to the art collection. Hillyer later adds $5,000 to the gift. This gift, the largest received by the College since Sophia Smith's original bequest, comes as a complete surprise.

1882
Art school is established.

Hillyer Art Gallery is completed in the summer, designed by Peabody & Stearns of Boston. The gallery space is hung with paintings by living American artists, as well as casts of ancient and modern sculpture.

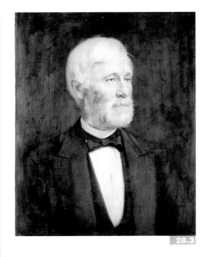

1883, April
Winthrop Hillyer dies suddenly, intestate. His surviving brother and sister, Drayton Hillyer and Sarah Hillyer Mather, find in his papers an unsigned memorandum indicating his wish to give the College $50,000 to endow a fund for the art collection. While the document has no legal validity, Winthrop Hillyer's siblings scrupulously adhere to their brother's wishes.

1883, June 26
Dedication of Hillyer Art Gallery

1886
Recognizing the need for additional instruction in fine arts, President Seelye persuades Dwight William Tryon to join the faculty as a part-time instructor, coming to Northampton periodically to criticize students' work, while day-to-day instruction is given by an assistant. Tryon, who spends winters in New York and summers in South Dartmouth, Massachusetts, is at age thirty-seven an established and successful painter of landscapes. Tryon begins to advise Seelye on acquisitions for the art collection (**14.2**).

1887
Drayton Hillyer and Sarah Hillyer Mather give the College $10,000 for an addition to the Hillyer Art Gallery.

1889
The first graduating class celebrates its tenth reunion.

1897
The Detroit industrialist Charles Lang Freer, patron and friend of Dwight Tryon, lends thirty Japanese paintings for display in the gallery.

1901, March
Freer lends thirty-five Japanese hanging scrolls to the gallery.

1902, September 16
The trustees vote to discontinue the art and music schools and integrate them into the College as academic departments.

1905
A chair of History and Interpretation of Art is created, and Alfred Vance Churchill is invited by President Seelye to serve as first incumbent. He is living abroad but agrees to take up his duties the following year. An artist, Churchill had most recently been head of the fine arts department at Teachers College, Columbia University.

1906, September
Alfred Vance Churchill begins instruction at Smith.

1907, November 2
A letter from President Seelye is read at the trustees' meeting. In it he announces his intention to retire. Seelye is persuaded to postpone his retirement until 1910.

1910
Christine A. Graham (class of 1910) gives the college $27,500 to construct an addition to the Hillyer Art Gallery to serve as a lecture room for the art department. Churchill later recalled that, in making the donation, Graham said, "I feel that I have received more good from the art courses than from anything else here at Smith."

President Seelye retires and Marion LeRoy Burton becomes Smith's second president.

1911
An exhibition of famous etchings is shown at the gallery. An enthusiastic group of students purchases a proof of the fourth state of Rembrandt's *The Three Crosses* and gives it to the gallery.

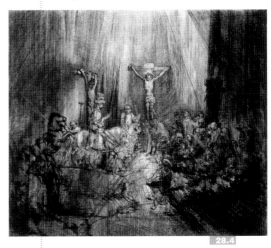

1913

Hillyer Gallery's lower floor is renovated, and electric lighting is installed. The gallery is open on Sundays for the first time.

1914

Churchill purchases a small bronze sculpture by Auguste Rodin, *Children with Lizard*, thus committing the gallery to the collecting of European art.

28.5

1917

Charles Lang Freer gives the gallery a group of Asian objects from his collection. At his death in 1919 he would leave a large group of 19th-century etchings.

William Allan Neilson becomes third president of the College.

1918, January 23

Churchill appeals to Smith College Librarian Josephine A. Clark to transfer the library's art books to Hillyer Gallery, establishing the art library as a separate departmental (and later branch) library.

1919–20

Churchill is appointed Director of the Smith College Museum of Art, as it is called for the first time. At the request of the trustees, he spends five months in Europe collecting art.

1920

The first annual *Bulletin* of the museum is published.

Churchill is asked by the trustees to develop a plan for the collecting of art (published in the May 1932 *Bulletin of Smith College Museum of Art*).

1923

Dwight Tryon retires from the faculty.

1924

Tryon declares his intention to pay for the construction of a new building in his name at Smith College, for the sole purpose of housing and displaying the art collection.

1924–25

Art 22, the first team-taught, yearlong survey of the history of art, is offered.

1925, July 1

Dwight Tryon dies in South Dartmouth, Massachusetts, leaving a bequest to the College for the completion of the building and for an endowment for its maintenance and the purchase of works of art.

1925

Publication of the illustrated *Handbook of the Art Collections of Smith College*.

1926

The trustees vote on February 19 to give the name of the Smith College Museum of Art to the various collections of objects of art belonging to the College.

Designed by Frederick L. Ackerman, the Tryon Gallery opens in September.

1927, Fall

The art library is officially named Drayton Hillyer Art Library and opens in new quarters in the Hillyer Art Gallery.

1928–32

Publication by Smith College of Clarence Kennedy's seven portfolios of photographs of Renaissance sculpture and scholarly commentaries, *Studies in the History and Criticism of Sculpture*.

28.6

1929

Churchill purchases a major Gustave Courbet painting, *The Preparation of the Bride* (later re-titled *The Preparation of the Dead Girl*).

1932

Alfred Vance Churchill retires. Jere Abbott (**22.1**) becomes second director of the museum, coming to Smith from his position as founding associate director of the Museum of Modern Art in New York. His first purchase for Smith (and fourth addition to the collection) is the Pablo Picasso painting, *Table, Guitar and Bottle (La Table)* (**22.2**).

A small wing is added to the Tryon Gallery on the southwest.

28.7

1933

Abbott purchases a major unfinished Edgar Degas painting, *The Daughter of Jephthah*.

Abbott purchases seven photographs by Luke Swank (**19.1**), George Platt Lynes, Walker Evans and László Moholy-Nagy. These are among the first photographs to enter an American museum collection (the Museum of Modern Art had begun collecting photographs the previous year).

An important exhibition of the work of Edgar Degas is held November 28–December 18.

1934

Abbott purchases an important small painting by Georges Seurat, *Woman with a Monkey*, a study for *A Sunday on the Island of La Grande Jatte*.

1937

Publication of *Smith College Museum of Art Catalogue*, with introductions by President Neilson and Jere Abbott.

1938

Smith's Committee on Motion Pictures is established, with Jere Abbott as founding member.

Abbott purchases two drawings by Georges Seurat, both studies for *A Sunday on the Island of La Grande Jatte*.

1939

Abbott purchases the first major African object to enter the collection, a Luba ceremonial axe.

Abbott purchases one of the earliest and most important drawings to come to the collection, *Portrait of a Young Man*, attributed to Dieric Bouts and dating from the late 1460s–70s (**22.5**).

President Neilson retires just before World War II begins; alumna and trustee Elizabeth Cutter Morrow serves as acting president.

1940

Herbert Davis becomes Smith's fourth president.

Oliver Larkin offers the first course in American art history at Smith (**8.1**).

Abbott purchases the painting *Rolling Power*, by Charles Sheeler (**22.4**).

1940–41

First year in which the making of sculpture is taught in the art department.

1943

The Mexican muralist Rufino Tamayo is commissioned to paint a fresco in Hillyer Art Library. He chooses as his subject *Nature and the Artist: The Work of Art and the Observer*. The commission is made in honor of Elizabeth Cutter Morrow (**26.2**), for her service to the College.

Major loan exhibition drawn from public and private collections, *American Negro Artists*, is shown February 18–March 14. Organized in conjunction with the Institute of Modern Art in Boston, it is the most comprehensive exhibition of paintings and sculpture by African Americans to be seen in New England.

1944

Randolph Johnston teaches the first printmaking courses (woodcut, wood engraving, lithography).

First appearance of Art 13, directed by Mervin Jules, taught by members of the studio wing, a year-long requirement for all studio majors. It lasts thirty years.

1946

One of Abbott's last purchases for the museum is an early Claude Monet painting, *The Seine at Bougival*.

In May, Frederick Hartt (**22.6**) is appointed acting director of the museum.

In September Hartt proposes to sell a number of American paintings deemed either "duplicates" or less than top quality, in order to raise funds to build an addition to the building. Over the next two years, many American paintings, some of the earliest museum acquisitions, are sold through the Kende Galleries at Gimbel Brothers department store in New York City.

Administration of the art library is transferred from the museum to the art department.

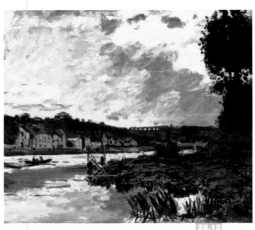

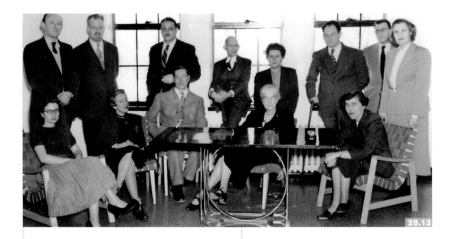

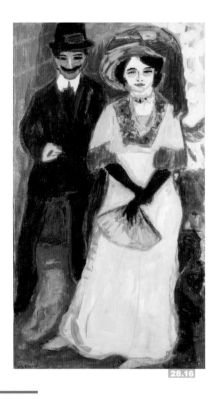

1947

Edgar Schenck (**22.7**) is appointed acting director of the museum.

1948

The eminent architectural historian Henry-Russell Hitchcock (**3.2**, **9.1**, **23.1**) joins the faculty of the art department.

Major loan exhibition, *Pompeiana*, celebrating the 200th anniversary of the 1748 discovery of the buried city of Pompeii and its influence on later art, shown November 18–December 15. Loans include five Boscoreale silver treasure pieces from the Louvre.

1949

Benjamin Fletcher Wright becomes Smith's fifth president.

Henry-Russell Hitchcock is appointed acting director of the museum and a few months later, director. He is assisted by Mary Bartlett Cowdrey (**23.2**), a historian of American art, who occupies the position of assistant curator in 1949, curator in 1950–51, assistant director from 1951 to 1955, and acting director in Hitchcock's absence in fall 1954.

1950

Oliver Larkin's book, *Art and Life in America*, wins the Pulitzer Prize in History.

1950–51

A bridge linking Tryon and Hillyer is opened.

1951

Hitchcock and Bernice McIlhenny Wintersteen (class of 1925) form the museum's Visiting Committee, a board of museum professionals and alumnae collectors, to advise on all aspects of the museum's operations. The first committee consists of ten members plus the director.

Hitchcock purchases contemporary works in Europe. Two exhibitions of them, *Smith Collects I & II*, are circulated nationally by the American Federation of Arts.

1953

Leonard Baskin appointed; teaches graphic art and establishes the Apiary Press for students, which lasts for ten years.

1954

Courbet's *Preparation of the Dead Girl* is lent to the Venice Biennale, then to France and Britain.

1955

Hitchcock returns to teaching and research. Robert Owen Parks is appointed museum director. He begins actively making acquisitions for the collection; one of his earliest purchases is a magnificent Ernst Ludwig Kirchner painting, *Dodo and Her Brother*.

1956

In the fall semester, Asian art is taught for the first time at Smith by Professor Charles Whitman MacSherry of the history department.

1958

Parks purchases (with an anonymous gift in honor of the class of 1898) a black chalk *Study of Drapery* by Matthias Grünewald, one of very few extant drawings by the artist and the only one in an American collection.

1959

Thomas Corwin Mendenhall (**24.1**) becomes sixth president of Smith College.

Major exhibition of the work of Giovanni Battista Piranesi is held April 4–May 4.

Mr. and Mrs. Ivan B. Hart of New York City make the first installment of a gift of fifty-seven important archaic Chinese jades, a collection originally assembled in the 1930s by the Dutch financier S. H. Minkenhof.

28.18

1961

Parks organizes an exhibition, *The Work of Shaker Hands*, and related symposium on the art of the Shakers (**23.6**).

Parks resigns as director; Patricia Milne Henderson becomes acting assistant director of the museum.

1962

Charles Chetham (**24.1**) is appointed director of the museum.

1963

Chetham designs an outdoor sculpture garden between Tryon and Hillyer.

28.19

1965

Medievalist Robert Harris teaches the honors unit on Problems in the History of Art for the first time.

Class of 1965 places a bronze owl by Leonard Baskin in front of Wright Hall.

28.20

1966

Having purchased a major Henri Fantin-Latour painting, *Mr. Becker*, in 1964, Chetham organizes a Fantin-Latour retrospective exhibition, April 28–June 6.

David Huntington (**8.2**), an assistant professor at Smith, is successful in his effort to preserve Olana, the Hudson River mansion of painter Frederic Church.

1966–67

Art 11 becomes Art 100 (general survey of the history of art).

1967

Two concurrent exhibitions on the art of ancient Crete are held. *A Land Called Crete: Minoan and Mycenaean Art from American and European Public and Private Collections* and *A Land Called Crete: Photographs of Minoan and Mycenaean Sites and Works of Art by Alison Frantz* are shown October 6–November 19.

1968

Administration of the art library is transferred from the art department to the Neilson Library.

1969

Elizabeth Mongan (**24.2**), former curator of the Lessing J. Rosenwald Collection and curator of prints at the National Gallery of Art, joins the museum staff as curator of prints and drawings.

The artist Frank Stella gives the museum his monumental, 10 x 40-foot canvas, *Damascus Gate (Variation III)*.

1970

Tryon and Hillyer Halls are demolished to make way for the new Fine Arts Center.

Artist George Cohen teaches the first course in the history of film at Smith.

1970–72

During construction of the Fine Arts Center an exhibition of fifty-eight paintings from the museum's collection travels to nine museums across the country.

1972

The Fine Arts Center, designed by the Andrews/Anderson/Baldwin firm of Toronto, is completed. The principal participants in the design team are John Andrews, Edward Galanyk and Brian Hunt.

28.21

Selma Erving (class of 1927) makes the first gift to the museum of her collection that will include, with the bequest at her death in 1980, several hundred prints, drawings and *livres d'artiste* by artists of the late 19th and early 20th centuries.

With the support of the National Endowment for the Arts, the museum begins a graduate internship program. The first two interns to be hired are Marilyn Symmes and Donald Clausing, from the museum training program at the University of Michigan. Over the next thirty years more than twenty-five interns will be trained by SCMA.

28.22

1973, February

The museum reopens to the public, with galleries, storage spaces and offices on three floors, and an outdoor sculpture courtyard between the museum and art department buildings, which continue to take the names Tryon and Hillyer. A large lecture hall below carries the name of Christine A. Graham.

1974

Elliot Offner is appointed Printer to the College, to design and print with students the ephemera for the ceremonial events of the College.

1975

Jill Ker Conway (**24.1**) is named seventh president of Smith College.

Ruth Mortimer (class of 1953) is appointed rare book librarian and begins to teach Composition of Books, a historical course complementing existing studio book arts courses.

1977
Gallery Assistants Program (GAPS) begins at the museum, founded by interns Linda Muehlig and Sarah Ulen. The program, which continues today, is a non-credit course that trains Smith students to give tours of the museum.

1978
To honor Phyllis Williams Lehmann, Kenan Professor of Art, upon her retirement, a major exhibition exploring the rediscovery of antiquity and its influence in the Renaissance, *Antiquity in the Renaissance*, is held at the museum April 6–June 6.

1980
Publication of "The Survival of Antiquity," vol. 47 of the *Smith College Studies in History*, with seven essays in honor of Phyllis Williams Lehmann.

1981
Important exhibition exploring the renewed interest by contemporary architects in classical forms, *Speaking a New Classicism: American Architecture Now,* is shown April 30–July 12. Guest curator is Professor of Art Helen Searing (**2.17, 9.4**).

1982
Chetham purchases a collection of more than 2,000 19th-century photographs from the Lenox Library Association, Lenox, Massachusetts. This collection, largely assembled by Caroline Sturgis Tappan, more than doubles the museum's photography holdings.

28.23

A major exhibition chronicling the life and art of Edwin Romanzo Elmer is shown April 8–July 18. Organized by Associate Director and Curator of Painting Betsy B. Jones.

28.24

1984
Dwight Pogue inaugurates the annual Smith College Print Workshop.

1985
Mary Maples Dunn (**24.4**) is named eighth president of Smith College.

1986
A Guide to the Collections, Smith College Museum of Art is published.

Gary Niswonger teaches the first computer-based design course, as an experimental version of ARS 161, Basic Design.

1988
Edward J. Nygren becomes museum director.

28.25

1988–89
Art 100 expands to survey global art.

1989–90
First semester-long courses in African and Pre-Columbian art history are offered.

1990
While the museum is closed for asbestos abatement, eighty-two paintings and sculptures from the collection are shown at the IBM Gallery in New York City, October 2–November 24.

28.26

1991
Charles Parkhurst becomes interim director of the museum.

Exhibition of contemporary art drawn from alumnae and museum collections, *Smith Collects Contemporary*, organized by Edward Nygren, is shown May 3–September 15.

Nancy Rich is appointed the museum's first curator of education.

28.27

1992
An exhibition of rare, pre-1950 photographs of Lhasa, Tibet, from the Tuladhar collection, is shown in the Hillyer Gallery from March 23–April 5, organized and curated by Marylin Rhie.

Suzannah J. Fabing becomes museum director.

1993
The Andrew W. Mellon Foundation makes the first of two three-year grants to support the development of new academic courses utilizing the museum's collection.

In the fall semester, lectures on Asian art are first included in Art 100.

1993–94

First full-semester course in American Indian art and architecture is offered.

1994

Mr. and Mrs. William A. Small, Jr., of Tucson, Arizona, give the museum ninety-two works of primarily contemporary art.

1995

Ruth J. Simmons is named ninth president of Smith College.

Publication of *Smith College Museum of Art Newsletter and Calendar* begins.

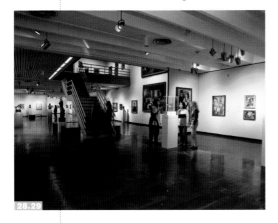

1996

Dana Leibsohn teaches the first *Insight*-based digital art history course.

1997

The Andrew W. Mellon Foundation awards the museum a challenge grant toward an endowment to support the use of the museum's collections in teaching at Smith. The challenge is met three years later.

1998

Major retrospective of the work of Sandy Skoglund is shown March 12–May 24. Travels to four other museums over the next eighteen months.

The trustees announce the selection of The Polshek Partnership as the architectural firm in charge of the renovation and expansion of the Fine Arts Center.

1998–99

The year-long art history survey course, Art 100, is reorganized into one-semester colloquia.

1999

The museum closes at the end of the year for renovation and expansion.

Publication of *Masterworks of American Painting and Sculpture from the Smith College Museum of Art*.

2000

Art department, art library and museum staff move to temporary offices at the Clarke School for the Deaf.

Two traveling exhibitions drawn from the permanent collection, *Corot to Picasso: European Masterworks from the Smith College Museum of Art* and *American Spectrum: Painting and Sculpture from the Smith College Museum of Art*, begin a national tour to sixteen venues.

Publication of *Master Drawings from the Smith College Museum of Art*.

Publication of *Smith College Museum of Art: European and American Painting and Sculpture 1760–1960*.

2001

The third traveling exhibition drawn from the collection, *Master Drawings from the Smith College Museum of Art*, opens at the Frick Collection in New York in the summer, traveling in the fall to the Uffizi Gallery, Florence, Italy, and the following year to the Fundación "La Caixa," Madrid, Spain.

An important Baroque painting, *Adoration of the Shepherds*, by the Flemish artist Erasmus Quellinus II, is purchased (**25.6**).

2002

Carol T. Christ takes office as tenth president of Smith College.

In September, the Brown Fine Arts Center partially reopens, with the art department and art library operating from the renovated Hillyer Hall.

2003, spring

Reopening of the Smith College Museum of Art.

28.1 Edmund Charles Tarbell. American, 1862–1938. *Laurenus Clark Seelye,* 1907–08. Oil on canvas, 72 × 60 in. (182.9 × 152.4 cm). Smith College Museum of Art. Gift of alumnae and friends, 1908.

28.2 Robert Swain Gifford. American, 1840–1905. *An Old Orchard near the Sea, Massachusetts,* 1877. Oil on canvas, 22 1/8 × 40 1/4 in. (56.2 × 102.2 cm). Smith College Museum of Art. Purchased, 1879.

28.3 Charles Noel Flagg. American, 1848–1916. *Winthrop Hillyer.* Oil on canvas, 26 1/2 × 22 in. (67.3 × 55.9 cm). Smith College Archives.

28.4 Rembrandt Harmensz. van Rijn. Dutch, 1606–1669. *The Three Crosses* (first state 1653), c. 1660. Etching, engraving and drypoint on paper, fourth state of five, 15 1/8 × 17 3/4 in. (38.3 × 45.1 cm). Smith College Museum of Art. Gift of the Studio Club and Friends, 1911.

28.5 Auguste Rodin. French, 1840–1917. *Children with Lizard,* c. 1881. Bronze, 15 1/2 × 10 × 9 3/4 in. (39.4 × 25.4 × 24.8 cm). Smith College Museum of Art. Purchased, 1914.

28.6 Gustave Courbet. French, 1819–1877. *The Preparation of the Dead Girl (La Toilette de la morte),* formerly called *The Preparation of the Bride (La Toilette de la mariée),* c. 1850–55. Oil on canvas, 74 × 99 in. (188 × 251.5 cm). Smith College Museum of Art. Purchased, Drayton Hillyer Fund, 1929.

28.7 Maitland de Gogorza with an art class, 1932. Smith College Archives.

28.8 Edgar Degas. French, 1834–1917. *The Daughter of Jephthah,* 1859–60. Oil on canvas, 77 × 117 1/2 in. (195.6 × 298.5 cm). Smith College Museum of Art. Purchased, Drayton Hillyer Fund, 1933.

28.9 Georges Seurat. French, 1859–1891. *Woman with a Monkey,* study for *A Sunday on the Island of La Grande Jatte,* 1884. Oil on wood

panel, 9 3/4 × 6 1/4 in. (24.8 × 15.9 cm). Smith College Museum of Art. Purchased, Tryon Fund, 1934.

28.10 President and Mrs. Neilson with Jere Abbott, 1938. Photograph by Paul Cordes.

28.11 Georges Seurat. French, 1859–1891. *Three Young Women,* study for *A Sunday on the Island of La Grande Jatte,* c. 1884–85. Black conté crayon on cream paper, 9 1/4 × 12 in. (23.5 × 30.5 cm). Smith College Museum of Art. Purchased, Tryon Fund, 1938.

28.12 Claude Monet. French, 1840–1926. *The Seine at Bougival, Evening,* 1869. Oil on canvas, 23 5/8 × 28 7/8 in. (60 × 73.3 cm). Smith College Museum of Art. Purchased 1946.

28.13 Members of the art department, 1951. Seated: Ann H. Belding, Priscilla Paine Van der Poel, Oliver W. Larkin, Ruth Wedgwood Kennedy, Eleanor D. Barton. Standing: George H. Cohen, Henry-Russell Hitchcock, George Swinton, Clarence Kennedy, Mary Bartlett Cowdrey, Mervin Jules, Louis Manzi, Phyllis Lehmann. Smith College Archives.

28.14 Oliver Larkin on Smith campus with Dewey House in background, 1955–56. Smith College Archives.

28.15 Robert Owen Parks, Professor Sidney Packard, Priscilla Cunningham (class of 1958) and Charles C. Cunningham, 1958. Photograph courtesy Priscilla Cunningham.

28.16 Ernst Ludwig Kirchner. German, 1880–1938. *Dodo and Her Brother,* 1908/20. Oil on canvas, 67 1/8 × 37 7/16 in. (170.5 × 95.1 cm). Smith College Museum of Art. Purchased, 1955. © (for works by E. L. Kirchner) by Ingeborg & Dr. Wolfgang Henze-Ketterer, Wichtrach/Bern.

28.17 Mathis Gothart Nithart (called Grünewald), commonly known as Matthias Grünewald. German, c. 1475/c. 1480–1528. *Study of Drapery,* c. 1508–15. Black chalk on paper, 5 1/8 × 7 1/8 in.

(13.1 × 18.1 cm). Smith College Museum of Art. Purchased with an anonymous gift in honor of the class of 1898, 1958.

28.18 Anonymous. Chinese, late Chou (end of 7th century BCE–3rd century BCE). *Pendant or Plaque.* Jade, 6 × 2 3/8 × 1/16 in. (15.3 × 6 × .2 cm). Smith College Museum of Art. Gift of Mr. and Mrs. Ivan B. Hart, 1960.

28.19 Sculpture court, 1960s.

28.20 Henri Fantin-Latour. French, 1836–1904. *Mr. Becker.* 1886. Oil on canvas, 40 × 32 1/2 in. (101.6 × 82.5 cm). Smith College Museum of Art. Purchased, 1964.

28.21 Fine Arts Center, 1973.

28.22 Henri de Toulouse-Lautrec. French, 1864–1901. Cover for *L'Estampe originale,* 1893. Lithograph, 22 3/4 × 25 3/4 in. (57.8 × 64.4 cm). Smith College Museum of Art. Gift of Selma Erving (class of 1927).

28.23 Anonymous. 19th century. *Pyrénées: Gavarnie. Hôtel des Voyageurs.* 1870s (?). Albumen print, 7 3/8 × 10 1/8 in. (18.7 × 25.7 cm). Smith College Museum of Art. Purchased with the Hillyer-Mather-Tryon Fund, with funds given in memory of Nancy Newhall (Nancy Parker, class of 1930) and in honor of Beaumont Newhall, and with funds given in honor of Ruth Wedgwood Kennedy, 1982.

28.24 Edwin Romanzo Elmer. American, 1850–1923. *Mourning Picture,* 1890. Oil on canvas, 27 15/16 × 36 in. (70.9 × 91.4 cm). Smith College Museum of Art. Purchased, 1953.

28.25 Vanessa Bell. English, 1879–1961. *Landscape with Haystack, Asheham,* 1912. Oil on board, 23 3/4 × 25 7/8 in. (60.3 × 65.7 cm). Smith College Museum of Art. Purchased with funds given by Anne Holden Kieckhefer (class of 1952) in honor of Ruth Chandler Holden (class of 1926), 1989. © 1961 Estate of Vanessa Bell, courtesy Henrietta Garnett.

28.26 Asbestos removal in the Fine Arts Center, 1990. Photograph by M. Richard Fish. Smith College Archives.

28.27 Anonymous. Netherlandish, 16th century. *Rosary Bead,* c. 1500–1510. Boxwood, 1 5/8 in. diam. (4.1 cm). Smith College Museum of Art. Purchased, 1991.

28.28 George McNeil. American, 1908–1995. *Spring Street,* 1987. Acrylic on canvas, 77 1/2 × 64 in. (196.9 × 162.6 cm). Smith College Museum of Art. Gift of Mr. and Mrs. William A. Small, Jr. (Susan Spencer, class of 1948), 1994. Photograph by Stephen Petegorsky.

28.29 Doyle Gallery of the museum, 1995. Photograph by Jim Gipe. Smith College Archives.

28.30 Sandy Skoglund. American, born 1946. *Revenge of the Goldfish,* 1981. Cibachrome print, 27 1/4 × 35 in. (69.2 × 89 cm). Smith College Museum of Art. Purchased with the Madeleine H. Russell (class of 1937) Art Acquisition Fund, the Janice Carlson Oresman (class of 1955) Fund, the American Art Acquisition Fund, the Class of 1990 Art Fund, the Josephine A. Stein (class of 1927) Fund in honor of the class of 1927, and museum acquisition funds. © Sandy Skoglund.

28.31 The *Insight* online database of the museum's collection allows for study from any networked computer, anywhere on the campus. *Head of a Young Woman* by Federico Barocci, c. 1574, is one of the works available.

28.32 John Davis, Alice Pratt Brown Professor of Art, gives a tour of the under-construction Brown Fine Arts Center to interested students and visitors in the spring of 2002. Photograph by Jim Gipe.

28.33 Ellen Driscoll oversees the installation of *Catching the Drift,* one of two artist-designed restrooms in the renovated Museum of Art. Photograph by Jim Gipe.

29.1 Department of Art Faculty and Staff, 2003. Front row, left to right: Susan Greenspan, Katherine Schneider, Susan Heideman, Donna Dorrell, Sherry Poirrier, Beverly Cronin, Karen Koehler, Meridel Rubenstein, Brigitte Buettner; back row, left to right: Jim Hume, Kevin Kanda, Marylin Rhie, Jolene de Verges, Martin Antonetti, Chester Michalik, Barry Moser, John Davis, Elliot Offner, Caroline Houser, Barbara Lattanzi, Barbara Kellum, A. Lee Burns, Frazer Ward, Dwight Pogue, Gretchen Schneider, Elisa Lanzi, Roger Boyce, M. Richard Fish. Photograph by M. Richard Fish/Eric Parham.

29.2 Art Library Staff, 2003. Left to right: Barbara Polowy, Josephine Hernandez, Matthew Durand, Joanne Nadolny. Photograph by M. Richard Fish/Eric Parham.

29.3 Museum of Art Staff, 2003. Front: Suzannah Fabing; behind, left to right: William F. Myers, Louise Laplante, Ann Johnson, Alona Horn, Nan Fleming, Aprile Gallant, Nancy Rich, Margi Caplan; back row, left to right: Ann Mayo, Alicia Guidotti, Ann E. Musser, Linda Muehlig, Michael Goodison, David Dempsey. Photograph by M. Richard Fish/ Eric Parham.

Faculty and Staff of the Brown Fine Arts Center

Department of Art Faculty, 2003

Martin Antonetti
Lecturer and Curator of Rare Books

Roger Boyce
Assistant Professor

Brigitte Buettner
Priscilla Paine Van der Poel Associate Professor

A. Lee Burns
Associate Professor

Carl Caivano
Lecturer

John Davis
Alice Pratt Brown Professor and Chair

Suzannah Fabing
Lecturer

Craig Felton
Professor

John Gibson
Lecturer

Susan Greenspan
Lecturer

Susan Heideman
Professor and Associate Chair

Caroline Houser
Professor

Barbara Kellum
Professor

Karen Koehler
Lecturer

Barbara Lattanzi
Harnish Visiting Artist

Dana Leibsohn
Associate Professor

Jaroslaw Leshko
Professor

Jane Lund
Lecturer

Chester Michalik
Professor

John Moore
Associate Professor

Barry Moser
Lecturer

Gary Niswonger
Professor

Elliot Offner
Andrew W. Mellon Professor in the Humanities (Art) and Printer to the College

John Peffer
Lecturer

Dwight Pogue
Professor

Marylin Rhie
Jessie Wells Post Professor

Meridel Rubenstein
Lecturer

Gretchen Schneider
Lecturer

Katherine Schneider
Lecturer

Rebecca Senf
Lecturer

Anna Sloan
Mellon Postdoctoral Fellow and Lecturer

Sonya Sofield
Assistant in Architecture

Kane Stewart
Lecturer

Henk van Os
Visiting Professor

Frazer Ward
Assistant Professor

Department of Art Staff, 2003

Daniel Bridgman
Visual Communications Specialist, Educational Technology Services

Beverly Cronin
Curator of Slides

Rebecca Davis
Assistant for Administration

Jolene de Verges
Digital Image Cataloger, Educational Technology Services

Donna Dorrell
Academic Secretary

M. Richard Fish
Photographer

James Hume
Shop Supervisor/Technician

Kevin Kanda
Davis Fellow for Digital Imaging, Educational Technology Services

Elisa Lanzi
Director of Image Collections

Sherry Poirrier
Image Collections Curator

Ed Snyder
Digital Assistant

Mark Zunino
Technical Assistant

Art Library Staff, 2003

Matthew Durand
Branch Services Assistant

Josephine Hernandez
Hillyer Library Assistant

Joanne Nadolny
Processing Assistant

Barbara Polowy
Art Librarian

Museum of Art Staff, 2003

Stacey Anasazi
Budget and Accounting Coordinator

Margi Caplan
Membership and Marketing Director

David Dempsey
Associate Director for Museum Services

Martha J. Ebner
Membership and Marketing Assistant

Suzannah Fabing
Director and Chief Curator

Nan Fleming
Museum Store Manager

Aprile Gallant
Associate Curator of Prints, Drawings and Photographs

Michael Goodison
Archivist and Editor

Alicia Guidotti
Secretary/Receptionist

Kelly Holbert
Exhibition Coordinator

Alona Horn
Curatorial Assistant, Prints, Drawings and Photographs

Ann D. Johnson
Administrative Assistant

Louise Laplante
Collections Manager/Registrar

Ann Mayo
Manager of Security and Guest Services

Linda Muehlig
Curator of Painting and Sculpture and Associate Director for Curatorial Affairs

Ann E. Musser
Associate Curator of Education

William F. Myers
Preparator

Nancy Rich
Curator of Education

Colophon

This book was composed with Adobe InDesign 2.0 for Mac OS X and produced on an Apple Power Macintosh G4 and Apple Cinema Display.

Designed by John Eue, Director of Publications and Communication, Smith College, Northampton, Massachusetts.

The principal typeface is Adobe Garamond, Robert Slimbach's digital interpretation of the roman types of Claude Garamond and the italic types of Robert Granjon. The display face is Garamond Condensed, designed by Tony Stan for the International Typeface Corporation and released in 1976–77. Some of the most popular typefaces in history are based on those of Claude Garamond, whose 16th-century types were modeled on those of Venetian printers from the end of the previous century. Illustration numerals and subheads are set in Helvetica, designed by Max Miedinger in 1957 for the Haas foundry of Switzerland.

Text: Scheufelen Consort Royal Silk 100LB text
Dust jacket: Scheufelen Consort Royal Gloss 100LB text
Printing: Lithographics, Inc., Farmington, Connecticut
Binding: Smyth sewn with Brillianta over board by the Riverside Group, Rochester, New York

Edition: 2,500